KT-514-324

Wyggeston QE I

00395970

Museum of Contemporary Art

TELLO DI RIVOLI

VIDEO ART
THE CASTELLO DI RIVOLI COLLECTION

The catalogue has been made
possible thanks to the
COMPAGNIA DI SAN PAOLO

VIDEO ART
THE CASTELLO DI
RIVOLI COLLECTION
edited by
Ida Gianelli, Marcella Beccaria

Texts
David A. Ross
Marcella Beccaria [M.B.]
Francesco Bernardelli [F.B.]

Editorial Assistance and
Bibliographical Research
Karin Gavassa
Federica Martini

Translations
Howard Rodger MacLean
Emily Ligniti
Marguerite Shore

Copyediting Assistance
Laura Petican

Cover
Pipilotti Rist,
Pickelporno (Pimple Porno), 1992
video still
Purchased with the contribution
of the Compagnia di San Paolo

Cover Design
Marcello Francone

Graphic Design
Leftloft, Milan

Editing
Emily Ligniti

Layout
Sara Salvi

First published in Italy in 2005 by
Skira Editore S.p.A.
Palazzo Casati Stampa
via Torino 61
20123 Milan
Italy
www.skira.net

© 2005 Castello di Rivoli
Museo d'Arte Contemporanea, Rivoli-Torino
© 2005 by Skira editore, Milano
© Joseph Beuys, Sophie Calle, Marie-Ange Guilleminot,
Carsten Höller, Rebecca Horn, Gordon Matta-Clark,
Tracey Moffat, Bruce Nauman, Lawrence Weiner by SIAE
2005
All rights reserved under international copyright
conventions.
No part of this book may be reproduced or utilized in any
form or by any means, electronic or mechanical, including
photocopying, recording, or in any information storage and
retrieval system, without permission in writing from the
publisher.

Printed and bound in Italy. First edition

ISBN-13: 978-88-7624-534-3
ISBN-10: 88-7624-534-0

Distributed in North America by Rizzoli International
Publications, Inc., 300 Park Avenue South
New York, NY 10010.
Distributed elsewhere in the world by
Thames and Hudson Ltd.
181a High Holborn, London WC1V 7QX, United Kingdom.

Acc No.
00395970

Class No.
778.59 GIA

REGIONE PIEMONTE

FONDAZIONE CRT

CAMERA DI COMMERCIO INDUSTRIA
ARTIGIANATO E AGRICOLTURA DI TORINO

CITTÀ DI TORINO

UNICREDIT PRIVATE BANKING – GRUPPO UNICREDIT

CASTELLO DI RIVOLI
MUSEUM OF CONTEMPORARY ART

Board of Directors

Chairman
Cesare Annibaldi

Board Members
Fabrizio Benintendi
Antonino Boeti
Elena Bucarelli
Roberto Cena
Giovanni Ferrero
Walter Giuliano
Antonio Maria Marocco
Giuseppe Pichetto
Luigi Quaranta
Alessandro Riscossa
Mario Turetta

Board Secretary
Alberto Vanelli

Board of Auditors

Chairman
Francesco Fino

Auditors
Guido Canale
Alfredo Robella

Director
Ida Gianelli

Curatorial Department
Carolyn Christov-Bakargiev,
Chief Curator
Marcella Beccaria, *Curator*
Franca Terlevic, *Registrar*
Chiara Oliveri Bertola,
Assistant Curator
Federica Martini,
Curatorial Assistant

Public Relations
Massimo Melotti

Press Office
Massimo Melotti
Silvano Bertalot
Manuela Vasco
Assistants

Promotion
Roberta Aghemo

Education Department
Anna Pironti, *Head*
Paola Zanini, *Workshop
Activities*
Barbara Rocci, *Secretary*

Department of Advertising and Communication
Andrea Riparbelli, *Head*

Administration
Gabriella Traschetti

Architectural Conservation Manager
Andrea Bruno

Conservation and Restoration
Luisa Mensi

Director's Office
Anna Odenato

Library and Multimedia Facilities
Maria Messina

Technical Department
Giorgio Carli, Fulvio Castelli, Francesco Ciliberto Attitudine Forma P.S.C. a R.L.

Insurance Consultancy
Agenzia Augusta Assicurazioni Torino 12
Rosy Gaia Pane

Supporting Friends of the Castello di Rivoli
Carlo Boggio
Maria Gabriella Bonelli
Angelo Chianale
Francesca Cilluffo
Anna Rosa Cotroneo Bidolli
Paolo Dardanelli
Carla Ferraris
Marina Ferrero Ventimiglia
Elena Geuna
Bruna Girodengo
Marino Golinelli
Andrea Ruben Levi
Barbara Maccaferri
Warly Moreira Tomei
Renata Novarese
Alessandro Perrone di San Martino
Attilio Rappa
Giovanna Recchi
Alessandro Riscossa
Marco Rocca
Patrizia Sandretto Re Rebaudengo
Tommaso Setari
Anna Giorgina Siviero
Gianluca Spinola
Carlo Traglio
Laura Antonietta Trinchero
Emanuela Vallarino Gancia
Matteo Viglietta
Andrea Zegna

CONTENTS

WQEIC LIBRARY

FOREWORD

Within the context of the cultural policies of the Region of Piedmont, contemporary art plays an important role, bearing witness to new developments in the complexity of present-day knowledge and experience. From its inception, the Castello di Rivoli has been distinctive for its clear vision, intended to reveal crucial events in the world of contemporary art by constantly proposing new exhibitions, publications, and catalogues and by building its collections in the interest of the community as a whole.

The Museum's latest project—an in-depth analysis of its impressive video collection—once again demonstrates how this institution strives to be truly contemporary and dedicated to an art form that has been around for less than forty years, but whose impact deserves great attention. Familiarity with an image broadcast on a monitor or projected is, in fact, typical of our age, and forms and expressions initially explored by artists have been adopted on a large scale, thereby contributing to the creation of a new type of language. In its totality, while the Museum's collection thus far is distinguished by the excellence of the works and the artists represented, it also constitutes an invaluable documentation of the capacity of art to maintain its universal value beyond the technology used.

The dream of creating a video collection has become a reality thanks to the generous support provided by the Compagnia di San Paolo, within a fruitful collaboration between public and private sectors.

Gianni Oliva
Councillor for Culture
The Region of Piedmont

Mercedes Bresso
President
The Region of Piedmont

THE VIDEO ART LIBRARY

With this publication, the Compagnia di San Paolo is delighted to present a significant cultural project. Established in 2001, the Castello di Rivoli's Video Art Library was created with the goal of collecting and supporting video and film as expressions of an autonomous art form. The project called for the acquisition of approximately 200 visual works of art (DVDs and videotapes), as well as documentaries on important artists, which would thus become part of the Castello's permanent collection. The video collection began with the master originators of the post-war period, starting with Korean artist Nam June Paik, moving through the seventies with Bruce Nauman and Vito Acconci, including the work of Bill Viola, the first artist who conceived of video as an autonomous "medium." Numerous exhibitions have been dedicated to this collection, beginning with *Arte in Video* (*Art in Video*) in 2002.

The Compagnia's renewed participation in 2003, which brings the total funds being used for this project to over 500,000 Euros, has enabled further contribution to the already existing collection of high-level historical videos, along with the acquisition of interesting current works. This initiative has allowed the Castello to devote greater space to previously explored artistic trends and to give greater emphasis to artists of recent generations. The Video Art Library's new works come from all over the world, and their creators range from members of the Fluxus movement to the most well-known contemporary artists such as Grazia Toderi, Vanessa Beecroft, Monica Bonvicini, and Liliana Moro. Moreover, recent acquisitions cover the artistic course of

renowned artists such as Rebecca Horn, Shigeko Kubota, Frank
Gillette, and others.

The Video Art Library completes—and at the same time renews—the
range of the Castello di Rivoli's collections, further emphasizing the
Museum's role as an institution of international stature. The initiative
is consistent with the Compagnia's aspiration to promote the Region's
cultural assets.

Franzo Grande Stevens
President
Compagnia di San Paolo

FOREWORD

This publication represents an occasion to present a selection of video works and artists that have become part of the Museum's collection. Indeed, there was a desire to bring together some of the most significant expressions of contemporary art and to indicate a new stage in the growth of the collection, which, as in every fine museum, is becoming the heart of its activity.

The distinctive value of this artistic language and its effectiveness in rooting itself in the universalization of communicative processes and in stimulating creativity that links imagination and realism have justified the definition of an *ad hoc* project.

The creation of this collection, which contains works by internationally renowned artists over the past forty years, has been made possible thanks to the support of the Compagnia di San Paolo, to whom we express our most heartfelt thanks.

Cesare Annibaldi
President
Castello di Rivoli Museum of Contemporary Art

INTRODUCTION

Although the Castello di Rivoli is a young museum and was founded just twenty years ago, it boasts a considerable number of works, thanks to the great efforts and energy employed in establishing a permanent collection with the conviction that this is the fundamental element for a public institution. Collecting attests to the mission of the Museum, thereby demonstrating that it believes in the art it promotes by fostering its presence on permanent display.

Among many methodologies of choice, the one favored by the Castello is that of constructing an international history, beginning with the late sixties up to the immediate present, paying particular attention to Italian art aware of its roots but in dialogue with the various cultures that have developed throughout the world. This dialogue has been maintained in part thanks to the heterogeneity of the artistic process.

It was precisely in the late sixties, the historical period from which the Castello collection begins, that a new emblematic tool—video— emerged with possibilities that have proven infinite.

Over the last twenty years, many artists have expressed their vision through video, however in keeping with the Museum's acquisition policy, key figures from the sixties and seventies have been selected, concentrating on a relatively limited number of artists who have made an essential contribution to the history of contemporary art. These artists are represented in the collection with an extremely vast body of works, and in some cases their entire oeuvre. Several important acquisitions have been made of works by artists from subsequent

generations, and we hope to be able to add to these in the near future. Today, the Museum's video collection consists of approximately 700 works and 130 documentaries, acquired with the support of the Compagnia di San Paolo, which in 2002 allocated to the Castello the funds needed to create this project and to publish this catalogue in order to inform the public about the videos in the collection and the artists who have created them.

This book contains an introductory text by David A. Ross, an eminent scholar in the field, and I would like to thank him for having accepted my invitation. In the early seventies, as the very young Director of the Museum of Contemporary Art in La Jolla, California, he was the first to demonstrate his belief in this form of artistic expression, installing shows that included the works of many of the artists present in our collection.

I would like to conclude by expressing my deepest thanks to the Compagnia di San Paolo for its generous assistance and for the confidence and support it has shown to the Castello di Rivoli. It has been a fruitful collaboration that I hope will continue in the future.

Ida Gianelli
Director
Castello di Rivoli Museum of Contemporary Art

THE HISTORY REMAINS PROVISIONAL
David A. Ross

Roughly forty years after its first appearance, *video art* remains difficult to define historically. Even though the medium evolved from obscurity to ubiquity in our time, and we have witnessed its evolution, its history remains elusive.

It's not that the history of artists' video is difficult to track; rather it's that the term video art refers to a set of tools, not a particular aesthetic orientation. In other words, since video art involves a remarkably wide range of artists, doing an equally broad range of things, its definition remains elusive, and its history will remain contentious.

For video art has its origins not in some murky, arguable pre-history, but in the confluence of several contemporaneous histories: art, social, and technological. In fact, the history of video art reveals art history's deep dependence on the context of related social, political, and technological change.

To do justice to the history of video art, you would need to trace the confluence of:

1. The history of twentieth-century art—with an emphasis on post-war movements including Pop Art, Post-Minimalism, Conceptualism, and Post-Modernism, and an exploration of the evolution of the global art scene;

2. The history of film—with an emphasis on independent cinema and the Expanded Cinema movement of the late sixties;

3. The evolution of video technology—in particular the development of portable video devices, cable and satellite delivery systems, personal computing, the Internet, etc.;

4. The development of journalism—in particular a study of the politicized "new" subjective journalism of the sixties and seventies;

5. The evolution of philosophical concerns emanating from the impact of Structuralism, French theoretical writings, post-Freudian scholarship, etc.

Bruce Nauman,
Bouncing in the Corner,
1968
video, black and white,
sound, 60 min., loop
Purchased with the
contribution of the
Compagnia di San Paolo

3

But the central problem is the very *idea* of video art. Simply put, as an art historical category, video art does not actually exist. It is provisional—a simple category of convenience. Of course it is ironic that artists working with video in the sixties and seventies often did so to escape being wrongly, prematurely, or at least unnecessarily categorized. This is not to say that video has no distinctive qualities, but rather it was the medium's malleability, its lack of art-historical baggage, its ephemeral nature, and its odd quality of non-objecthood that attracted such a widely varied group of artists.

This reading is complicated by the fact that when an artist decided to use video—like the contemporary decision to use the Internet as a site for creative work—it signified something inherently political. Then as it is today, that decision implied that as an artist, you were reaching out of the traditional boundaries of the art world and engaging a medium with the potential to create direct lines of communication between artists and audiences, ignoring or short-circuiting the power of museums, galleries, and critics.

And finally, our historical understanding of artists' video use is hindered by simple medium-based categorization. One rarely learns anything important about an artist's work or aesthetic orientation through simple knowledge of what medium he or she uses. To restate the problem, video is not a movement or the label for a shared aesthetic—it is simply a set of tools; tools capable of producing extraordinary works of art.

Yet the relentless systems of the art world—essentializing art histories, institutionalized art education, and globalized, highly competitive, art collecting—need to keep art in tidy categories. As a result, video art has become one of those meaningless designations of little real distinction and questionable value. But the good news is that artists generally ignore this kind of labeling, and work with whatever medium suits the needs of a particular artwork. And accordingly, a widely diverse group of artists have worked with video, heedless of the label-makers, for over four decades.

So what of this dubious history? The standard anecdotal video art creation myth relates the story of Nam June Paik, the Korean artist trained in philosophy and music in Japan and Germany, who as part of the Fluxus movement pushed his interest in the music of Stockhausen and Cage into experimentation with "prepared" television sets and (as the newly evolving technology presented itself) with video recording. At about the same time—in the early sixties—the German artist Wolf Vostell working with a collagist vocabulary derived from the early "combine" paintings of Robert Rauschenberg began incorporating televisions into large-scale assemblage works he termed works of "de-collage."

One of the things that both of these origin myths have in common is their relation to the prolonged moment in post-war art and music when the influence of Buddhism

Nam June Paik,
Video Synthesizer and "TV Cello" Collectibles,
1965–1971
in collaboration with Jud Yalkut
video, color, silent, 23 min. 25 sec.
Purchased with the contribution of the Compagnia di San Paolo

5

Fluxus, *Stockhausen's Originale: Doubletakes,* 1964–1994
transferred from 16 mm film, black and white, sound, 30 min. 05 sec.
Purchased with the contribution of the Compagnia di San Paolo

began to spread, opening the door not only to artistic exploration of the notion of randomness and indeterminacy, but promoting the central idea that art and life needed to be experienced in an integrated and integrating fashion. But the upshot of art that engaged the real world was that artists had to confront prevailing forces in their society, and make art that spoke truth to power as it sought transcendence.

It is that both Paik and Vostell were politically engaged artists, and that their use of video reflected a sophisticated understanding of the nature of mass media and power. Flowing from the strong anti-authoritarian influence of Beat culture in the United States and Asia, and related indirectly to the anti-spectacularist notions of the European Situationist

International, these early uses of video were often critiques of the alienating and otherwise-destructive power of mass media.

As early as 1929, the playwright Bertold Brecht warned, in his essay propounding a "theory of radio," that the potential for authoritarian misuse of mass media was inherent in the "one-way" nature of broadcast radio. He urged that to avoid the fascist potential of the new medium, radio be developed as "two-way" or what we would now term an "interactive" medium. What Paik and Vostell were evoking in their use of television was nothing less than the specter of alienated societies manipulated into cozy forms of subjugation every bit as pernicious as that practiced by more overtly dictatorial twentieth-century regimes.

Fluxus, *26'1.1499"*
For A String Player, 1973
video, color, sound, 42 min.
Purchased with the
contribution of the
Compagnia di San Paolo

1. In a 1974 *Art Forum* article, the poet and critic David Antin discussed the influence of broadcast television on the evolving video art form, and the language and grammar it introduced. In the article, he introduced his term for television: it was "video's frightful parent."

2. Videotape was developed by Ampex Corporation in 1957, and was up until the mid-sixties, only affordable by large-scale commercial broadcast television organizations. The revolutionary technological change that is in some ways the underpinning of the rise of video art was the development, in 1963, of low-cost, consumer-grade portable video technology. A technology now so pervasive and inexpensive, it is hard to imagine how radical a shift in thinking was brought about by the appearance of these new tools. Cheap re-usable videotape, relatively lightweight cameras and recorders, instant replay, and the ineffable sense of real time that could be recorded and played back, created a new palette with which artists and journalist/documentary-makers could experiment.

In retrospect, this approach seems to have been quite appropriate in the socio-political context of ideologically wary post-war Europe. Artists recognized that it was the official governmental nature of repressive political art that presented a problem, rather than the idea that artists themselves could be political as individuals, using their free and independent voices to create works that sought to energize, humanize, and inform the world at large. And what could provide a better platform for this kind of work than television, which the critic David Antin termed "video's frightful parent."[1]

The politics of video art's early history, then, was not so much measured in the specific ideological content of the works produced, but by the inherently political decision to work with this highly politicized medium. In this context, we can see that video sprung from a significant social historical moment when the authority of mass media began to shift in ways that are still unsettled four decades later. Artists using video were the vanguard of a generational shift in our understanding of media and power.

It is not surprising, then, that in Paik's earliest video sculpture—*Magnet TV,* 1962—he symbolically *inserted* the artist's hand into a technology that had previously been impervious to such overt poetic manipulation. By placing a large permanent magnet atop a standard domestic television set from the fifties, he mechanically warped whatever video image was showing on the set. Not unlike a "prepared" piano, this intervention established a fixed point of disorientation into a random flow of otherwise normal information. A not-so-subtle reminder of the fact that what appeared on the screen was essentially a social construction, Paik's "de-construction" or distortion of the broadcast signal marked the insertion of the artist into a system that had previously excluded this kind of direct engagement.

When Paik began working with the still relatively new technology of video recording[2] his earliest pieces involved the manipulation of overtly political news programs, like the still prominent and powerful NBC-TV newsmaker

interview show, *Meet the Press*. In 1963, Paik video
recorded an interview with the then Undersecretary
of State George Ball functioning as an official apologist
for US involvement in Vietnam. By placing a live wire
across the reel of recorded videotape, he erased a line
directly below the magnetic current of the wire.
The result was a simple recurring erasure of the recorded
interview which at first occurred every three seconds,
but then as the tape wound towards its core, the erasure
created a nearly constant interference. Again, the artist's
hand was asserted, but this time not into the random
flow of broadcast television, but rather into the media
stream of government propaganda that was being
employed to sustain the American war effort in
Southeast Asia.

Peter Campus,
Set of Concidence, 1974
video, color, sound, 13 min.
24 sec.
Purchased with the
contribution of the
Compagnia di San Paolo

3. The politics of community cable television were a part of the video ethos, as the nascent video medium was quickly seen as a valuable tool for community organizing, and for giving voice to social groups that had previously been ignored or grossly misrepresented by mainstream mass media. In many ways, the advent of the video movement marked the beginning of the end of the hegemony of mass media, as even the concept of mass media began to wither under the promise of a medium with hundreds if not thousands of channels. This promise proved false, in the short and mid-term, however, and it was not until the early nineties and the advent of the Internet that the structure of media engagement began to rapidly break down and reformulate into a wholly new set of relationships between individuals and audiences.

Charlemagne Palestine, *Four Motion Studies*, 1974 video, black and white, sound, 13 min. 24 sec. Purchased with the contribution of the Compagnia di San Paolo

Pervasive, but subtle, politics underlay much early video work.[3] Yet to be clear, in the first years after the appearance of video, two very separate approaches developed. There were artists working in the tradition of documentary film and employing the "new" journalism of overt subjectivity and transparency in their approach to subject matter that the mainstream mass media were either uninterested in or were covering in promotion of corporate and government interests. And there were those who chose to eschew the overtly political, engaging in the equally compelling politics of art for art's sake, making video that had little if anything to do with documentary representations of the real world.

But this rather simplistic bifurcation faded over time. This becomes even more evident as we move closer to the contemporary explosion in the use of video; the early divisions have seemingly merged or simply disappeared.[4] The most prominent examples of the early video documentary can be seen in the production of alternative media collectives like the Videofreex and Raindance. Composed of artists and filmmakers who were taken by the medium's potential for social critique, they found in video the promise of truly independent television in the

hands of individuals rather than solely a function of corporate journalism.

At the same time, there were artists in the United States and in Europe manifestly "uninterested" in video's journalistic capacity, or in the implications the technology had in regard to empowering marginalized communities. Rejecting the idea of overtly political video work, they sought to explore video for more personal aesthetic ends.[5]

In the United States and Canada, where artists' use of video spread more quickly than in Europe or Asia, dozens of artists including John Baldessari, Vito Acconci, Bruce Nauman, and William Wegman were using simple, low-resolution black and white video to extend their language-oriented work as Conceptual artists. The works typically took the form of simply recorded video performances, but nonetheless were compelling and enormously influential on a generation of younger artists just emerging from art schools. But language and related philosophical issues were their primary concerns—not the medium of video per se, and surely not the politics of mass media.

In parallel were artists like Steina and Woody Vasulka, whose well-crafted and highly technological video-based works were based on formalist strategies similar to the work of film artists like Paul Sharits and Hollis Frampton. The influence of "Structuralist Cinema," and allied movements within the film community, had an odd "love-hate" relationship to video, but in retrospect, the intellectual rigor of the film scene had a very strong influence—especially in the area of theoretical writing about new media.

One should recall that the late sixties and early seventies was, after all, the era of drugs, psychedelic music, and light shows, and this influence also found its way into early video. Artists in New York, Chicago, and San Francisco began working with video feedback and synthesized video imagery derived from analogue image-generating devices analogous to music synthesizers.[6]

4. It is quite interesting to note that at the present time, this division between the high-art and the documentary has thoroughly dissolved, with many of the most prominent uses of video in the 50th and 51st editions of the Venice Biennale reflecting artists exploring political issues quite directly, dealing with issues of human rights, homelessness, forced migration, etc. Perhaps it is that the notion of a politicized art, in the era in which global activism and responsiveness to serious issues such as AIDS, forced mass migration, the response to terrorism following 9/11, the war in Iraq and its geo-political implications, has evolved in parallel to the global expansion of the art world. And the use of video remains the most straightforward method of sharing the broad diversity of world-views and ideological perspectives that have naturally accompanied this welcome expansion of our collective experience.

5. Narrative work, resolutely non-cinematic, was quite prevalent in the work of William Wegman,

11

for example. The early poetic performance-based video work of Joan Jonas often played with some of the specific capacities of the video image, but only as an extension of her work with mirrors and mirroring. Vito Acconci exploited the intimate, domestic, private relationship that people generally have to the viewing of television, and sought to heighten that intimate space with loaded language and highly charged performance.

6. Nam June Paik, oddly enough, was also the pioneer in this aspect of video art, as his Paik-Abe video synthesizer was the first device to be widely used in the creation of special video "feedback" effects that later became the staple of the music video industry. His original synthesizer was a homemade, relatively crude device that a mere twenty years later would be rendered obsolete by far more sophisticated digital devices.

7. For example, the sculptor Richard Serra, whose formally brilliant early sculptures and drawings, and sculpture-

Much of this work was quickly identified as video art by the mainstream press, as it was, after all, work that could only be made with video, and it had a startling effect on a public that had yet to experience the dazzling but now standard special effects commonly employed in music videos.

Artists exploring the relationship of performance to sculpture and an understanding of the body included sculptors, choreographers, and performance artists. They, too, found great promise in the use of video, though they tended to use it as a compositional device, a means of direct documentation, a new way of drawing, or simply as a way to more directly engage audiences. Without a doubt, the practical applicability of video made it an essential tool for choreographers, performers of all kinds, from poets to performance artists. Artists as diverse as Joan Jonas, Bruce Nauman, Meredith Monk, Barbara Lloyd, and Charlemagne Palestine found enormous potential using video both as a performance prop (or substitute for a traditional set) as well as a compositional medium in its own right.

So widely did the video wildfire spread that by the mid-seventies there was barely any area of artistic practice not explored by artists working with video recorders and monitors. The explosion of creativity and fully unbridled invention is unmatched in twentieth-century art, as the simplicity of the medium, its relative low cost, and the total lack of critical response made video, in the words of the Japanese video artist Shigeko Kubota, "the vacation of art."

This lack of critical scrutiny was a crucially important factor, as it allowed artists during the seventies and eighties to escape the false categories and increasingly meaningless *isms* being propagated seasonally by the reining critical establishment. Using video implied a relaxed, informal field of endeavor with no awards, prizes, or even serious mentions in the prevailing art press. And this relative anonymity made it possible for artists to extend themselves in ways they might not in other areas of their work.[7]

But soon enough, the idea of a video art began to surface. As a museum professional with the designation Curator of Video Art,[8] I (along with my peers at other museums) become unwitting accomplices to the framing of a new false category—one whose uselessness took a while to see, but now can be easily recognized as such. Survey exhibitions, coffee table art books, special issues of art magazines, even state and federal funding agencies all tried to address this phenomenon and wrestle it into critical submission. But since there was nothing essentially art-historical to the notion of the wide range of works being made, the idea of a generic video art soon ran aground.

I am not saying that it is pointless to categorize groupings of artists working within shared sensibilities or sharing other critically significant qualities within their work. What I am saying is that video art is not that kind like films, was able to extend the process-oriented nature of his work by using video to produce far less formal studies of principles that still underlie his work thirty years later. Similarly, Lynda Benglis explored the feminist themes of gender redefinition and, with the legendary filmmaker

Bill Viola, *Return*, 1975 video, color, sound, 7 min. 15 sec. Purchased with the contribution of the Compagnia di San Paolo

13

Stanton Kaye, was also among the first to twist narrative conventions of television in the service of an examination of moral and social conventions. John Baldessari produced a series of simple video

Frank Gillette,
Symptomatic Syntax, 1981
video, color, sound, 27 min. 20 sec.
Purchased with the contribution of the Compagnia di San Paolo

of a category. Clearly, video implies the use of a set of tools, as the category "drawing" roughly implies the use of a certain set of aesthetic decisions, as does "works on paper," which may involve drawing, but may also involve the use of photography or even paint. But the ways in which the term *video art* has been used to imply some explicit category of art making has become less than useful. Gordon Matta-Clark's use of video to document his site-related sculptural works and Martha Rosler's ideologically pointed social critique videotapes bear little if anything in common, yet they share a place in the history of video art.

Most often, at this point in time, *video art* is a term of convenience valued by museum conservators who have a

professional need to devise proper storage and conservation standards for this specific medium, but even in this situation it is inadequate.[9] For video installations, which generally involve video projectors, a sound system, a lighting plan, and other sculptural elements deployed within a space whose design and specific construction are also an integral part of the work, are hardly definable by the video alone. These works, increasingly ubiquitous in contemporary art museums and at biennials, are more properly categorized as mixed media sculptural installations.

It may be interesting to explore this ubiquity, for it seems to have arisen from the need for artists using video to claim space and attention for their time-based works when they are presented in the context of a large-scale group or thematic exhibition. Videotapes themselves—most of the material in this collection for example—are rarely shown within institutions or institutionalized settings in this primary format. Generally speaking, though this may be a trend that is in decline, people approach the viewing of art in museums or festivals with a certain pre-determined attitude towards time. And setting oneself in a darkened room for several hours of video viewing is often at odds with the feeling that one should move through an exhibition from point A to point B with minimal interruptions. So the presentation of videotapes had to be adapted to the viewing patterns of museum visitors.

The idea of moving from the viewing of a work of art produced with traditional materials—a painting for example—to a video work that requires you to spend fifteen minutes standing still in a dark room creates a certain psychological discomfort. If the videotape is presented as an installation, in a simple sculptural context—as Bruce Nauman's early single-channel monitor works were presented at the Nicholas Wilder Gallery in 1968—then by implication you are not entering a cinema-type theatrical experience where one is expected to sit through a work from start to finish, but rather experience the work for as long as you remain interested in doing so.

works as parody of the essentialist rigor of much early conceptual art, including his great homage to his friend and fellow Conceptualist Sol LeWitt.

8. At the Everson Museum of Art in Syracuse, New York, James Harithas (the Everson Director in the early seventies) took the risk in 1971 of appointing me as the first formally titled "Curator of Video Art," with the charge to produce exhibitions and a collection of video-based work for the museum. Video curators at the Whitney Museum and the Museum of Modern Art soon joined me, producing exhibitions and catalogues exploring and promoting this new medium for artistic expression.

9. Few standards for preservation currently exist, and the storage of "variable" media like videotape is the subject of a great deal of professional consternation. For more information about this topic, please visit the website of the New Art Trust, a California foundation that has been working with museums around the world to help develop and implement

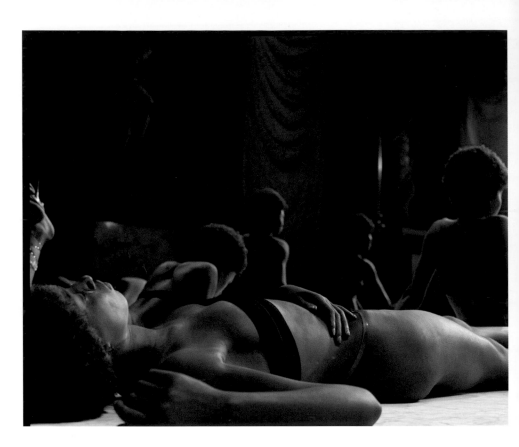

Vanessa Beecroft,
VB48, 2001
video projection, DVD,
color, silent, 91 min.
Purchased with the
contribution of the
Compagnia di San Paolo

When an artist like Bill Viola creates specific video environments he does so with complete control over every aspect of the work he can manage to manipulate, in the way that any artist takes complete control over all aspects of his or her work. But in viewing a simple videotape by Viola, it will be seen on some monitor or projector, in some space with some sort of seating (or not) and none of these elements will be in the artist's control. This is not a problem, but rather a given that artists understand quite well. For this reason, artists increasingly insist that even a simple, single-channel videotape be handled as an "installation."

So increasingly, as artists, audiences, and institutions became more experienced with video,[10] the simple videotape was relegated to a second-class status—unless it

was to be displayed as a stand-alone installation of one sort or another.

But exhibition prejudices aside, the single-channel videotape held great appeal for many artists because it could be easily duplicated in unlimited editions, sold or rented at a very low price, conceivably shared through some traditional broadcast or cable outlets, and perhaps even establish a new model for connecting artists with audiences. And beyond that, since it is the videotape itself that is the software or content of more complex video installations, it is in fact the core of a work that may eventually resolve itself in other formats. So collections of artist's videotapes function as extremely functional archives, and as valuable resources for those trying to construct and learn from their own art histories, even if they are rarely exhibited in their pure form. But perhaps the most influential function of the simple videotaped work has been as course material to three or four generations of art students, who have been exposed to these seminal works during their formative years at art school.

This collection, composed of work by a wide range of artists from several generations, represents a very important aspect of the Rivoli collecting strategy. For in a relatively compact fashion, it provides an overview of a wide range of quite diverse aesthetic directions pursued by artists during the last thirty years. Ranging from the key early works by Nauman and Paik to more recent tapes made by artists as diverse as Bill Viola, Dara Birnbaum, Pipolotti Rist, and Vanessa Beecroft, this collection does not purport to be comprehensive. Rather, as a complement to the integrated Rivoli collections of painting, sculpture, and photography, this remarkable collection of videos provides specific opportunities to view in-depth, significant video work made by artists of several over-lapping generations representing a broad overview of the various aesthetic directions and strategies employed by artists using video during the past thirty-five years.

standards for handling this kind of material.

10. When did the word *video* become a noun, as in "let's go watch a video"? I assume it was as a result of the rental of feature films in home video format, which then transformed picking up a "video" into a commodity like milk or bread.

VIDEO ART
THE CASTELLO DI RIVOLI COLLECTION
Ida Gianelli, Marcella Beccaria

Following the guide to the Museum's contemporary art collection, this publication is an in-depth examination devoted entirely to the video works brought together to date at the Castello di Rivoli Museum of Contemporary Art. In this case as well, the publication is organized according to monographic entries, though avoiding national or chronological forms of categorization. Presented in alphabetical order, entries include a critical introduction to the artist, followed by information and commentary on the works, accompanied by relevant images.

Though rather brief, the history of video art—the earliest examples of which date back to the introduction of the handheld Portapack video camera around 1965—is characterized by a wide variety of artistic visions and linguistic forms and is marked by the rapid development of technology and new possibilities employed for the recording, transmission, and preservation of the electronic image. In terms of the latter, an essential role was played by Electronic Art Intermix (EAI), the New York-based organization that is the distribution house from which the Castello di Rivoli acquired a number of its videos, particularly many of those now considered historical. Some works have also been acquired from Video Data Bank, Chicago. In agreement with the artists, these distribution houses transferred the original masters onto new formats, compatible with new technologies, ensuring the preservation of an irreplaceable patrimony. For this reason, in compiling this publication, except in cases where the artists made requests to the contrary, the label "video"

groups together works shot in a variety of formats. In particular, it includes early videos, initially produced on half-inch tape, as well as recent works employing digital technology and produced for DVD, but also single-channel works, intended for broadcast on monitors. Even when these are available in different formats, we considered it appropriate to differentiate works that were initially produced on film, maintaining information related to any Super 8, 16 millimeter, or 35 millimeter recordings. Finally, the label "video installation" is used for works that include sculptural elements, while "video projection" indicates works intended for projection on a wall or screen. The publication concludes with a list of video documentaries in the collection.

Marcella Beccaria
Curator
Castello di Rivoli Museum of Contemporary Art

VITO ACCONCI
(New York, 1940)

From his initial interests in experimental literature and poetry, with which he established a relationship of powerful physical and communicative intensity between the author and the spectator, Acconci, towards the end of the sixties, became involved in a direct confrontation with the public, moving from the space of the page to that of the gallery. By elaborating obsessively intense performances, the artist recorded his actions in a series of films and videos.

His first "threadbare" works express a search for strong, and at times even disturbing, physical and psychological impact with a series of performances recorded on film without sound. Almost at the same time, he embarked upon a more self-analytical phase, combined with a rereading of the audience-performer relationship, emphasizing forms of communication that go beyond conventional public-private confines. He developed a series of monologues similar to streams of consciousness, aimed at the spectator, thus assigning the works the descriptive title of the action that takes place.

In delving into the relationships between communicative closeness and violence, Acconci's interest progressively moved towards describing interpersonal psychological states, arriving at cultural and political implications tied to the performance spaces and the places intended for these. Through video and audio installations, starting in the second-half of the seventies, he explored the implications of the chosen exhibition context, reflecting on the spectator's role.

From the early eighties, a newfound interest for sculpture has led him to explore situations of a more participatory nature for the audience, thereby dedicating himself to works that are decidedly more architectural in nature. In an attentive dialogue with design, and landscape and public architecture, he founded Acconci Studio, a group of architects and city-planners with whom he collaborates on increasingly vaster urban interventions. [F.B.]

Three Frame Studies, 1969
transferred from Super 8 film, black and white,
color, silent, 10 min. 58 sec.
Purchased with the contribution of the
Compagnia di San Paolo
In these three short studies, Acconci carries out a
series of actions in which his gestures meet with
various forms of physical resistance by testing the
real and symbolic limits of the film frame space.

Applications, 1970
transferred from Super 8 film, color, silent,
19 min. 32 sec.
Purchased with the contribution of the
Compagnia di San Paolo
Acconci's body is literally covered with red signs,
traces of lipstick from the kisses of female lips.
The artist then rubs his body against another
man.

Corrections, 1970
video, black and white, sound, 12 min.
Purchased with the contribution of the
Compagnia di San Paolo
Naked, his back to the camera, Acconci lights
matches, one after the other, and tries to bring
them near his shoulder, though each time causing
small burns.

Open-Close, 1970
transferred from Super 8 film, color, silent,
6 min. 40 sec.
Purchased with the contribution of the
Compagnia di San Paolo
In this brief study, the artist explores and tests a
series of exercises of opening and closing his
anus.

Openings, 1970
transferred from Super 8 film, black and white,
silent, 14 min.
Purchased with the contribution of the
Compagnia di San Paolo
In a close-up and detailed shot of his stomach,
the artist pulls out the hairs around his navel.

See Through, 1970
transferred from Super 8 film, color, silent,
5 min.
Purchased with the contribution of the
Compagnia di San Paolo
Seen from behind, Acconci concentrates on his
mirror-reflected image. He then breaks the
mirror, thereby eliminating his reflection.

Three Adaptation Studies, 1970
transferred from Super 8 film, black and white,
silent, 8 min. 05 sec.
Purchased with the contribution of the
Compagnia di San Paolo
In *Blindfold Catching*, Acconci, blindfolded, tries
unsuccessfully to catch a series of balls that are
thrown at him. In *Soap & Eyes*, he attempts to
keep his eyes open, even though he has soap in
them, thus making him grimace in a grotesque
way. In *Hand and Mouth*, he repeatedly tries to
force a hand into his mouth, which his body
violently rejects.

Three Relationship Studies, 1970
transferred from Super 8 film, black and white,
color, silent, 12 min. 30 sec.
Purchased with the contribution of the
Compagnia di San Paolo
Shadow-Play presents the artist bent on fighting

against himself, sparring in a boxing match with his own shadow. In *Imitations*, he tries as accurately as possible to imitate the gestures and words of another person. In *Manipulations*, hidden behind a mirror but visible to the spectator, he seems to direct the gestures of a girl on the other side of the mirror.

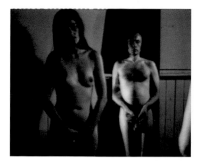

Two Cover Studies, 1970
transferred from Super 8 film, color, silent, 7 min. 46 sec.
Purchased with the contribution of the Compagnia di San Paolo
In *Scene Steal*, the artist, completely dressed, tries to shield a naked girl, attempting to cover her. In *Container*, he wraps his naked body around a sleeping cat, as if to totally absorb it.

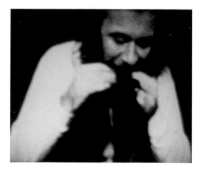

Two Takes, 1970
transferred from Super 8 film, black and white, silent, 9 min. 40 sec.
Purchased with the contribution of the Compagnia di San Paolo
In *Grass/Mouth*, the artist ingests grass until he chokes. In *Hair/Mouth*, he places himself behind a seated girl and tries to swallow her long hair.

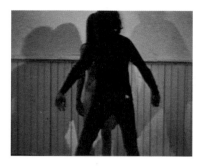

Association Area, 1971
video, black and white, sound, 62 min. 13 sec.
Purchased with the contribution of the Compagnia di San Paolo
Acconci and a young man, both blindfolded and wearing earplugs, intuitively try to imitate each other's movements, while an off-screen voice offers some suggestions the two performers cannot hear.

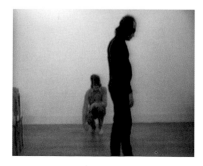

Centers, 1971
video, black and white, sound, 22 min. 28 sec.
Purchased with the contribution of the
Compagnia di San Paolo
Focusing obsessively on the tip of his index
finger, placed precisely at the center of the
monitor, Acconci develops a rigorous and
disorienting analysis of the relationship between
viewer and actor, inverting and reversing the
terms of active action and passive reception.

Claim Excerpts, 1971
video, black and white, sound, 60 min. 20 sec.
Purchased with the contribution of the
Compagnia di San Paolo
Blindfolded and armed with a metal pipe at the
bottom of a flight of stairs, the artist, all alone,
obsessively repeats to himself and to others that
he wants to be left alone.

Contacts, 1971
video, black and white, sound, 29 min. 47 sec.
Purchased with the contribution of the
Compagnia di San Paolo
Immobile and blindfolded, Acconci stands naked
before a girl who slowly comes close to him,
though without touching him. At the height of
concentration, Acconci tries to intuit the areas of
potential contact.

Filler, 1971
video, black and white, sound, 29 min. 16 sec.
Purchased with the contribution of the
Compagnia di San Paolo
Acconci lies on the floor, facing the camera, but
at the same time is hidden behind a large
cardboard box. The long silence is interrupted
only by the repeated coughing that shakes him.

Waterways: 4 Saliva Studies, 1971
video, black and white, sound, 22 min. 25 sec.
Purchased with the contribution of the
Compagnia di San Paolo
Through a series of saliva-producing techniques,
Acconci re-creates and associates artistic
production to natural biological secretion.

Conversions, 1971
transferred from Super 8 film, black and white,
silent, 65 min. 30 sec.
Purchased with the contribution of the
Compagnia di San Paolo
In three slow and planned exercises, Acconci
manipulates, plays with, and alters parts of his
body in order to suggest anatomical
transformations, thereby simulating the other sex.

Pick-Up, 1971
transferred from Super 8 film, color, silent, 16
min. 50 sec.
Purchased with the contribution of the
Compagnia di San Paolo
Completely blindfolded, bent over, and
concentrating intently, Acconci attempts to intuit
the movements of the hands of the person in
front of him.

Remote Control: Parts I & II, 1971
two-channel video installation, black and white,
sound, 62 min. each
Purchased with the contribution of the
Compagnia di San Paolo
The artist and a girl find themselves inside a
wooden box in two separate spaces. The artist has
a monitor and a microphone through which he
can observe and control the girl.

Face to Face, 1972
transferred from Super 8 film, color, silent,
15 min.
Purchased with the contribution of the
Compagnia di San Paolo
In a performance entirely centered on his own
face, and without ever using forms of verbal
communication, the artist explores the
connections between facial expressions and their
psychological and narrative resonance.

Face-Off, 1973
video, black and white, sound, 32 min. 57 sec.
Purchased with the contribution of the
Compagnia di San Paolo
Seated before a tape recorder playing previously-
recorded tapes in which he relates secret details
about his private life, Acconci reacts to and tries
to drown out the stream of taped confessions,
revealing himself in a continuous and conflicting
play of reticence and exhibitionism.

Command Performance, 1974
video, black and white, sound, 56 min. 40 sec.
Purchased with the contribution of the
Compagnia di San Paolo
Acconci, lying on his back so that the audience
cannot see him, progressively abandons himself
to a sort of extended confession in which he
expresses thoughts and doubts regarding the
expectations of the public and his performance
activity. He occasionally invites the listener to
take his place.

Face of the Earth, 1974
video, color, sound, 22 min. 18 sec.
Purchased with the contribution of the
Compagnia di San Paolo
In an extended, intense, and increasingly
hypnotic tale, Acconci, his face in extreme close-
up and almost always covered by his hands,
evocatively describes a solitary figure traveling
towards the frontier of the Far West, thus

creating a refined verbal and sound orchestration
of actions and explorations.

Shoot, 1974
video, color, sound, 10 min. 18 sec.
Purchased with the contribution of the
Compagnia di San Paolo
In a crescendo of theatrical forcefulness, Acconci
strings together descriptions and memories of his
origins, of his being an American citizen,
alternating these with onomatopoeic sounds of
explosions, shaking his penis and creating a
never-before-seen and pitiless revision of the
American Dream.

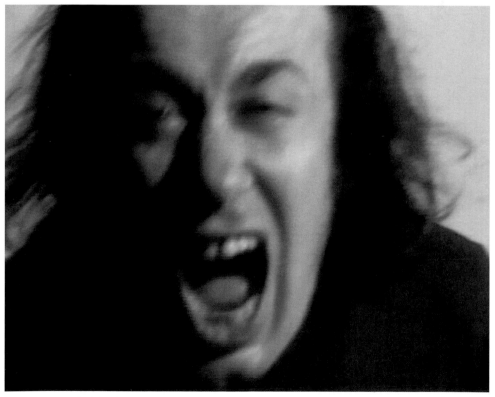

BAS JAN ADER
(Winschoten, Netherlands, 1942 – missing, 1975)

Bas Jan Ader studied art in Amsterdam and, after a number of adventurous trips at sea, a voyage on a cargo ship from Morocco lasting eleven months landed him in Los Angeles, where he settled down. Here he studied art and philosophy from 1963 to 1969 at the Otis Art Institute and subsequently at the Claremont Graduate School. Shortly afterwards he became a member of the Faculty of Art at the University of California (Irvine).

Through his artistic research, which oscillated between the melancholic and the metaphysical, Ader was interested in the figure and the idea of the artistic personality on the border between art and life. His work can be aligned with practices tied to Conceptual and Performance Art, which allowed further exploration into themes of human limits and fragility.

With particular attention to the centrality of the human figure and bodily presence, the majority of his work centers around ephemeral gestures or actions of very short duration.

Like many of his contemporaries, Ader used photography, film, and video to document his performances. Treating situations that are closer to states of mind than to pure plastic forms, some of his projects—such as the famous cycle dedicated to the theme of "falling," entitled the *Fall*—show the artist both in photographic sequences and in 16 mm films performing brief actions. This is the case of those works in which he literally falls from a tree into a stream, rolls off the roof of his bungalow in California, or plunges with his bicycle into a canal in Amsterdam.

After a few years spent in California, Ader decided to make his return to Europe part of a vast project dealing with the themes of solitude and nomadism. The project consisted in a solitary voyage lasting about sixty days, including crossing the Atlantic from Cape Cod (Massachusetts) to Cornwall (England). Ader planned to hold an exhibition in Holland, presenting the material accumulated during the voyage: diaries, films, and photographs. He left Cape Cod on July 9, 1975 but never reached his destination. Six months later his small boat was found almost submerged off the Irish coast. [F.B.]

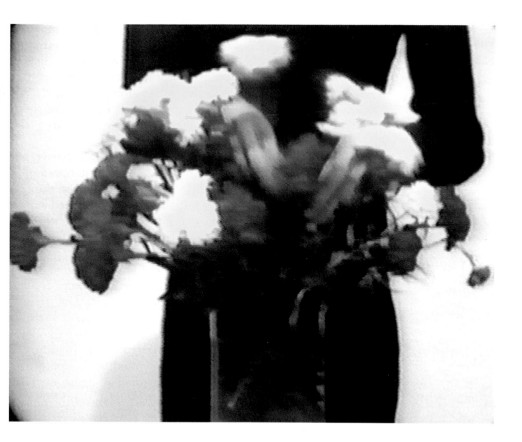

Primary Time, 1974
video, color, silent, 25 min.
Castello di Rivoli Museum of Contemporary Art,
Rivoli-Turin
In a single continuous film sequence, the work is
exclusively focused on the arm of the artist who is
intent on arranging and rearranging a bouquet of
primary-colored flowers in a vase. The precise
and measured gesture creates continuously new
harmonious and chromatic compositions in a
process of slow and methodical alternation.

JOHN BALDESSARI
(National City,
California, 1931)

Educated in the language of Abstract Expressionism, in 1970 Baldessari burnt the paintings he had created before 1966 and put their ashes in an urn. The symbolic rejection of producing art characterized by the gesture of the artist was extended to his subsequent production, which placed him among the most important exponents of Conceptual Art. Consequently, Baldessari positioned at the center of his research the essential idea of art, and each of his works can be considered an investigation aimed at exploring the concrete reality of art. In ironic accord with his activity as a professor at the most prestigious universities of California, in his works the artist uses seemingly didactic tones that underline the arbitrary relationship between meaning and signifier.

In the late sixties, he began employing photography, using it to directly record visual data or as an element from which to extract paintings of a purely factual nature. This is the case of the paintings depicting the daily urban landscapes of southern California—taken from snapshots—that include writings executed by commercial sign and billboard painters, hired especially for the job. In some cases, language remains the only visual element used by the artist and the information given with the writings is transmitted with an ironic intention.

His ability to question the mechanisms leading to the creation of meaning also places Baldessari among the protagonists of eighties art. In adopting the Post-Modern practice of drawing on the most disparate visual information, he produces numerous photographic works that are based on juxtaposition, collage, thereby making the most of the mechanism of binary opposition.

Following an important aspect of Marcel Duchamp's legacy, Baldessari gives considerable space to humor and irony, components at play in his videos of the early seventies. Since he is often the only protagonist, he uses both his person and his voice as neutral instruments, keeping a detached and impassive approach, seemingly immune to all emotion. This aloofness, displayed in paradoxical situations, as when he teaches the alphabet to a plant in a vase, produces a humorous comment, whose subject is the very language of Conceptual Art. [M.B.]

Folding Hat, 1970–1971
video, black and white, sound, 29 min. 48 sec.
Purchased with the contribution of the
Compagnia di San Paolo
In handling a man's hat, the artist tries to free it
of its quiddity—its "hatness"—though in vain.

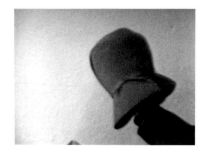

4 Short Films, 1971
transferred from 16 mm film, color, silent,
5 min. 52 sec.
Purchased with the contribution of the
Compagnia di San Paolo
Without sound, these films present four
consecutive frames: the juxtaposition of an hour-
glass and a thermometer; the close-up of two
small portable mirrors handled in such a way as
to reflect light; three glasses; a few containers of
colored pigments.

Art Disaster, 1971
video, black and white, sound, 32 min. 40 sec.
Purchased with the contribution of the
Compagnia di San Paolo
The expression "Art Disaster" appears on a
newspaper snippet the artist pins to a wall. Below,
he arbitrarily juxtaposes a series of different
images, thereby creating a sort of narration.

I Am Making Art, 1971
video, black and white, sound, 18 min. 40 sec.
Purchased with the contribution of the
Compagnia di San Paolo
The artist carries out a series of slight movements
with his body and repeats the sentence "I am
making art." The result is an ironic reference to
the Body Art of the period.

I Will Not Make Any More Boring Art, 1971
video, black and white, sound, 13 min. 06 sec.
Purchased with the contribution of the
Compagnia di San Paolo
The promise to not make boring art any longer is
put on paper in the form of a sequence of hand-
written sentences. The assertion is denied by the
repetitive actions.

Baldessari Sings LeWitt, 1972
video, black and white, sound, 15 min.
Purchased with the contribution of the
Compagnia di San Paolo
Declaring he wants to pay tribute to an important
protagonist of Conceptual Art, Baldessari uses
some phrases by Sol LeWitt to sing melodies of
commercial songs, which, sung in this way,
detract from the seriousness of Conceptual Art
paradigms and take on unexpected meanings.

Xylophone, 1972
video, black and white, sound, 25 min. 38 sec.
Purchased with the contribution of the
Compagnia di San Paolo
In alluding to the coldness of Conceptual Art
language, the artist uses a series of images for
children, continuing to repeat the name of the
object or the animal represented. The monotony
of the voice and the repetition transform the
words into a sort of empty lullaby.

Title, 1972
transferred from 16 mm film, black and white,
color, sound, 25 min.
Purchased with the contribution of the
Compagnia di San Paolo
Consecutive images without any hierarchy or
recognizable order highlight the elements that
construct a traditional film. The video camera
frames objects, persons, and landscapes,

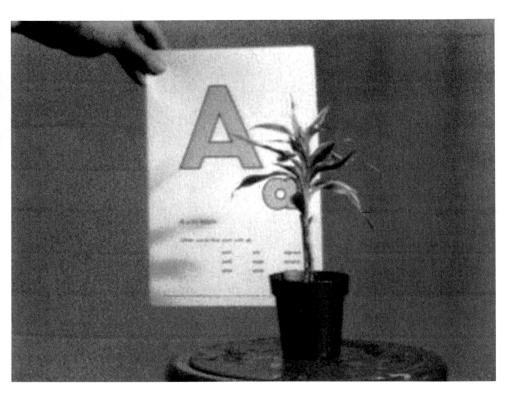

proposing the deconstruction of possible
narrative interweavings through a sequence of
almost immobile images and sounds isolated from
their context.

Teaching a Plant the Alphabet, 1972
video, black and white, sound, 18 min. 40 sec.
Purchased with the contribution of the
Compagnia di San Paolo
Almost as if it were a small schoolboy, a
houseplant is taught alphabet sounds and forms.

*The Meaning of Various Photographs to Ed
Henderson*, 1973
video, black and white, sound, 15 min.
Purchased with the contribution of the
Compagnia di San Paolo
Baldessari subjects his acquaintance Ed
Henderson to a sort of test in which he asks him

to decipher photographs taken from newspapers. In having removed possible captions and traces of the context, the artist demonstrates the fluctuating relationship between an image and its meaning.

The Way We Do Art Now and Other Sacred Tales, 1973
video, black and white, sound, 28 min. 28 sec.
Purchased with the contribution of the Compagnia di San Paolo
Baldessari assembles a series of brief episodes regarding situations in which the words or the images do not correspond to the meaning or which underline the arbitrary nature of the language.

Three Feathers and Other Fairy Tales, 1973
video, black and white, sound, 31 min. 15 sec.
Purchased with the contribution of the Compagnia di San Paolo
Seated on a chair in front of the camera, the artist reads six stories dealing with themes of unconscious fears and desires.

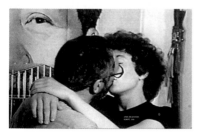

Script, 1974
transferred from 16 mm film, black and white, sound, 50 min. 25 sec.
Purchased with the contribution of the Compagnia di San Paolo
The video presents a sequence of ten short scenes taken at random from commercial films. The protagonists are seven couples of non-professional actors (at the time Baldessari's students). The video presents the written description of the scenes, the performances, and a selection of the ten best sequences.

The Italian Tape, 1974
video, black and white, sound, 8 min. 33 sec.
Purchased with the contribution of the
Compagnia di San Paolo
Baldessari writes a series of sentences in English
and their respective Italian translations on a
blackboard, using bits of dialogue published in a
guide to Rome. In taking these out of their original
context, the sentences seem to be addressed to the
observer and, at times, allude to the relationship
between the viewer and the work of art.

*Four Minutes of Trying to Tune Two Glasses (For the
Phil Glass Sextet)*, 1976
video, black and white, sound, 4 min. 09 sec.
Purchased with the contribution of the
Compagnia di San Paolo
The artist tries to adapt the sound of two glasses
containing water to the ticking of minutes by a
clock whose alarm is set to twelve o'clock. The
title is a pun that involves the well-known
composer Philip Glass.

6 Colorful Inside Jobs, 1977
transferred from 16 mm film, color, silent,
30 min.
Purchased with the contribution of the
Compagnia di San Paolo
The artist paints a canvas that during the film
becomes an ever-changing monochrome painting.
Each painting corresponds to a day of the week,
thus making the film a disenchanted and ironic
reflection on the relationship between daily life
and the creative process.

**VANESSA
BEECROFT
(Genoa, Italy 1969)**

On the occasion of her first exhibition in June 1993, Vanessa Beecroft presented *Despair*, the "Book of Food," a typed manuscript listing the food she ate every day, specifying quantity and color. For the exhibition she invited a group of female students from the Accademia di Brera (Milan), along with some young women to present themselves as the audience.

From this first revelation, Beecroft has identified the sphere of her research in the female image, and in performance, the purest expression of her art.

The protagonists of her first performances were young women, either acquaintances or recruited off the street. Dressed in order to make a strong visual and formal impact, the women wore monochrome items chosen among a selection of mainly red, yellow, pink, white, or black. The models were chosen on the basis of similarity to precise female types, initially exploring themes of food and behavioral disorders, investigated also through drawings. There were numerous references to art history and especially to painting and to cinema, from which the artist cites preferred characters and films.

The performances slowly evolve to incorporate professional models and Beecroft's relatives, along with the contribution of make-up artists and hair-stylists. Moreover, the choice of clothing and accessories becomes more defined, often made specifically by fashion designers. In some cases, the models' unclothed bodies are covered with special cosmetics that enhance the pictorial effect.

The rules Beecroft established for her performers have remained unchanged: the women are always forbidden to talk and they cannot act or move with particular speed or slowness. In order to emphasize the fact that the performances compose a single work, the artist assigns them progressive numbers.

Together with photography, video and film occasionally also offer Beecroft the possibility of creating additional independent works, extending the life of her performances. In realizing these videos, the artist is assisted by professional photographers, directors of photography, and cameramen. In her recent videos, editing plays an important role, while the presence of the public becomes a subject of attentive investigation. In some cases, passages of classical music act as a sporadic soundtrack. [M.B.]

VB47, 2001
video, DVD, color, silent, 43 min. 11 sec.
Purchased with the contribution of the
Compagnia di San Paolo
The video was made on the occasion of the
artist's performance in the galleries of the Peggy
Guggenheim Collection in Venice. The piece was
inspired by the metaphysical works of Giorgio de
Chirico in the museum's collection.

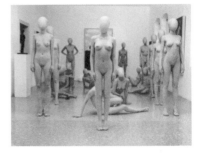

VB48, 2001
video projection, DVD, color, silent, 91 min.
Purchased with the contribution of the
Compagnia di San Paolo
Created in Genoa during the days prior to the
G8 Summit in July 2001, the performance *VB48*
took place in the same building where the heads
of state would later meet. The protagonists are
thirty black models wearing high heels, bikinis,
and thick, curly wigs. The video underscores the
performance's contrast between light and shade,
inspired by the paintings of Caravaggio.

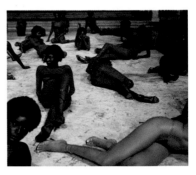

VB52, 2003
video projection, DV CAM, color, sound,
129 min.
Castello di Rivoli Museum of Contemporary Art,
Rivoli-Turin. Gift of the artist
Produced for the artist's retrospective exhibition
at the Castello di Rivoli, the performance *VB52* is
a banquet for thirty guests. The protagonists are
women of different ages, including women who
participated in previous performances, close
relatives, acquaintances, professional models, and
women from the Turin aristocracy. The video
shows the banquet, organized into foods chosen
according to color, selected by the artist to create
a sequence of monochromatic arrangements. The
images also dwell on the personal impulses of the
guests, examining the close relationship with food
that characterizes the artist's early work. The
soundtrack includes passages of classical music.

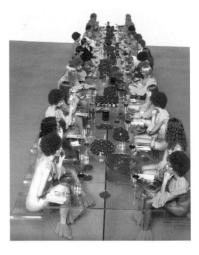

LAETITIA BÉNAT
(Vichy, France, 1971)

Belonging to a generation of young French artists who reject labels and classifications, Laetitia Bénat has made multidisciplinary research a continuous practice: her work is open and responsive to the stimuli of fashion, photography, and *auteur* cinema. She has participated in various exhibitions tied to the experience and initiative of the Purple Institute, whose publishing and exhibition practices have left a rich legacy. For example, *Purple*, founded in 1992 as a black and white magazine project by two Parisian art critics, Elein Fleiss and Olivier Zahm, became a reference for artists, photographers, and designers alike. Today, existing in two versions, *Purple Fashion* and *Purple Magazine* discuss art, fashion, and photography and have unquestionably reshaped the imaginary of art and fashion since the nineties.

The attention paid to signs and the most accidental and ephemeral observations acts as a catalyst in this French artist's powerful imagination. In fact, Bénat often gathers impressions through drawings and sketches that establish a quasi-fantastical dimension—somehow suspended in time—in which a state of fragile balance and threatening calm obscures unexpected surprises.

This oscillation between anxiety and tranquility is particularly evident in the *corpus* of Bénat's video works. In her preference for long sequences, in her sensibility for alternating images of interiors (such as bedrooms, white walls, or girls in contemplation) and exteriors (landscapes filmed in 16 mm), the artist creates evocative dimensions. Her works often seem to provoke in viewers an experience beyond the visual, creating almost physical sensations. [F.B.]

Royal Garden, 1997–1998
video, color, sound, 33 min. 10 sec.
Purchased with the contribution of the
Compagnia di San Paolo
Indian Summer, 1997
video, color, sound, 14 min. 18 sec.
The video aligns a series of strongly evocative situations. An off-screen voice narrates memories that seem to be taken from a letter, while a sequence of shots exposes the actions and tensions produced by a female body. Two girls seated at a party drink and smoke, while background music

and noise create an estranging effect. At the end, one of the seated girls tries to put nail polish on one of her toes, while the camera highlights an unhealed wound on her big toe.

Songs from a Room, 1997
video, color, sound, 7 min. 16 sec.
Against a background of songs in a predominantly red room, several girls seated next to each other play around and put on make-up.

Summer Love, 1998
video, color, sound, 9 min. 36 sec.
A solitary blonde girl lies down and listens to music with her head covered by a hood. Other images of girls appear in colored rooms, first red, then green. Finally, a couple, dressed in white, flirts with each other to the sound of sensual music. The couple is filmed against the light with a visibly overexposed effect.

LYNDA BENGLIS
(Lake Charles,
Louisiana, 1941)

Lynda Benglis produced a number of key works during the feminist revolution years between the late sixties and early seventies. Direct and visceral, her approach confronts the spectator with themes such as the representation of women, the role of the audience, and the exploration of female sexuality, as well as the creation of moving images in light of the new and radical practices of audiovisual production during those years.

During the second-half of the sixties, Benglis developed and experimented with pioneering investigations regarding forms somewhere between painting and sculpture that involve plastic masses created by the solidification of brightly colored polyurethane foams. These works were made and placed on floors in such a way as to appear still dripping or expanding. If on the one hand these works are linked to the contemporary practice of Process Art, on the other hand they already point out the artist's steadfast orientation. Benglis became interested in undermining the prevailing and severe rationalism of Minimalism (greatly dominated by male artists) by creating harmonious forms of strong metaphorical impact tied to female anatomy and nature.

Throughout the seventies Benglis explored and broaden ed her research of female identity and sexuality, making these an explicitly dominant theme in her audiovisual works. From her interest in human forms expressed in her sculptures, her investigation found new directions through a series of analytical and self-reflective videos. Benglis tested and experimented with the properties and limitations of video, stressing its physical aspects. Since her early works, she became interested in fundamental technical processes and modalities, such as repeatedly shooting material already filmed, manipulating the images on the screen, or working on the overlapping disjunction between audio and video tracks. In using her own physical presence and often creating multiples of her own image, Benglis has questioned the relationship between Ego and body, specifically working on the interrelations between interior and exterior reality and the cultural and anthropological implications of an interpretation focused on the relationships between ideas regarding female nature and culture. [F.B.]

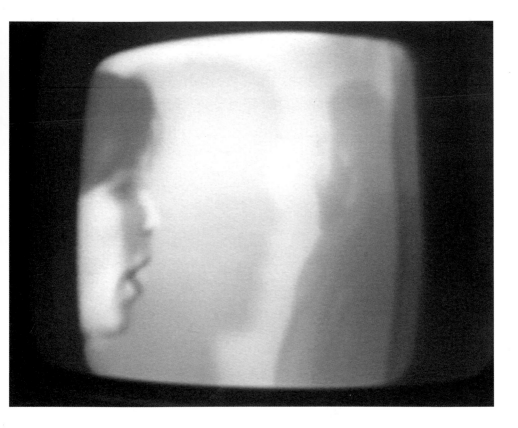

Mumble, 1972
video, black and white, sound, 20 min.
Purchased with the contribution of the
Compagnia di San Paolo
Placed in profile in front of a Robert Morris
video, Lynda Benglis and her brother Jim carry
out repeated gestures while the artist's off-screen
voice pronounces ambiguous and disorientating
statements, which become more and more like an
unintelligible, repetitive flow.

Now, 1973
video, color, sound, 10 min.
Purchased with the contribution of the
Compagnia di San Paolo
In her first color video, Benglis experiments with
the potentials of unnatural colors, increasing their

saturation to the point of reaching considerable artificiality, thus challenging the commonly-shared opinion of video as an impartial medium. Throughout the entire work, Benglis asks "Now?" and "Would you like to direct me?" She repeats instructions such as "Start the camera" and "I said: begin to record." This takes place as she makes faces and sounds in reaction to other images of herself on a monitor.

Female Sensibility, 1973
video, color, sound, 14 min.
Purchased with the contribution of the Compagnia di San Paolo
With strong, bright colors the video presents two female figures wearing heavy make-up and who pamper one another in turns, caressing at length and intensely kissing each other. They seem to exhibit themselves to the camera lens.

How's Tricks, 1976
video, color, sound, 33 min. 45 sec.
Purchased with the contribution of the Compagnia di San Paolo
The work presents a combination of live performances, interviews, and different television material that closely concerns the structure inherent to mass-media production. Albeit in a fragmentary way, the elaboration touches upon the very foundations of the process of artistic creation. In a radical deconstruction of the illusory nature of communication, this video develops an investigation on the roles and relationships among artists, representation, and the public. The image of the artist conversing with her collaborator, Stanton Kaye, is alternated with others dealing with the preparations for Richard Nixon's farewell speech, a comedian and TV host who is interrupted by the technicians in his own studio, and footage of Rita Hayworth ecstatically dancing in a nightclub.

The Amazing Bow Wow, 1976
video, color, sound, 32 min.
Purchased with the contribution of the
Compagnia di San Paolo
A work with a more pronounced narrative
structure, this video describes the adventures and
misfortunes of a talking hermaphrodite dog,
staged using an enormous animated puppet. The
dog is given as a present to Rexina and Babu,
circus performers. The dog's extraordinary
intelligence progressively endears it to Rexina,
while making the ever-jealous Babu try to castrate
it. Filmed in a variety of outdoor locations and
with costumes, make-up, and music composed for
the occasion, the work, though seemingly farcical,
actually veils a bitter metaphor on the risks of
sensationalism, coupled with a reinterpretation of
Oedipal themes.

SADIE BENNING
(Milwaukee,
Wisconsin, 1973)

Sadie Benning has been making videos since the age of fifteen. Initially, she primarily used the Fisher Price Pixelvision video camera she received from her father, the experimental filmmaker James Benning. Right from the start, she showed unique and precocious talent. Starting with the most intimate sphere of her own experience and the most immediate physical universe of her camera, Benning elaborated a series of works that are linked to a glorious tradition of experimental cinema and video narrated in the first person, though offering new and intense testimonies of female and lesbian observation and reflection.

In fact, all of Benning's work began and continued from a fervent process of re-evaluation of personal daily experiences. Her audiovisual productions are centered around growth experiences, on both an internal level and in relation to society, with all its limits, conditioning processes, and unpleasant moments. Desires, fears, and fantasies are added to the process of confrontation, the social and sexual development one would expect from a young woman conforming to so-called norms. Instead, the various forms of rebellion and transgression—as they are evoked in many of her videos—indicate the need for a different identity beyond heterosexual conventions. Benning demonstrates a unique talent in making use of and transforming images appropriated from various sources, ranging from television to newspapers, magazines, and many other situations tied to forms of mass culture. The artist reconsiders these images through her own sensibility. Often somewhere between an almost seductive ability and a somewhat disarming honesty, Benning's narrations make use of objects, fragments of writing, and (above all in her first works) her constant looking into the camera. Along with extreme close-ups and shots that almost seem to fly and float, her works carry the spectators into a universe of intimate and evocative revelations.

With humor and frankness, but also with disillusion or sadness, the complex personality of the young artist has revealed itself, year after year, work after work, not only accompanying the viewer through different existential situations, but also in phases of self-awareness and maturing. In recent years, Benning has progressively

German Song, 1995

46

grown interested in using third person narration, creating personal reinterpretations of animation techniques and 16 mm cinema. [F.B.]

A New Year, 1989
video, black and white, sound, 6 min.
Purchased with the contribution of the
Compagnia di San Paolo
In a flow of video footage of TV entertainment programs and radio sounds, the work shows the sharp contrast between the intolerance—almost existential exasperation—of the artist and her contact with the outside world, as it is filtered in the particular and topical moment of a New Year's Day.

Living Inside, 1989
video, black and white, sound, 6 min.
Purchased with the contribution of the
Compagnia di San Paolo
A sort of self-portrait, consisting in extreme
close-ups with her off-screen voice, the video
describes a phase of reflection on the part of the
artist who, after moments of nervous
dissatisfaction, decides to return to work.

Me and Rubyfruit, 1989–1990
video, black and white, sound, 5 min. 30 sec.
Purchased with the contribution of the
Compagnia di San Paolo
Images of a doll accompany the voice of the artist
who follows a series of considerations regarding
the problematic condition of girls and the
difficulty of an openly homosexual relationship,
combined with a sense of inadequacy and distress
with consolidated social expectations.

If Every Girl Had a Diary, 1990
video, black and white, sound, 9 min.
Purchased with the contribution of the
Compagnia di San Paolo
Scenes of strongly contrasting interiors alternate
with the artist's eyes. Benning talks about herself,
describing and comparing her life to what is
commonly defined as an alternative lifestyle.
Comparisons to her own life, as how it was lived
in the past, are coupled with the present.
The video records details of the room where the
girl lives and has decided to film.

Jollies, 1990
video, black and white, sound, 11 min.
Purchased with the contribution of the
Compagnia di San Paolo
Marked at the beginning by the presence of two
naked dolls, the video narrates, to the pace of the

artist's hushed voice, the essential stages of her first sexual curiosities and shy contacts. More intimate moments alternate, up until the final scene where the artist enacts the typically male rituals of shaving and knotting a tie.

A Place Called Lovely, 1991
video, black and white, sound, 14 min.
Purchased with the contribution of the Compagnia di San Paolo
Benning talks, in the first person, about a series of situations of discomfort and uneasiness: physical violence, deceit, fear, and forms of social inequality and injustice, as found and experienced in daily reality, on the streets or in a bus. While the video camera lingers on the details of a diary, little toy cars, TV film scenes, and tabloid-like headlines are shown as elements and clues of a crime scene. In a close analysis of her past, Benning, though confessing she was bullied and hurt, refuses to remain a mere victim.

It Wasn't Love, 1992
video, black and white, sound, 20 min.
Purchased with the contribution of the Compagnia di San Paolo
In a fragmentary story, although characterized by a subtle humor that is not immediately evident, Benning shows us various poses— almost stereotypes—of specific figures of masculinity and femininity: from the rebel to the vamp, the biker to the naive girl. In between, she talks about an adventure with an "easy girl" on the Hollywood hills. As the story

gradually unfolds, Benning addresses herself directly to the spectators, taking great care of the visuals and sound: in fact, every excerpt of music represents a comment, as well as a specific mood.

Girl Power, 1992
video, black and white, sound, 15 min.
Purchased with the contribution of the Compagnia di San Paolo
The video begins with a series of considerations regarding the need for the artist to create an imaginary world of her own—a place, a situation to believe and live in. Benning narrates the former need to impersonate the winning models of young, successful men, who are always ready to take care of girls. Then she describes the gradual process of transformation through which a girl can once again win back confidence in the female presence within society thanks to models represented by some female rock stars (such as Joan Jett, Debbie Harry, and the Go-Go's).

German Song, 1995
transferred from Super 8 film, black and white, sound, 5 min.
Purchased with the contribution of the Compagnia di San Paolo
In a series of shootings in desolate places, Benning offers us an image of separated, almost lost, youth, accompanied by the music of the group Come. The work is filmed in an evocative and atmospheric Super 8.

The Judy Spots, 1995
video, black and white, sound, 15 min.
Purchased with the contribution of the Compagnia di San Paolo
In a series of short animated episodes, based on

papier mâché characters (who remind us of the traditional Punch and Judy), this work shows us Judy's daily life, a girl who tries to establish herself in various ways, confronting a growing feeling of isolation and estrangement. Verbally animated, she does not lack ability to analyze the world that surrounds her (for example, when she works at a fast food restaurant or when she visits a large mall). She seems to be able to fulfill her dreams only when she is playing with her band.

Flat Is Beautiful, 1998
video, black and white, sound, 50 min.
Purchased with the contribution of the Compagnia di San Paolo
In this complex narration, the actors wear large paper masks over their faces. The situations are described minimally, with brief dialogues and seem frozen by a slow tone. Taylor, an eleven-year-old girl, lives with her mother—lonely and separated—in an apartment shared with a young gay man called Quiggy. The father exists only on the phone and is always complaining and physically distant. Taylor feels attracted to other girls, but at the same time she feels confused, always left alone in front of the TV screen where she spends her days playing video games. Her mother goes from periods of frustration, due to bulimia, to encounters with new partners, who do not seem to interest her a great deal, except for spending a little time together. Taylor seeks comfort by asking advice from Quiggy, but he is uncomfortable playing the father figure.

Filmed in video (Pixelvision), together with Super 8 film and cartoons, the work is solidly structured by a seemingly hopeless scenario. The figure of the solitary, lonely girl convincingly represents all the difficulties and uncertainties of growing up in a hostile and desolate world.

**JOSEPH BEUYS
(Krefeld, Germany,
1921 – Düsseldorf,
1986)**

Divided between his interest in natural sciences and art, Beuys, as a young man, chose medicine. After enrolling in the army in 1940, he was first an air radio operator and then a pilot. During his years of military service he survived a few accidents that left him with numerous scars. At the end of the war he was interned in a British prisoner of war camp and only after various months in 1945 was he allowed to return to Kleve.

The relationship with his war memories was to become a recurrent theme with powerful symbolic implications, above all in the use of animal fat and felt transformed into true sculpting materials (allegedly after an emergency landing, Beuys was saved by a group of nomad Tartars who covered his body in fat and then in felt).

When he returned from the war Beuys radically changed his projects for the future. He decided to attend the art academy in Düsseldorf, where he studied sculpture. He graduated in 1952.

In the years that followed, he produced a vast quantity of drawings and his interest in various disciplines broadened: philosophy, poetry, literature, and a personal reinterpretation of esotericism and shamanism.

In the early sixties, Beuys began teaching at the Kunstacademie in Düsseldorf during a particular historical moment when the city became a focal point for contemporary art, especially through the Fluxus artists and Nam June Paik, whose performances initiated new fluidity within the already blurred confines among literature, music, visual arts, and performance. In line with this same attitude, Beuys carried out a series of actions and developed ideas regarding the increasingly complex and relevant role art should play in society. His artistic works grew into large and composite installations. He was also interested in developing new contacts with a potentially vaster public by creating art editions and multiples aimed at starting a veritable dissemination consisting in a democratic circulation and spreading of ideas.

Parallel to his artistic activity, Beuys saw the need to continuously commit himself to founding and supporting groups of political activists. The artist formed the Organization for Direct Democracy Through Referendum (1970) and the Free International University (1972), whose interest was the creative potential in every human being.

During the final years of his life, he was among
the founders of the Green Party, and the project of
the 7,000 trees planted in Kassel for Documenta 7 bears
witness to this.
His profound sense of urgency and his charismatic
presence, combined with his openness towards dialogue,
reshaped his already unconventional approach to art. This
led to international fame, also documented by a noteworthy
number of invaluable filmed public meetings and debates.
[F.B.]

J. Beuys' Public Dialogue, 1974
by Willoughby Sharp
video, black and white, sound, 120 min. 15 sec.
Purchased with the contribution of the
Compagnia di San Paolo
Filmed at the New School for Social Research in
New York, this document is Beuys' first public
event in the United States. The artist presents his
theories about art as social sculpture, covering
three large blackboards with diagrams and
drawings. As the artist continues with his
explanations, tension grows among the audience.

A Conversation, 1974
in collaboration with Nam June Paik and
Douglas Davis
video, black and white, sound, 34 min.
Purchased with the contribution of the
Compagnia di San Paolo
Centered on a conversation between Beuys,
Douglas Davis, and Nam June Paik that took
place in 1974 at the Ronald Feldman Fine Arts
Gallery in New York, this video illustrates the
discussion on the ideas and hopes connected to
the possibilities for an artist to use satellite

technology. Three years later, for Documenta 6 in Kassel, the artists would collaborate on the first satellite broadcast.

Willoughby Sharp Videoviews Joseph Beuys, 1975
by Willoughby Sharp
video, black and white, sound, 27 min. 45 sec.
Purchased with the contribution of the
Compagnia di San Paolo
In this portrait/interview by one of the most important critics of the day, Beuys talks about some of his fundamental concepts regarding life, artistic practice, and work.

Documenta 6 Satellite Telecast, 1977
in collaboration with Nam June Paik and
Douglas Davis
video, color, sound, 30 min.
Purchased with the contribution of the
Compagnia di San Paolo
During a broadcast shared by twenty-five countries, the performances of Nam June Paik, Joseph Beuys, and Douglas Davis are presented. With live performances in Kassel, Paik and Charlotte Moorman offer some Fluxus classics including *TV Bra*, *TV Cello*, and *TV Bed*. Music and performance—via television video—form the basis of this incredible tribute to global-age communications. Once again from Kassel, Beuys directly addresses the public, explaining his theories of art as "social sculpture." Finally, Davis from Caracas performs *The Last Nine Minutes*, a participatory piece in which he uses the space-time distance that separates him from TV viewers.

Dialogue with Audience, 1980
in collaboration with Gianfranco Mantegna
video, black and white, color, sound,
50 min. 19 sec.
Purchased with the contribution of the
Compagnia di San Paolo
This video presents the encounter and discussion
held between Beuys and the audience at Cooper
Union in New York on January 7, 1980.

Pop-Pop Video, 1980
video, color, sound, 9 min.
Castello di Rivoli Museum of Contemporary Art,
Rivoli-Turin
General Hospital / Olympic Women Speed Skating,
1980
video, color, sound, 6 min.
Dramatic editing of two different television
programs, the work juxtaposes a sporting event
and a soap opera.
At the same time, Birnbaum uses this
chance to analyze syntaxes and gestures
that television imposes upon the shows. The
original footage deals with a couple trying to
resolve their problems (a scene from a famous
TV series)
and the performance of two female Olympic
speed skaters who uninterruptedly pirouette.
Kojak / Wang, 1980
video, color, sound, 3 min.

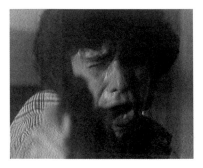

An authentic, obsessive crescendo of gunshots
and distorted guitar sounds, alternated with
sound fragments of questions and answers—as in
a police interrogation—synthesize this work in an
explosive back-and-forth of repeated images. The
short sequences taken from the *Kojak* detective
series and from a commercial of the Wang
Corporation alternate with television signal color
bars. The images of the famous TV inspector
Kojak, interrogating a criminal, lead viewers to
associate the implicit violence of the great society
of telecommunications with imaginary detective
situations.

Remy / Grand Central: Trains and Boats and Planes,
1980
video, color, sound, 4 min. 18 sec.
Castello di Rivoli Museum of Contemporary Art,
Rivoli-Turin
This work plays at blurring the distinction
between real and fictional advertising, though
maintaining an approach of critical and
deconstructive irony. A girl, next to the trains

about to leave in a big station, drinks Remy champagne. However, from this typical advertising scene (created to emphasize wealth, beauty, and lifestyle), the artist, with the help of Burt Bacharach's music and careful editing, overturns the situation.

PM Magazine / Acid Rock, 1982
video, color, sound, 4 min. 09 sec.
Castello di Rivoli Museum of Contemporary Art, Rivoli-Turin
The video is a ferocious critique of the typical associations between consumerism and sexuality. The introduction to the TV show *PM Magazine* and a segment of a commercial for Wang computers becomes the basis for this work with its strong effect and intense editing. Stereotypical gestures and symbols of entertainment are recomposed, re-edited, and rendered increasingly abstract—if not absurd—in a powerful crescendo.

Fire! Hendrix, 1982
video, color, sound, 3 min. 13 sec.
Castello di Rivoli Museum of Contemporary Art, Rivoli-Turin
Sexuality and consumerism are also at the origin of this short work, in which the images of a girl are placed in relation to a flow of consumer symbols: fast food, shiny new cars, money. Accompanied by the penetrating music of Jimmy Hendrix, the video creates a visual flow in which every distinction between who consumes and who is consumed is annulled.

Damnation of Faust: Evocation, 1983
video, color, sound, 10 min. 02 sec.
Castello di Rivoli Museum of Contemporary Art, Rivoli-Turin
Prologue to the three-part series dedicated to the Faust story, this video offers an introspective viewpoint regarding the duality between the inside and outside worlds of its young

protagonists. Set in a Manhattan playground, the video is structured around multiple images and has a three-part soundtrack that develops from the initial dubbed music to an evocative section and finally closes with a synth-pop finale.

Damnation of Faust: Will-o'-the-Wisp (A Deceitful Goal), 1985
video, color, sound, 5 min. 46 sec.
Castello di Rivoli Museum of Contemporary Art, Rivoli-Turin
Will-o'-the-Wisp, the second part of the video trilogy, shows us a girl—a new Marguerite—who looks out of a window, meditating on the meaning of loss and betrayal. What she is looking at—some young boys on the street below—simultaneously appears in real "windows" inserted within a refined composition of the screen, with references to the art of Japanese etching.

Damnation of Faust: Charming Landscape, 1987
video, color, sound, 6 min. 30 sec.
Castello di Rivoli Museum of Contemporary Art, Rivoli-Turin
Images of a playground demolition in Manhattan are mixed and juxtaposed with the images of two adolescent girls thinking about their past. The video then aligns repertory TV footage portraying civil protests—from the struggle of the Civil Rights Movement to sixties anti-war demonstrations and student uprisings in China in the eighties—and at the same time shows the power of the mass media in documenting and uniting individual forces that join in a politically vaster, more challenging, and more powerful voice.

Will-o'-the-Wisp, 1985
video installation, color, sound, loop, plywood,
acrylic paint, black and white photographic
prints, dimensions determined by the space
Gift of Zerynthia Associazione per l'Arte
Contemporanea
Three monitors are placed at the center of a large
panel that bears the photographed image of a
female face on a background of leafy tree
branches. This same image is seen throughout
the video, in which a voice whispers about a lost
love and alternates with landscapes and scenes of
children playing in a city street. The female
figure is the equivalent of Marguerite, the
protagonist of the Faust story. According to the
artist, Marguerite is an archetypal figure of the
relationship between man and woman, as
established by Western culture.

*Canon: Taking to the Streets, Part One: Princeton
University - Take Back the Night*, 1990
video, color, sound, 10 min.
Castello di Rivoli Museum of Contemporary Art,
Rivoli-Turin
Created by using documentaries, also supplied by
the university students involved, this work is
based on the *Take Back the Night* protest march.
Held at Princeton University in 1987, this protest
voiced solidarity against every form of violence
towards women. The documentation of student
activism is extended to a vaster and more general
plea for tolerance and political involvement.

JOHN BOCK
(Gribbohm,
Germany, 1965)

After graduating in Economics, John Bock studied art in Hamburg. In line with his studies, mathematical models and economic theories are the bases of the performances he defines as "lectures." These actions, hypnotic explosions of pure Dionysian energy, are manifold attempts at interpreting the real and are always destined to raise further questions rather than resolve the initially posed problem. In addition to the artist, occasional non-professional actors and objects and materials of all kinds (such as glue, foam, knitted clothing, and various types of food) are included in his performances. Initially amorphous or possessing organic characteristics, the materials are activated through assemblage or deconstruction and, following their use, they either become installations or autonomous works. In bearing witness to the variety and fervid activity of existence, at times insects or small animals also become part of the artist's investigations. Closely related to the Theater of the Absurd, the actions are cadenced by the original language employed. As enthralling as they are estranging, his monologues are in fact prevalently done in his native tongue, German, with the use of invented word combinations. As is the case for the objects or materials, the artist manipulates the grammar and the rational flow of the language, proposing unstoppable expositions that combine politics, literature, economics, and science. The sense of Bock's monologues deliberately reveals itself as elusive precisely when it seems to become comprehensible. According to the artist's intention, every lecture manifests the impossibility of arriving at its predetermined goal, thereby delineating the perpetual condition of the "unfinished."

Video is an essential part of his oeuvre, an ideal medium for increasing its vitality and range of communication. In some cases, it is employed during the performances insofar as it is a means capable of showing the presence of the artist though he is hidden from the public, engaged in actions inside his structures. At times video is instead used to record the performance itself and, immediately edited, is projected. In this way, it becomes part of the installation. In other cases, videos are made inside his studio where even domestic animals can become the actors-protagonists. Or, yet again, the video camera follows Bock during solitary actions performed outdoors. [M.B.]

Schöner Linden, 2000
video, color, sound, 18 min. 24 sec.
Castello di Rivoli Museum of Contemporary Art,
Rivoli-Turin
In the countryside, a young man wears a series of
garments and accessories with forms that
contradict and undermine the traditional rules of
Western clothing. The title refers to the place near
Berlin where the video is filmed.

Astronaut, 2003
video, color, sound, 22 min. 30 sec.
Purchased with the contribution of the
Compagnia di San Paolo
Like a space traveler, Bock seems to undertake a
journey inside an illogical and parallel universe,
disquieting but also vital. This universe seems to
be his own mind, attracted to the latent complexity
each and every minute thing or insect can contain.

MONICA BONVICINI
(Venice, 1965)

Bonvicini's art delineates an ideal space for debate in which relationships of power, sexual evocations, and reflections on Modernist legacy and Minimalist aesthetics meet. The artist uses photography, installation, video, and performance and chooses the medium depending on the work and its message.

The reflection on the role of architecture and the socio-cultural conditioning factors connected to it are fundamental themes of her oeuvre. These themes are chosen as they belong to a field lying outside art, but are tangential to it. Bonvicini confronts the traditionally masculine, Modernist tradition, tied as it is to the rhetoric of control and domination. This encounter is resolved in works where dynamics of destruction or deconstructivist notions take on an analogous or greater creative value with respect to codified architectural principles. At the same time, the artist directs her attention to the material aspect of architecture and the physical act of building, choosing, for example, to hand out a questionnaire with her own questions to carpenters and bricklayers in Germany, Italy, and the United States. In her installations, she favors the use of specific materials, such as wood, plasterboard, and bricks, although she also employs the grand protagonists of the Modernist aesthetic rigor: steel and glass. In her most recent installations and sculptures, Bonvicini analyzes other relationships of power strictly tied to the realm of sex. In appropriating materials or forms that possess powerful erotic and sadomasochist references, like chains, black leather, and vinyl, she constructs environments or creates intentionally perverse fetishes.

The use of video in her work dates back to the mid-nineties. In these works, the image, broadcast on a monitor or projected, often stages female characters within cold, temporary rooms, defined by simple walls. With harsh, often extremely explicit language, the artist shows the contradiction of spaces conceived by male minds but meant for female bodies. Lacking recognizable faces, these women are represented as sexual bodies who violently react to the surroundings that contain them. Later works are instead conceived as projections that simulate a breaking through of architectural space. On other occasions, the experimentation with simple geometrical spaces brings about a confrontation between male and female behavior. [M.B.]

Destroy She Said (D.S.S.), 1998
double video projection, DVD, black and white,
color, sound, 60 min., plasterboard, wooden
structures, dimensions determined by the space
Gift of the Associazione Artissima
Film footage by famous directors—Fellini,
Antonioni, Godard, Rossellini, Polanski, and
Fassbinder—are projected onto two temporary
walls. The film snippets isolate the female
protagonists, describing the close relationship
that exists between the woman's body and the
architectural elements within which the films are
set. The title of the work refers to *Détruire, dit-
elle*, a novel and experimental film made in 1969
by Marguerite Duras.

Hammering Out (an old argument), 1998
video projection, DVD, color, sound, 60 min.
Purchased with the contribution of the
Compagnia di San Paolo
The video shows a female hand pounding against
a wall with a hammer. Edited as an excerpt of
electronic music, the video never documents the
complete destruction: the plaster flakes, exposing
the bricks behind it. The action then begins once
again.

CANDICE BREITZ
(Johannesburg, 1972)

In her art, Candice Breitz uses mass culture and existing commercial images found in pop music, MTV video clips, television series, and films produced by American studios. According to the artist, these forms of media expression represent a sort of "lingua franca," a zone shared by all and one dangerously oppressive in its ability to level the diversity of local cultures. At the same time, however, these forms of low culture are rich in potential, due to the enormous scope of their dissemination and consumption on a global level. In redefining the artistic gesture—through a process of selection and translation—the artist takes possession of this collective patrimony, which she refers to as the "lowest common denominator form." Working from within, Breitz dismantles these given products of the entertainment industry, transforming herself from a passive spectator into an active, creative, critical voice. The deliberate choice of drawing upon existing images and the definition of a precise work method were already present in her first photographic works, which are centered on the commodification of the female body. She created these works using the imagery of postcards sold to tourists in South Africa and photographs published in ethnographical magazines.

In her successive video installations, Breitz used fragments of video clips, TV series, and Hollywood films to create performances for videos or short films written by her, appropriating the faces and voices of rock stars and actors. The complex digital interventions carried out by the artist undermine their original meaning and expose the ideological, commercial, and economic mechanisms that regulate pop culture. For her video installations, the artist occasionally seeks the collaboration of non-professional actors, volunteers who bear witness to the capillary diffusion of particular aspects of pop culture.

Both alien and dangerously invasive, potentially lacking communicative characteristics and validity, the kind of language resulting from these manipulations is an essential component of her videos. Intended as projections, or broadcast on monitors or plasma screens, the artist's video installations always possess a considerable degree of physicality, with the aim of involving the audience in an active confrontation. [M.B.]

Yes / No (Babel Series, Diptych), 1999
two-channel video installation; two DVDs, two
monitors, color, sound, loop
Purchased with the contribution of the
Compagnia di San Paolo
Two monitors on a pedestal: one shows an image
of Prince and the other that of Grace Jones. In
taking a clip from a music video of each singer,
Breitz reduces the performance to mere
monosyllabic repetition.

Soliloquy Trilogy, 2000
video projection, three films transferred to DVD,
color, stereo sound, 29 min., dimensions
determined by the space
Purchased with the contribution of the
Compagnia di San Paolo
The work is composed of three short films
(respectively 6 min. 57 sec., 14 min. 06 sec., and 7
min. 11 sec.) projected in sequence. The material
is taken from the Hollywood films *Dirty Harry*,
The Witches of Eastwick, and *Basic Instinct*. From
each of these, Breitz isolates each verbal moment
of the leading actor or actress according to a
conceptual editing process. The moments of
psychological tension and the narrative plots that
characterize the original films appear senseless,
whereas the presence of each protagonist
becomes obsessive, circularly entangled in a
narcissistic monologue void of all
communicative value.

ROBERT CAHEN
(Valence, France, 1945)

Robert Cahen studied music and composition, joining Le Groupe de Recherches Musicales of the ORTF of French radio and television between 1971 and 1974. In the mid-seventies, he became Director of experimental video research at the INA (the national audiovisual institute), within which he was to produce many of his later audiovisual pieces. Acknowledged for his research work in video and electronic formats, since 1972 Cahen has produced a vast series of works for both cinema and television. The power of the narration and the document coexist in Cahen's visual universe, where they take on a metaphorical presence both in the journeys within the imaginary and in the careful descriptions of passages in time, places, and, generally speaking, the perception and resonances of the memory. The presence of performances and live events in his works are transformed and re-created in accordance with those modalities with which he explores sound and temporal fragments of reality.

Over the years, Cahen's approach to the possibilities offered by the developments in electronics has led to a gradual transformation of his style, becoming more stratified and complex. By using electronic techniques capable of manipulating sounds and images, together with the spatiality and temporality connected to these, the artist has developed the possibilities of transforming the blurred confines between illusion and reality. Able to completely control a vast knowledge that ranges from music to acoustic engineering, film techniques, and special effects, he has worked with the textures of sounds and images in such a way as to reinvent representational modalities within a boundless expressive spectrum. This begins from a personal reinterpretation of the pictorial qualities of photography and arrives at the rereading of film narration conventions. Often centered on the themes of journey, movement, transition, and transformation, Cahen's research has touched upon, both formally and thematically, oneiric situations that redesign the transitory reality of things. [F.B.]

Boulez-Répons (*Boulez's Répons*), 1985
video, color, sound, 42 min. 58 sec.
Purchased with the contribution of the
Compagnia di San Paolo
In this work commissioned for television, Cahen

enters into a dialogue with the complex musical structure of *Répons*, a recent creation by the French composer Pierre Boulez. Performed by the Ensemble InterContemporain and directed by Boulez himself, this composition involves an ensemble of twenty-four musicians, six soloists, and a real-time digital processor. With visual and temporal inventions and transformations, in this work Cahen reinterprets the images of the concert, applying electronic techniques in order to immerse the performers in vast natural scenarios of seas, trees, and sky. Simultaneously, he creates a corresponding visual flow capable of interacting with the transformative processes at the basis of Pierre Boulez's music.

Parcelle de ciel (*Fragment of Sky*), 1987
video, color, sound, 18 min.
Purchased with the contribution of the Compagnia di San Paolo
This work is an interpretation of a dance piece choreographed by Susan Buirge. By using specific and limited electronic techniques Cahen creates a rapt and evocative atmosphere. With the music of Ives, Purcell, and Webern, the fluid images of the dancers' movements prove to be light and almost ethereal with an effect of supernatural reality.

Sept visions fugitives (*Seven Fleeting Visions*), 1995
video, color, sound, 31 min. 43 sec.
Purchased with the contribution of the Compagnia di San Paolo
Created during a trip to China, this video presents a vast series of images, born as visual annotations and memories. At the same time the video carries out transformations of landscapes and persons filmed with the use of Impressionist color. Scenes of everyday life and traditional ceremonies are re-elaborated with painstaking visual and acoustic care (particular visual effects were created for the video). Michel Chion also participates in the project.

SOPHIE CALLE
(Paris, 1953)

Sophie Calle began her career as an artist in the early eighties. Her work has inspired contrasting reactions, even among critics, due to its seeming narcissism, an affinity for transgression, and a substantial degree of ambiguity. For these reasons her work eludes all classification. In fact, her art is characterized by a solitary approach with regards to the contemporary artistic panorama. It takes on "shape" precisely due to the concepts of emptiness, absence, and disappearance, although it cannot be included within the categories of Conceptual Art, in the true sense of the term. In fact, her work is almost immodestly teeming with intimate and personal experiences.

Her interest in a random and chance component is always in conflict with the highly formalized systems of her art: Calle uses media—photography above all—with the detachment of an amateur and the sharpness of a true expert.

Through various forms of personal research, she re-interrogates the terms and parameters of the public versus private, vis-à-vis role-playing. In her numerous projects, Calle has immersed herself in a profound investigation of notions of voyeurism, intimacy, and identity.

By analyzing, documenting, or reconstructing the life of unsuspecting strangers, the artist manipulates situations and individuals, even taking on different identities for specific periods of time.

The documentation of this research and the resulting works are presented as photographs, installations, or texts—authentic narrative books.

Double-Blind was made in the early nineties with a specific interest in the nature of desire, the documentation of an ephemeral and unique situation (almost a bet with herself), and the exploration of production modalities normally taken into consideration when making a film. It is a sort of road movie, even if mostly centered around the deviations, estrangements, and upheavals that take place internally.
[F.B.]

Double-Blind (No Sex Last Night), 1992
in collaboration with Gregory Shephard
video, color, sound, 75 min. 58 sec.
Castello di Rivoli Museum of Contemporary Art,
Rivoli-Turin
The first narrative video work by the artist, and
one of considerable length, was created together
with her then-collaborator and partner, Gregory
Shephard, and is an authentic *tour de force* of
pitiless self-analysis. Equipped with portable
video cameras, Calle and Shephard drive across
the United States towards the West in a Cadillac
convertible, looking for new experiences to
document the real events of their meeting, their
scheduled journey, and their personal
relationship. Each records and narrates a personal
diary, giving radically different versions of most
of the facts. In a sort of emotional crescendo, the
couple documents the various phases of a voyage
that is above all an exploration of the relationship
of their personalities, sexuality, and desire.

**PETER CAMPUS
(New York, 1937)**

Campus earned his first degree in Experimental Psychology at Ohio State University and later studied at the City College Film Institute.

During the seventies, Campus made a fundamental and outstanding series of closed-circuit video installations and video projections, both thematically and formally related to his artistic investigations, as exemplified in each single work. These video installations entail a reflection on the position of the spectator and his/her perceptive experience as integral parts of audiovisual research. Self-observation through faces and bodies, seen in its phenomenological extensions in space, is represented and deployed with the use of mirror effects and negative images, inversions and doublings in a fascinating and introspective psychological and visual exploration of the physical presence of the observers. In Boston, between 1973 and 1976, Campus produced a series of videos

R-G-B, 1974

considered milestones in his career. In these short works, the artist also participates as an actor, performing gestures and actions that are then re-elaborated electronically. The gestures, the presence of the performer's body, and often his face, evoke a meditative dimension of intense psychological and even philosophical exploration. Through a skillful use of the technical and expressive characteristics of video, Campus develops the possibilities of this medium through effects such as the chroma key (the removal of a layer of color), video feedback, and the Larsen effect (feedback between microphone and amplifier). Focusing on the relationship between illusion and reality, Campus has elaborated an intense study concerning representation modalities and video as mirror of identity. [F.B.]

Dynamic Field Series, 1971
video, black and white, sound, 23 min. 42 sec.
Purchased with the contribution of the
Compagnia di San Paolo
Through an exploration of the perception of physical and illusory space surrounding him, in his first video work Campus tests the ability of vision on the part of the video camera in relation to the performer and the viewer. First, the artist aims the camera towards his feet, giving the impression that the floor tilts and turns. He then lies on the floor and his body appears to advance, recede, or spin with the use of a camera pulled and moved with an attached cord. Finally, he wraps the video camera with gauze or cellophane and creates unique visual effects as he gradually frees the camera with a pair of scissors.

Three Transitions, 1973
video, color, sound, 4 min. 53 sec.
Purchased with the contribution of the
Compagnia di San Paolo
In the first *Transition*, Campus simultaneously films a yellow, two-dimensional surface from both sides using two video cameras. As he stands

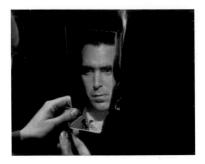

centered within the video frame, an incision he makes in the yellow background also appears to pass through his own body. In the second part, he uses the chroma key effect in order to obtain (also on a metaphorical level) a new and unusual result. With one hand he erases his face, behind which another image emerges. In the final part, he burns the image of his own face, holding it as if it were a photograph. The burning results in a black screen.

R-G-B, 1974
video, color, sound, 11 min. 30 sec.
Purchased with the contribution of the Compagnia di San Paolo

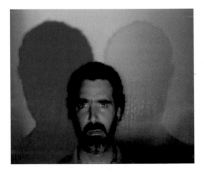

Campus, the protagonist, obtains a very particular self-portrait through video technology by physically, mechanically, and electronically manipulating the colors. Observing the "eye" of the video camera, he first puts color gelatine on the lens, projecting pure color onto himself. He aims the video camera towards the monitor and, in retouching the color values, he creates a chain reaction of infinite image multiplication (Larsen effect). Finally, he immerses his body in the horizon of the images that are saturated with electronic chromatism, thereby letting himself be absorbed to the point of disappearing inside a sea of colored signals.

Set of Coincidence, 1974
video, color, sound, 13 min. 24 sec.
Purchased with the contribution of the Compagnia di San Paolo

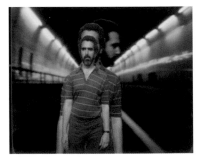

The first work produced by Fred Barzyk, it was made shortly after the death of Campus' father. As the protagonist, the artist sets out to explore a room and then a long tunnel made up of video sound signals. Numerous and simultaneous images of himself multiply and enlarge the perception of his body during the video.

East Ended Tape, 1976
video, color, sound, 6 min. 46 sec.
Purchased with the contribution of the
Compagnia di San Paolo
Through a series of brief actions carried out by
the artist with a female collaborator, simple
situations develop. Each episode shows the effects
of a single action on a close-up of a human face.
The woman erases her face with the shadow of
her hand, while the man hides under a wrapping.

Six Fragments, 1976
video, color, sound, 5 min. 07 sec.
Purchased with the contribution of the
Compagnia di San Paolo
As in a dreamlike and theatrical *mise en scène*,
Campus gathers together several performers to
recite a text. Two lines form the structure of the
narration, based on the transcription of a dream
through six evocative images.

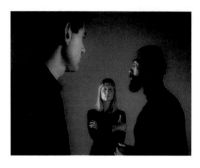

JEM COHEN
(Kabul, 1962)

Every project by Jem Cohen is born from the collecting and editing of diverse visual materials archived while traveling. Going beyond the usual categorizations, his works illustrate a particular visual and descriptive documentary sensibility that unites narrative approach and audiovisual components. Confines between documentary fiction and film experimentation are constantly blurred and questioned. What results is a space of lyrical narration that combines fragments of reality and rapid annotations and impressions, with attention to sensitive and volatile data. Resembling a cine-essay/personal diary, Cohen's works are simultaneously portraits of places and people as well as situations that constitute a specific way of observing. They are greatly characterized by a subjective viewpoint that portrays the world through the eye of the movie or video camera. Precisely in this sense, his works often possess the pensive tone of memory, a memory substantiated by words, sounds, and images that are recombined and reedited beginning with personal archives and documentation. Working mainly with 16 mm and 8 mm film, often re-elaborated in video, almost all of Cohen's work has been carried out with a solitary and introspective approach. Constant attention is dedicated to the desire to investigate and shed light on what seems invisible—those traces of daily life and ephemeral moments, often ignored but of significant impact, that influence the real world.

Cohen recently produced his first full-length film and in the course of his career he has received important awards and taken part in numerous film festivals. [F.B.]

This Is a History of New York, 1988
video, black and white, sound, 23 min.
Purchased with the contribution of the
Compagnia di San Paolo
This work is based on a selection of Super 8 semi-documentary shots taken along the streets or in places of New York, which is where the artist lives.
Seven frames with seven architectural layerings, seven human miseries, threatening or extraordinary buildings,

and humanity of all kinds are the protagonists. New York seems like the accumulation and inventory of various eras and civilizations. Poetic documentation, photographic evocativeness, and social portraits are all interwoven in a composition without words.

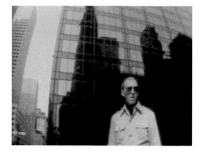

Lost Book Found, 1996
video, color, sound, 37 min.
Purchased with the contribution of the Compagnia di San Paolo
This work constitutes a vast and subtle meditation on the reality of urban living. Working with a two-fold approach between documentary and narration, the video is about a mysterious small book that contains long lists of objects, places, and events. Filmed with a partially-concealed, hand-held camera, the work penetrates into an unknown New York, soliciting attention for the manifold components and evocations that emerge from an "underground" point of view and suggesting the all-involving feeling of losing one's way in the city.

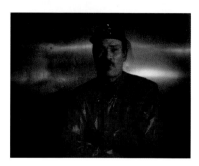

Instrument, 1999
video, color, sound, 1 min. 55 sec.
Purchased with the contribution of the Compagnia di San Paolo
Created in collaboration with the post-rock group Fugazi (originally from Washington), this work condenses a period of time that spans ten years, following the evolution of the band. Having little in common with musical documentaries, this project is instead an attempt at offering an image of musicians in daily contact with the most delicate part of their work: musical creation. By mixing different formats, this video assembles live excerpts from concerts, trips, rehearsals, interviews, and moments of interaction with the audience.

CECELIA CONDIT
(Philadelphia, 1947)

Most of the video works by Cecelia Condit explore the dark side of female subjectivity. She interrogates and reflects on the tensions, fears, and forms of aggression between men, men and women, women and society, and human beings and animals.

With a unique ability to mix humor with fear, the extravagant, the macabre, and sometimes even with horror, Condit elaborates short stories, almost modern fairy tales, in order to reveal obscure and repressed fantasies that seem to play a profound role in traditional American culture. Her particular narrative forms, which have been termed "feminist fairy tales," reinterpret and rewrite the traditions and myths of female representations, unveiling the implications tied to hidden forms of sexuality and violence. Condit has developed a fascinating, dream-like oeuvre in which the ordinary is transformed into the unexpected, and the familiar into the fantastic. This is made possible by attentive and refined video elaboration, films in Super 8, found footage, original music and oftentimes dialogues that are sung, and a series of references to popular and classical literary archetypes, from fairy tales to gothic literature.
[F.B.]

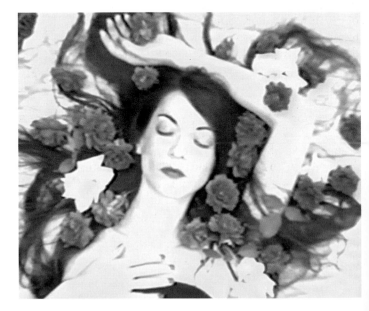

Possibly in Michigan, 1983

78

Beneath the Skin, 1981
video, color, sound, 12 min. 05 sec.
Purchased with the contribution of the
Compagnia di San Paolo
Through the story of a girl who discovers that her
boyfriend killed his former girlfriend and hid the
mummified body near their bedroom, Condit
elaborates a narration that is somewhere between a
dream and a hallucination. A sense of humor and the
macabre, together with a plot in which it is difficult to
distinguish between reality and dreams, characterizes
this story that goes beneath the skin, investigating the
veiled and repressed areas in the relationships
between men and women.

Possibly in Michigan, 1983
video, color, sound, 11 min. 40 sec.
Purchased with the contribution of the
Compagnia di San Paolo
Set in a typical American suburb, this video
narrates the story of two women who decide to
take revenge on their persecutor whose face is
masked like a large ape. In turn, the victims
become aggressors and the seeming familiarity of
the domestic scenarios is transformed into a sort
of psychosexual horror film with quasi-fantastical
tones. The use of songs and a growing sense of
disorientation characterize the video's pervasive
black humor.

Not a Jealous Bone, 1987
video, color, sound, 10 min. 24 sec.
Purchased with the contribution of the
Compagnia di San Paolo
An elderly, eighty-two-year-old woman searching
for her mother and a charming girl struggle to
possess a magic bone. The powers of this bone
promise eternal life. Accompanied by music
inserted sporadically, this psychological
melodrama stages vanity, jealousies, fatigue, and
the fear of aging in the form of a story.

FLUXUS

More than a movement, a precise moment in history, or a group of artists bound by a shared sensibility, Fluxus, as the name itself suggests, was a flow of energy, a continuously changing experience that left its mark on the art world by transmitting a feeling of extraordinary vitality and unpredictability. Indirectly derived from the experimentations of John Cage, in close contact with concomitant expressions of theatrical avant-garde movements, Fluxus was brought to life by charismatic figures such as George Maciunas, George Brecht, Yoko Ono, and La Monte Young—all bringing an indomitable intellectual liveliness on initiatives that were often ironically provocative.

Fluxus became known in the early sixties in various artistic centers in the United States, and particularly in Europe, in a continuous stream of initiatives that were neither planned nor directed, but which made contingency their main force. Paris, Cannes, Nice, Wiesbaden, Copenhagen, and New York hosted important festivals in which visual artists, avant-garde musicians, and especially performers presented programs teeming with events. The initiatives went full circle, with constant and polymorphous intermingling within an interdisciplinary environment.

Inevitably, video immediately became part of the rich repertory of adopted media and modalities. It was Nam June Paik who was among the first to use and promote the natural and unconstrained use of the possibilities offered by electronic images. It was precisely in the extreme variety of the situations and performances created that the true character of Fluxus could be found: an ironic and disenchanted creative vein that knew how to overturn and challenge every convention, despite the vast scenario of contemporary creation. Moreover, the deep involvement between their practices and the artists' personal experiences meant that discussion about Fluxus became a re-imaginative experience of everyday life. [F.B.]

Fluxfilm Anthology, 1962–1970
transferred from 16 mm film, black and white,
color, 120 min.
Purchased with the contribution of the
Compagnia di San Paolo
The anthology includes films by Nam June Paik,
Dick Higgins, George Maciunas, Chieko Shiomi,
John Cavanaugh, James Riddle, Yoko Ono,
George Brecht, Robert Watts, Pieter Vanderbiek,
Joe Jones, Eric Anderson, Jeff Perkins, Wolf
Vostell, Albert Fine, George Landow, Paul
Sharits, John Cale, Peter Kennedy, Mike Parr,
and Ben Vautier
The collection comprises thirty-seven short films
whose lengths vary from 10 seconds to 10
minutes, some of which were shown as part of the
events and happenings of the famous New York

avant-garde group. Created by its leading protagonists, they represent one of the most extraordinary documents of experimentation with avant-garde cinema.

Stockhausen's Originale: Doubletakes, 1964–1994
transferred from 16 mm film, black and white, sound, 30 min. 05 sec.
Purchased with the contribution of the Compagnia di San Paolo
This work documents the first production of *Originale*, a happening by Karlheinz Stockhausen, filmed at the *2ⁿᵈ Annual Avant-Garde Festival of New York*. It is directed by Allan Kaprow and includes performances by Nam June Paik, Charlotte Moorman, Jackson Mac Low, and Allen Ginsberg.

Some Manipulations, 1969
transferred from 16 mm film, color, silent, 3 min. 10 sec.
Purchased with the contribution of the Compagnia di San Paolo
Filmed by Jud Yalkut, the video includes some performances held in 1969 at Judson Church by artists such as Nam June Paik, Al Hansen, Jean Toche, and Steve Young. Yalkut autonomously contributes by alternating zoom shots of actions with luminous, abstract images and by dividing the screen into four squares, each of which is dedicated to a different image.

26'1.1499" For a String Player, 1973
video, color, sound, 42 min.
Purchased with the contribution of the Compagnia di San Paolo
Filmed by Jud Yalkut, this video documents a concert held by Charlotte Moorman and Nam June Paik dedicated to the composition of John Cage, *26'1.1499" For a String Player*.

The Chocolate Cello, 1973
video, black and white, sound, 30 min.
Purchased with the contribution of the
Compagnia di San Paolo
Filmed on Easter 1973, this video by Jud Yalkut
documents a performance in New York, in which
Charlotte Moorman is covered with chocolate.

Some Fluxus, 1991
video, black and white, color, sound, 59 min.
Purchased with the contribution of the
Compagnia di San Paolo
In this composite work, Larry Miller documents
the broad spectrum of experiences and various
personalities that constitute Fluxus. From a series
of historic performances taken from Miller's
archives, we can see, in addition to excerpts of
interviews with George Maciunas, works by Ay-O,
Eric Anderson, George Brecht, Philip Corner,
Ken Friedman, Al Hansen, Geoffrey Hendricks,
Dick Higgins, Joe Jones, Milan Knizak, Alison
Knowles, Takako Saito, Mieko Shiomi, Yasunao
Tone, Yoshi Wada, Ben Vautier, and Robert
Watts.

**RICHARD FOREMAN
(New York, 1937)**

After having studied literature and theater, Richard Foreman spent the second-half of the sixties associating with the explosive underground New York art scene. His direct relationship with Jonas Mekas, who introduced him to the films of Ron Rice, Jack Smith, and Ken Jacobs, along with the emerging Minimal Music scene and the dancer Trisha Brown all opened up new horizons for him. In 1968, he founded his own theatrical company, Ontological-Hysteric Theater, for which he directed numerous productions and which later became a foundation. In Foreman's own words: "[My theater had] to be [similar to] clinical documents. I wanted [it] to be as simple and as rigorous as what in those days was Minimalist art . . . I thought of myself as making Minimalist art like the music of La Monte Young, or the paintings of Frank Stella." It was precisely according to these influences that he structured an investigation that has as its presupposition the basic notion of a performance that is always shown and recognizable as such, in which the bodies of the actors are physically present and even create real *tableaux vivants* of great impact. From the way in which they express themselves, through references to their physicality, the concept of an "ontological-hysteric" theater is born. Between 1979 and 1985 a part of the theater company established itself in Paris, thanks to the assistance of the French government, thus giving the European audience the chance to discover his creations.

In a career spanning over thirty years, Foreman has directed and staged his own works as well as important opera productions and classical and contemporary theatrical texts. His work has also won numerous awards. The highly original style of his theater is characterized by a play of complex tensions and references between vocal-acting investigations and the meaning of the visual components of his performances. Constructed in such a way as to be distant from the identifying dynamics of the public, his creations, like his actors, function as theatrical machines, following a logic outside and beyond traditional dramaturgy and narration.

In transferring and re-creating his theatrical production through film and video, he produces works that are simultaneously more intimate and abstract with respect to his staged works. By using deconstructive and analytical

modalities that solicit the forms of theatrical illusion, such works become rigorously controlled compositions that analyze the structures and contacts between image and language. Formally Minimalist, Foreman's videos are in reality particularly rich and complex in their layers of meanings and in their textual components. [F.B.]

Out of the Body Travel, 1976
video, black and white, sound, 42 min.
Purchased with the contribution of the Compagnia di San Paolo
This audiovisual work, characterized by the photos of Babette Mangoste, is constructed on the juxtaposition of suggestions provided by the director's voice—Foreman—and the scene elaborations created by the actors (students of the American Dance Festival). The mingling of language and images, together with male and female presences, creates evocative results accompanied by an underlying erotic tension.

City Archives, 1978
video, color, sound, 28 min. 16 sec.
Purchased with the contribution of the Compagnia di San Paolo
Invited by the Walker Art Center in Minneapolis to create this video, in *City Archives* Foreman offers a labyrinthine collage of stories and images. The work centers on the viewing perspective of an outsider, a stranger presented as "the Other" who observes a city and its human artifacts. Foreman stages and deconstructs the forms of organizing, cataloguing, and archiving through which information and knowledge is arranged and structured.

FRANK GILLETTE
(Jersey City, New
Jersey, 1941)

Frank Gillette studied painting in New York. In 1968, he met Marshall McLuhan and was to remain profoundly influenced by him. Shortly afterwards he began working with video. In 1969, he was among the founders of the Raindance Corporation (with participants including Louis Jaffe, Marco and Judi Vassi, Judi Bosches, and Michael Shamberg) and he created his first installations entirely composed of videos. In fact, in that same year, he presented, together with Ira Schneider, *Wipe Cycle*, the first example of a multi-screen installation with image feedback in real time.

Gillette's video work elaborates a system of correspondences, echoes, communicative ties, and visual dialogues—all modalities to connect the Ego with surrounding reality. Already by the early seventies, Gillette experimented with multi-channel video installations that incorporate the images of the observer in authentic feedbacks, but which also question the seeming passivity of the information that is broadcast. He uses technological advancements in order to bring about changes in his relationship with viewers, addressing their subconscious. In coupling rich visual sensibility with an almost scientific attention for taxonomies and descriptions of ecological systems and environments, Gillette is one of the pioneers in video research. His multi-channel installations and single videos offer examples of an investigation where empirical observations of natural phenomena are reorganized into refined and layered audiovisual compositions. From among the first rigorous theorists of the formal and aesthetic parameters of video, Gillette has also written important essays on this topic, contributing to *Radical Software*, the most authoritative theoretical publication on video in the early seventies. [F.B.]

Hark! Hork!, 1972–1973
video, black and white, sound, 19 min. 25 sec.
Purchased with the contribution of the
Compagnia di San Paolo
With a title that refers to James Joyce's *Finnegans
Wake* (a passage where Finnegan awakens from a
dream), *Hark! Hork!* evokes natural and
subconscious landscapes. Inspired by the writer's
stream of consciousness technique, Gillette
creates a text of parallel visual and acoustic force
that combines organic and abstract forms with
fascinating still lifes of plants and vegetation,
capable of evoking all of the sensuality of nature.

JEAN-LUC GODARD
(Paris, 1930)

In the mid-seventies, following his experiences in *auteur* cinema during the Nouvelle Vague period and then with his political activism as animator and co-creator of audiovisual works in the Dziga Vertov cinema group, Jean-Luc Godard, together with director Anne-Marie Miéville, created a series of openly experimental works for television.

With a courageously independent choice, he founded in 1972, together with Miéville, the Sonimage alternative production and distribution company, employing video and television as his instruments of expression. It was during those years that he created his two important series: *Six fois deux / Sur et sous la communication* (*Six Times Two / Over and Under Communication*), 1976 and *France / tour / détour / deux / enfants* (*France / Tour / Detour / Two / Children*), 1978.

In concentrating their research on the meanings and modalities of signification of video in relation to mass media, work, the family institution, and individuals, Godard and Miéville reinvented the potentials of television, elaborating a vast series of reflections regarding the use of media images and, more generally, the discussion connected to these, in relation to contemporary society. These visual essays, punctuated by written or spoken words, synthesize a complex discussion on the ideological and social implications unleashed by television, advertising, and more inclusively by the entire universe of images in motion.

By adopting an essential and harsh television language, reinventing it from within, they developed a new style that went beyond the distinctions among the documentary, the interview, and the reportage, thanks to the use of a series of precise techniques: slow motion, the long-shot, the fixed camera, the overlapping of texts on images, and the inter-textual collage of images from diverse sources (photography, cinema, and television). Preferring a theoretical and philosophical approach, equally centered on the material nature of daily life, these works do not use professional actors but ordinary people as subject matter: schoolchildren, people at work, the artists themselves. And it is precisely their presence, even when not immediately detected, that contributes to the strong reflective tension and intellectual rigor that distinguishes every part and

every discussion elaborated in the works.
More recently, Godard once again extended and further
transformed the idea of the video-essay in a series made for
television. [F.B.]

Six fois deux / Sur et sous la communication (*Six Times
Two / Over and Under Communication*), 1976
in collaboration with Anne-Marie Miéville
video, color, sound, 9 hrs. 57 min.
Purchased with the contribution of the
Compagnia di San Paolo
Six Fois Deux, Part IA: Y a personne (*Six Times Two,
Part IA: Nobody's There*), 1976
video, color, sound, 57 min. 20 sec.
Six Fois Deux, Part IB: Louison (*Six Times Two, Part*

*France / tour / détour / deux /
enfants (France / Tour /
Detour / Two / Children),*
1978

91

IB: Louison), 1976
video, color, sound, 41 min. 43 sec.
Six Fois Deux, Part 2A: Leçons de choses (*Six Times Two, Part 2A: Lessons about Things*), 1976
video, color, sound, 51 min. 30 sec.
Six Fois Deux, Part 2B: Jean-Luc (*Six Times Two, Part 2B: Jean-Luc*), 1976
video, color, sound, 47 min. 50 sec.
Six Fois Deux, Part 3A: Photos et cie (*Six Times Two, Part 3A: Photos and Company*), 1976
video, color, sound, 45 min. 33 sec.
Six Fois Deux, Part 3B: Marcel (*Six Times Two, Part 3B: Marcel*), 1976
video, color, sound, 54 min. 48 sec.
Six Fois Deux, Part 4A: Pas d'histoire (*Six Times Two, Part 4A: No History*), 1976
video, color, sound, 56 min. 34 sec.
Six Fois Deux, Part 4B: Nanas (*Six Times Two, Part 4B: Nanas*), 1976
video, color, sound, 42 min. 30 sec.
Six Fois Deux, Part 5A: Nous trois (*Six Times Two, Part 5A: We Three*), 1976
video, color, sound, 52 min. 10 sec.
Six Fois Deux, Part 5B: René(e)s (*Six Times Two, Part 5B: René(e)s*), 1976
video, color, sound, 52 min. 56 sec.
Six Fois Deux, Part 6A: Avant et après (*Six Times Two, Part 6A: Before and After*), 1976
video, color, sound, 44 min. 30 sec.
Six Fois Deux, Part 6B: Jacqueline et Ludovic (*Six Times Two, Part 6B: Jacqueline and Ludovic*), 1976
video, color, sound, 49 min. 58 sec.
Through an analysis of modalities and particularities "regarding and beyond" communication, Godard and Miéville provokingly analyze the power constituted by media images with regards to our culture and daily life.
Each program is divided into two complementary sections: coupled with every "essaying" section, centered around an aspect of image production and consumption, there is an interview regarding an individual and his/her relationship with work and leisure time. We therefore see, by way of example,

an amateur filmmaker, a breeder, a mathematician, and Godard himself. Through extended interviews, we are offered a personal, "subjective" counter-reply to the most overtly theoretical part regarding work, the economy, and mass cultural imagery. In a coherent and concise social and meta-communicative analysis, the critique of television conventions solicits the traditional opinions of the viewer, redefining the forms and modes of television reception.

France / tour / détour / deux / enfants (France / Tour / Detour / Two / Children), 1978
in collaboration with Anne-Marie Miéville
video, color, sound, 5 hrs. 12 min.
Purchased with the contribution of the
Compagnia di San Paolo

In a twelve-part television cycle, Godard and Miéville deconstruct and recompose with precise formal care the intimate and everyday world of two children in modern-day France, paying particular attention to all of those details, looks, and gestures that when isolated give us a significant picture of this fragile slice of society. The interviews with the two young schoolchildren, Camille and Arnaud, alternated with scenes regarding their days at home and at school, are followed by the comments of two television journalists who reread what they have witnessed. The entire audiovisual work is a study of the effects produced by television on families and their children.

Alternated with multi-textual collages made up of TV, advertising, and movie images, this video analyzes the social, economic, and ideological dynamics and functions that presuppose the mass-media universe.
As the work unfolds, it becomes evident how the world of children is equally programmed by the family and by television.

**DAN GRAHAM
(Urbana, Illinois,
1942)**

Dan Graham's first works, starting from the mid-sixties, were a response to the contemporary art and the art system. Following a brief experience as the director of an art gallery, during which he came into direct contact with the emerging Minimalist movement, he decided to use the pages of commercial magazines to present his own works. With respect to the context of traditional art spaces, Graham was attracted by the close tie the press has with real time and its necessity to renew its contents daily, weekly, or monthly. Thus the artist could put his audience in contact with a temporality not aligned with the ideal eternity of art. On pages otherwise intended for advertising he published conceptual works that subverted that same Pop logic of using images taken from media and mass culture contexts that reflect on the idea of art as an economic product.

Interested in the complex relationship that exists between the work of art and the spectator, starting in the seventies Graham began to use performance, video, and film. Through performance, which video can document in real time, the artist investigated new definitions of the concept of the audience, elevating it from its traditional position of mere observer. Even when he exhibited himself, Graham experimented with ways that allowed the audience to find itself in a position analogous to and equally important as that of the performer. The importance given to the visual process as the determining element of the content and meaning of the work was developed in the films he produced between 1969 and 1974. Through its declared presence in the sphere of the work, the video camera affirmed the pre-eminence of the visual act. However, it is video—often presented within the context of structures similar to architectural models—that is the medium which allows the artist to more freely analyze the themes regarding vision and its relationship to spatial and temporal dimensions. In various installations, Graham has used a video camera connected to a monitor, allowing the public to perceive its own image in a different time with respect to that of the actual recording. The categories regarding present, past, and future are in this way re-examined. Similarly, the concepts of internal/external and public/private are also placed under scrutiny, thanks to the use of glass and mirrors. Above all, however, it is the role of

the audience that becomes fundamental, as the artist's work exists only through its viewers. In Graham's videos, the observer often corresponds to the person who is observed: both are the subject and object of the work. And in turn, artistic work shifts from the traditional object to become a fluid process open to the surrounding world, capable of interacting and taking an active part in the sphere of social exchange.

These themes are further investigated by the artist in the pavilions he began to produce in 1980. Constructed in metal and glass, they are characterized by an aesthetic that intentionally refers to Modernist architecture and Minimalist sculpture, both of which are subjected to a profound critical investigation. Often installed outdoors, like real independent constructions, Graham's pavilions are traversable structures. The use of opaque or reflecting glass contributes towards regenerating the artist's investigation concerning the borderlines between the presumed identification of the internal as a private dimension and the external as a public place, hence renewing the question regarding the definition of the work of art and its context. [M.B.]

Past Future Split Attention, 1972
video, black and white, sound, 17 min. 03 sec.
Purchased with the contribution of the
Compagnia di San Paolo
Inside the same space two persons who know each other speak into a microphone: one man predicts the behavior of the other, while the other person narrates the past behavior of his acquaintance. The performance documented by the video represents one of the artist's investigations dealing with the psychological aspects of space and time.

Performer/Audience/Mirror, 1977
video, black and white, sound, 22 min. 52 sec.
Purchased with the contribution of the
Compagnia di San Paolo
In real time, the artist describes his gestures to

the public, and then describes the public itself. He subsequently places himself in front of a mirroring wall and once again begins the two descriptions looking at the reflected reality.

Minor Threat, 1983
video, color, sound, 38 min. 18 sec.
Purchased with the contribution of the Compagnia di San Paolo
With a documentary style, the artist talks about a concert by Minor Threat, a Washington, D.C. hardcore music group. The video shows the aggressiveness unleashed by the concert and represents a chapter in the more in-depth investigation regarding popular music and its ritual implications the artist has carried out in a number of his works.

Rock My Religion, 1982–1984
video, black and white, color, sound,
55 min. 27 sec.
Purchased with the contribution of the
Compagnia di San Paolo
In making use of written texts, sound, and visual
material, the artist's intention is to demonstrate
the close relationship between religion and rock
music. The video focuses mainly on the Shakers,
the religious sect founded by Ann Lee, a woman
who believed she was the female incarnation of
Christ. More specifically, the artist concentrates
on their community rites, which included dances
done in a state of trance and considered necessary
for the healing of the soul. These rites, which
have represented an important aspect of
American culture, are paralleled with the
ideology of fifties and sixties rock'n'roll music.

MARIE-ANGE GUILLEMINOT
(Saint Germain-en-Laye, France, 1960)

The work of Marie-Ange Guilleminot investigates the dynamics regarding the private space of the individual and his/her surroundings. As a form of ecology, the artist's work brings into focus the relationship and study of living beings in relation to their environment.

Guilleminot's work is a vast research extending far beyond the fixed and established forms of art; it searches for ruptures, indetermination, and variety through the diversified supports she uses on each specific occasion. She has used video, sculpture, performance, often seeking the collaboration of groups of people. Each work takes on its form and existence at the point in time in which she presents a live or recorded action.

The series of the *Poupées* (*Dolls*) was created in 1993 as a video, followed by other "interpretations" manipulated by other persons she documented photographically. Transformations and processes are the procedures adopted in most of her works. Since 1992, she has created a series of garments modeled on her own measurements, but whose cut, however, only allows one to see the head and arms. They offer the characteristics of soft, protective coverings. It is precisely through their intense and implicit tactile nature, the need for direct and physical contact, that the mental relationship solicited by her videos emerges.

By overturning the tradition of Western sculpture, Guilleminot has developed a system of relationships and communication based on the immediacy and warmth of the quality of touch and proximity. In a play of seduction—but at the same time one of possible frustration—the sensual and experiential aspects of her work open the way to manifold possibilities of associations and interpretations capable of embracing the senses. [F.B.]

Mes Poupées (*My Dolls*), 1993
video, color, sound, 30 min.
Castello di Rivoli Museum of Contemporary Art,
Rivoli-Turin
In a single, continuous, close-up shot, we see the
hands of the artist that carry out a series of
uninterrupted actions. By manipulating, crushing,
and modifying a bag of rose-colored talcum powder,
they mold organic forms, similar to imaginary
organs. Often loaded with sexual connotations—
both male and female—the forms suggested by the
artist in the end appear to be hermaphroditic.
By evoking the world and time of infancy, this
hypnotic video seems to refer to that phase in which
sexuality has not yet been rigidly determined and
where a tactile and sensual playfulness are an
integral part of the growing process.

GARY HILL
(Santa Monica,
California, 1951)

A pioneer of electronic media, Gary Hill has developed his work with video and sound since the early seventies. In 1973, while still a student at the Arts Students League in Woodstock (New York) and at a time when he had only worked with sculpture (especially exploring the possibility of integrating sound), Hill borrowed a video camera from the Woodstock Community Video and began experimenting. Fascinated by its real time use, he employed video as if it were a means for "thinking aloud." This immediately functional process led him to consider video as the form of expression closest to thought. During the two years that followed he worked at Woodstock where he created his first videos. In these, he explored the relationship between sound and image and, in line with contemporary sensibility, he tackled ecological themes related to greater awareness regarding the environment. In 1974, he created his first installation that consisted in a closed-circuit broadcast. From the very beginning of his career, Hill has considered the potentials of technology one of the essential points of his artistic research. In fact, he uses video as a preferred and exclusive medium.

In his first productions, the creation of electronic images took on a specific importance. Later, by introducing spoken words, Hill became interested in its innate possibilities through phonation, the presence of an emitting body. A careful use of the diverse means employed, such as texts, words, and images, permits the physicality of language and its relative mental processes to be reflected in Hill's oeuvre. His research focuses on the forms of relation, reaction, and friction between language and images.

After he met the poet George Quash in 1976, Hill turned to the extraordinary possibilities of language when placed in relation to images in motion. Hill's research therefore moved towards exploring the intertextual relationships among image, sound, word, and language, especially in his late seventies and eighties works. Since the end of the eighties, he has earned international renown, dedicating himself to complex site-specific installations. [F.B.]

Selected Works I, 1975–1979
video, color, silent and sound, 26 min. 20 sec.
Purchased with the contribution of the
Compagnia di San Paolo

Objects with Destinations, 1979
video, color, silent, 3 min. 57 sec.
The work consists of superimposed layers and
colorings of objects and instruments in the
negative combined with an electronic re-
elaboration of the images.

Windows, 1978
video, color, silent, 8 min. 28 sec.
Images of windows, digitalized and in continuous
overlapping layers, rotate and sometimes appear
as abstract and unrecognizable forms, simulating
effects of spatial depth.

Bathing, 1977
video, color, sound, 4 min. 30 sec.
From the simple shot of a girl bathing, the artist
extrapolates a whole series of images that are
once again elaborated and transformed with the
use of colors, positive-negative inversions, still
images, and intersecting layerings.

Bits, 1977
video, color, silent, 2 min. 59 sec.
Fragments of images and details of objects,
increasingly enlarged, create a play of abstractions
and overlappings.

Mirror Road, 1975–1976
video, color, silent, 6 min. 26 sec.
Some shots taken while traveling in a car along a
road offer the primary material for a series of
visual treatments that render vision and
perception extremely abstract.

Selected Works II, 1977–1980
video, black and white, sound, 19 min. 26 sec.
Purchased with the contribution of the
Compagnia di San Paolo
Electronic Linguistic, 1977
video, black and white, sound, 3 min. 39 sec.
Minute electronic forms move on the screen with
progressive acceleration and become the visual
equivalent of electronic sounds.
Sums & Differences, 1978
video, black and white, sound, 8 min. 24 sec.
A series of images of musical instruments and
their corresponding sounds are alternated in a
progressively faster sequence. The accumulation
of the visual and sound flows—both vertically and
horizontally—creates a throbbing effect.
Black / White / Text, 1980
video, black and white, sound, 7 min. 23 sec.
This work is structured as a type of linguistic
deconstruction and represents a study of the syllables
making up the sentences that appear on the screen.

Selected Works, III, 1978–1979
video, black and white, color, sound,
19 min. 22 sec.
Purchased with the contribution of the
Compagnia di San Paolo
Full Circle (Ring Modulation), 1978
video, color, sound, 3 min. 38 sec.
Three sections make up the image: the close-up
of hands that bend a metal rod into a circle is
juxtaposed to the image of the whole body of the
person in question, and an electronic circular
shape visualizing the sound of the vocal. From
the progression of these different images a strong
tension arises between the action of manipulating
a physical object and the process of electronic
visualization.
Mouthpiece, 1978
video, color, sound, 1 min. 07 sec.
The continuous passing of a stylized red mouth,
seen on a blue background, transforms the
underlying image of another mouth. A landscape

of graphic forms and sound fragments
rhythmically pulses.

Elements, 1978
video, black and white, sound, 2 min. 13 sec.
In a visual articulation that is both strongly and
essentially terse, the screen presents a play
between black and white elements.

Primary, 1978
video, color, sound, 1 min. 19 sec.
This work is a study dealing with the colors red,
green, and blue. Some lips repeat their names
while the images change.

Picture Story, 1979
video, color, sound, 6 min. 26 sec.
Constructed on the visual intersections between
letters and textual sources, the work focuses on
the relationship between linguistic play of words

and video representation, the result being the creation of a brief narration based on puns and images.

Equal Time, 1979
video, color, sound, 4 min. 39 sec.
Two contrasting narratives are superimposed within an abstract setting: one is based on a psychological space whereas the other is based on a concrete one.

Soundings, 1979
video, color, sound, 18 min. 03 sec.
Purchased with the contribution of the Compagnia di San Paolo
Through a sequence of images of acoustic cones (loudspeakers) that are first placed in relation to a person who moves them and are then isolated and presented in close-up, this work offers a series of reflections on the relationships between "the images of sounds and the sounds of images." At the end a loudspeaker burns in flames.

Around & About, 1980
video, color, sound, 5 min.
Purchased with the contribution of the Compagnia di San Paolo
"It could have gone in another way . . ." Through a concise presentation of possibilities and conditions recited by an off-screen voice, this work presents details of objects, at the same time offering a series of considerations on the modalities of the contextual nature of communicative relationships.

Processual Video, 1980
video, black and white, sound, 11 min. 13 sec.
Purchased with the contribution of the Compagnia di San Paolo
The work is structured around the relationship that is continuously created between an absolutely minimal, abstract electronic image—a white line that moves on a black background—and a narrative text that talks about the movement and perception of forms.

Thanks to a progressive effect of communicative
feedback, resonances and correspondences between
words and visions are the result.

Videograms, 1980–1981
video, black and white, sound, 13 min. 27 sec.
Purchased with the contribution of the
Compagnia di San Paolo
This work is made entirely by using an electronic
scan processor (Rutt/Etra Scan) that literally
allows the artist to sculpt forms in sequence on a
black background, starting from single words or
sentences. The "videograms" created come to
form a dynamic relationship with the text Hill
reads, by both accompanying it and (in a more
mental counterpoint) through a complex series
resulting from abstract and optical forms.

Primarily Speaking, 1981–1983
video, color, sound, 19 min. 23 sec.
Purchased with the contribution of the
Compagnia di San Paolo
A single-channel version of an installation of the
same title for multi-screens placed in a parallel
sequence, this work offers a complex series of
audiovisual relations on a monitor that is divided
into two autonomous series of images. The off-
screen voice analyzes considerations regarding
contexts of communication and furnishes
variations on the theme of the potentials of
language.

Happenstance (Part One of Many Parts), 1982–1983
video, black and white, sound, 6 min. 47 sec.
Purchased with the contribution of the
Compagnia di San Paolo
An essential and refined play of interrelations
among written parts, words spoken off-screen,
sounds, and images, this short although dense
work is constructed upon a series of questions
dealing with the interpretation and the transitory
nature of textual meanings. Hill's voice, which is
manipulated, together with the text generated by
the characters used causes the black and white
images to correspond to the visualized forms of
Haiku poetry.

*Why Do Things Get in a Muddle? (Come on
Petunia)*, 1984
video, color, sound, 33 min. 09 sec.
Purchased with the contribution of the
Compagnia di San Paolo
Inspired by *Alice in Wonderland*, through an actual
staging two characters recite and develop an
analysis between the perception of time and the
order of things. The dialogue between Alice and
her father about "muddles" is recorded by means
of a double reversal technique of sentences

106

originally pronounced backwards. The apparently paradoxical situation seems to demonstrate how the order of discussions is caused by the ties among linguistic linearity, narration, and the meaning of the story.

URA ARU (The Backside Exists), 1985–1986
video, color, sound, 28 min. 30 sec.
Purchased with the contribution of the
Compagnia di San Paolo
This video investigates the structures of the ancient Noh drama and its structure of formal, technical, and linguistic dualities. From here

Hill constructs a series of acoustic palindromes using Japanese words, creating a visual counterpoint with lengthy sequences featuring Noh actors.

Incidence of Catastrophe, 1987–1988
video, color, sound, 43 min. 51 sec.
Purchased with the contribution of the Compagnia di San Paolo
Written, directed, and edited by the artist, this video shows the results of Hill's research during the early eighties. Inspired both by Maurice Blanchot's novel *Thomas l'obscur* and by his own son who began to speak at that time, the artist places the observer in the situation of becoming "text" through a succession of scenarios and motifs that describe the descent within language and within its labyrinthine ways of representation.

Site / Recite (A Prologue), 1989
video, color, sound, 4 min. 05 sec.
Purchased with the contribution of the
Compagnia di San Paolo
Produced with the most accurate precision, in
this work the video camera scrutinizes a vast table
with a series of still lifes, such as bones, butterfly
wings, shells, and skulls.

Solstice d'hiver (Winter Solstice), 1993
video, color, sound, 60 min.
Purchased with the contribution of the
Compagnia di San Paolo
Originally commissioned by the French television
network La Sept for a series of works created in
real time by artists, this video is centered on a
methodical and continuous observation that
records the daily life of the artist's domestic
surroundings. In a single, uninterrupted
sequence, Hill documents the objects, the spaces,
and the daily gestures surrounding him.

THOMAS HIRSCHHORN
(Bern, Switzerland, 1957)

Interested in a social and political dimension of art, Thomas Hirschhorn initially worked with the Grapus design group. In 1986, he decided to dedicate himself entirely to the plastic arts and, more specifically, to sculpture. Starting from his first solo exhibitions in the late eighties, he has progressively developed an original sculptural research that combines everyday, poor, and disposable materials—garbage bags, plastic, plexiglass, wood, cardboard, aluminum foil—retrieved and put together with an abundant use of adhesive tape. These works are enhanced through collages created from advertising images found in fashion magazines. Everything is then recomposed with fragments and quotations of philosophical texts, often directly rewritten by hand by Hirschhorn or photocopied. This gives rise to a complex and often hypertrophic body of work in which one finds the mingling of a wealth of ideas with a poverty of means: kiosks, altars, huts, information centers, and a wide range of pieces the artist defines as "monuments," all born from the total fragility of the differently assembled materials. The artist explains that what interests him in the apparent precariousness of the materials used is the mental energy kindled and stoked by the juxtaposition and reaction of different objects.

In experimenting with places and contexts that always differ, the artist develops interventions in private and public spaces and, in always going one step further, creates counter-monuments dedicated to philosophers and writers. In recent years, he has paid tribute to Robert Walser, Spinoza, Deleuze, and Bataille, showing his interest in and commitment to radical forms of contact and intervention in urban spaces. In recent years, larger and more complex projects have been conceived and co-created with the inhabitants of the city neighborhoods of Münster (summer 1997) and Kassel (summer 2002). The comparison—or confrontation—with an unpleasant past and with the most dramatically critical phenomena of the present-day political situation is the basis of Hirschhorn's interest, as are also the socio-economic conditions involved. As the artist puts it: "Art exists as the absolute opposite of its time—as the absolute opposite of the reality of its time." In a series of works of almost visceral impact, the explicative titles indicate his intention and the content of his work. On backgrounds of bright colors and with loud soundtracks it is the artist himself who stages the symbolic actions. As Hirschhorn puts it: "I am not interested in 'quality,' I am interested in 'energy'." [F.B.]

Five Bar Clips, 1995
video, color, sound, 25 min. 30 sec.
Castello di Rivoli Museum of Contemporary Art,
Rivoli-Turin
Robert Walser Video, 1995
video, color, sound, 4 min.
Portrayed frontally and with his head
rhythmically swaying in time with the music, the
artist is seated under a banner bearing the same
title as the video.

Thank You, 1995
video, color, sound, 8 min. 20 sec.
The naked artist first slaps his right and then his
left cheek, while in his other hand he holds a cut-
out of a female model.
*La cuisine des Mosquetaires (The Kitchen of the
Musketeers)*, 1995
video, color, sound, 1 min. 30 sec.
The artist's arm enters the shot and repeatedly
puts the beginning of a song by the Sex Pistols on
the record player, while on a monitor two cooks
are seen.
For Nelson Mandela (Biko), 1995
video, color, sound, 7 min.
With the accompaniment of "Biko" by Peter
Gabriel, the artist is posed in respectful adoration
of a South African flag with an image of Nelson
Mandela at the center.
I Will Win, 1995
video, color, sound, 4 min. 05 sec.
Seated, bare-chested, and his face wrapped in
tinfoil, Hirschhorn shows the victory sign, raising
both hands.

Zwei Tränen (Two Tears), 1995
video, color, sound, 24 min.
Castello di Rivoli Museum of Contemporary Art,
Rivoli-Turin
Zwei Tränen (Two Tears), 1995
video, color, sound, 1 min. 35 sec.
Hirschhorn tries to paint, placed next to another
painting.
Robert Walser Lektüre I (Robert Walser Lecture I), 1995

video, color, sound, 3 min. 20 sec.
Robert Walser Lektüre II (Robert Walser Lecture II), 1995
video, color, sound, 4 min. 20 sec.
In both of these works, the artist sits reading in front of a banner bearing the same title as the video. At a certain point he gets up and moves towards the camera.
Otto Freundlich Fan, 1995
video, color, sound, 11 min. 45 sec.
Hirschhorn starts playing a song ("The End" by the Doors), he gets up, puts on a scarf on which "Otto Freundlich" is written, and then listens to the music he has chosen.
Hallo-Schiff (Hallo-Boat), 1995
video, color, sound, 22 sec.
An off-screen voice says "Hallo" as a motorboat—flying the Swiss flag—passes by on a lake.

Video Compilation (Clips), 1995
video, color, sound, 22 min. 30 sec.
Castello di Rivoli Museum of Contemporary Art, Rivoli-Turin
Prince and Me, 1995
video, color, sound, 5 min.
To the rhythm of a piece by Prince heard in the background, the shot remains fixed on a reportage photo that shows an African man holding a human head in his hand.
Lust for Life (Claudia), 1995
video, color, sound, 5 min. 10 sec.
To the music track of the same title by Iggy Pop, the artist is hidden from the public behind a piece with a collage showing the face of Claudia Schiffer coupled with a horrifying photograph.
Rotes Tuch (Red Cloth - Desire 1), 1995
video, color, sound, 6 min. 10 sec.
Filmed from above the artist, from his waist up, he is lying on red cloth listening to the track "Desire" by U2.

Antifaschistcheaktion (Desire 2) (Anti-fascist Action - Desire 2), 1995
video, color, sound, 6 min. 10 sec.
A close-up of a ghetto blaster (portable radio) with a red flag next to it. At max volume the radio plays U2's "Desire." At regular intervals a forearm with a fist enters the scene.

Nice to Meet You, 1995
video, color, sound, 13 min. 40 sec.
Castello di Rivoli Museum of Contemporary Art, Rivoli-Turin
To the sound of "Sympathy for the Devil" by the Rolling Stones, in the famous recording of the mortal accident at the concert in Altamont, a blonde girl smiles in the direction of the video camera.

Stars in the Sky, 1995
video, color, sound, 4 min.
A still image dedicated to an ad for a fashion maison featuring Claudia Schiffer leaning on a table.
Moonlight Lady (Wiegenlied), 1995
video, color, sound, 3 min. 20 sec.
Filmed from above and with background music, Hirschhorn moves a wooden board with his hands.

Integrated Videos, 1999
video, color, sound, 15 min.
Castello di Rivoli Museum of Contemporary Art, Rivoli-Turin
A sequence of images shot during exhibitions held in recent years gives an account of the variety of Hirschhorn's installations and interventions. A musical crescendo accompanies.

CARSTEN HÖLLER
(Brussels, 1961)

Following his studies in agronomy and a specialization in entomology, Höller's work as an artist is influenced by his scientific studies and interests. Initially, he especially focused on the forms that natural evolutionary forces take on in their relationships with human emotivity. He began to relate his knowledge acquired as a biologist to evolution theories, directing his interest to those types of feelings—such as love, affection, and joy—that are essential elements for a favorable reproduction of human genetics. At the same time, he studied human beings as simple animal creatures from among other animals.

In developing installations and interactive sculptures, Höller consequently became interested in creating structures capable of inducing states of excitement, alteration, doubt, and confusion in the public (quite often in a playful way). By using the public as the subject of perceptive and psychological experiments, he studies and explores specific problems tied to the relationship between the individual and diverse psychological and emotive conditions.

Over the years, he has gradually become more interested in matters concerning perceptive functions, using art as the medium for carrying out both symbolic and real experiments. This has produced projects, actions, films, videos, and complex environmental installations—a few between 1997 and 1999 in collaboration with Rosemarie Trockel—including plants, animals, and persons. Here the intention has been to facilitate different forms of interactivity involving all human senses. His audiovisual production adopts a different style, depending on the exhibition contexts and his collaboration with other artists. [F.B.]

Jenny, 1992
video, color, sound, 13 min.
Castello di Rivoli Museum of Contemporary Art,
Rivoli-Turin
Structured as a series of independent scenes, this
video with its almost cartoon-like narration
extends the exploration of some of the themes
that are key to the artist's work: the idea of safety,
child-like curiosity, pleasure and joy as physical
states, play, and the dynamic relationship between
doubt and certainty.
Preparing traps on a beach, the methodical
process of poisoning children's candy, both shown
in the video, demonstrate Höller's intention of
undermining given cultural and ethical
categories.

NAN HOOVER
(New York, 1931)

Prior to dedicating herself to video, performance, and photography, in 1973 Nan Hoover practiced painting and drawing. This expressly "pictorial" approach to images has remained a fundamental component in her videos.

Over the years, and parallel to her exhibition activity, she has created an extensive and variegated body of performances in galleries, museums, and theaters, thereby acquiring a more complete understanding of space through "silence, concentration, and discipline."

A highly sensitive and tactile concern for forms is evident throughout Hoover's works, though it remains principally immaterial. With her meticulous care for the intensity of light, color, and minimal movements, over the years she has developed an extraordinary ability to produce visual compositions in which the association of images manages to create true external and internal landscapes. On more than one occasion Hoover has explained she loves "the transparency and luminosity in video." In exploring the subtle ambiguities of visual perception, she has analyzed the forcefully evocative tension that exists between abstraction and reality, fluidly intervening amidst the play of controlled light. Often created using a fixed, immobile video camera, these rapt, meditative, and dreamlike portraits are executed in real time.

Slight movements of parts of a body and subtle changes of weather within the landscapes filmed out in the open create true orchestrations that are carefully modulated with light. The resulting atmosphere induces viewers to lose the cognition of what is observed.

After her studies, she moved to Amsterdam in 1969 and later became a Dutch citizen. In recent years, she has grown increasingly interested in the creation of public installations made with light, responding to commissions by cities and museums mainly in Germany and Holland. [F.B.]

116

Selected Works II, 1983–1985
video, color, sound, 50 min. 51 sec.
Purchased with the contribution of the
Compagnia di San Paolo
Landscape, 1983
video, color, sound, 5 min. 42 sec.
A hand placed in front of the video camera is
transformed into a landscape thanks to light effects
and changes of scale. Reality and illusion
accompany each other in this up-close exploration.
Halfsleep, 1984
video, color, sound, 16 min. 43 sec.
With the help of a macroscopic lens and slow
shooting, the artist's attention is totally addressed
to examining the details of the surface of her face.
A dramatic texture of weavings and lights is the
result.
Eye Watching, 1984
video, color, sound, 7 min. 22 sec.

An extreme close-up of an observing eye is coupled with greatly amplified surrounding sounds. In concentrating on the act of looking, Hoover develops an extraordinary study on the properties of human vision, focusing on how and to what degree the eye responds to the passing of shadows, lights, and even sounds.

Returning to Fuji, 1984
video, color, sound, 8 min. 21 sec.
The appearance and perception of the famous mountain are blurred in an atmosphere of gray-violet mists, accompanied by gradual transformations of the intensity of the light and shadow and by evocative sounds.

Desert, 1985
video, color, silent, 12 min. 43 sec.
Played out entirely by using shades of deep red and ocher, this work evokes a desert landscape in which the variations of light and color refer to the day's cycle.

Flora / Watching Out - A Trilogy, 1985–1986
video, black and white, color, silent,
22 min. 11 sec.
Purchased with the contribution of the Compagnia di San Paolo

Flora, 1985
video, color, silent, 9 min. 11 sec.
With reference to the essential and refined composition of Georgia O'Keeffe paintings, this video describes the forms of a flower's petals, focusing on the transformations also given by the minimum changes of light.

Watching Out - A Trilogy, 1986
video, black and white, silent, 13 min.
This trilogy with its strong contrasts and chiaroscuro shows close-ups of a woman with fadings that distance and draw the work near to forms of visual abstraction. The gaze of the portrayed woman remains directed off-screen, thus testifying to a dimension of mysterious and enigmatic isolation.

Wigry, Poland / Blue Mountains, Australia,
1988–1989
video, color, black and white, sound,
13 min. 06 sec.
Purchased with the contribution of the
Compagnia di San Paolo

Wigry, Poland, 1989
video, color, sound, 6 min. 50 sec.
This study of reflections of light and shadow on
water is accompanied by the sounds of trickling
water. The monochrome atmosphere suggests a
mysterious, almost abstract painting.
Blue Mountains, Australia, 1988
video, color, sound, 6 min. 16 sec.
The landscape depicted in *Blue Mountains* stands
out immobile and the image gradually comes to a
stop while the sound continues.

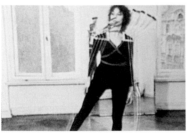

Federn tanzen auf den Schultern (Feathers Dance on the Shoulders), 1974–1975
A costume with feathers is applied to the body of a female dancer. The movements of the feathers follow the rhythm of the music played in the background.

Die untreuen Beine festhalten (Keeping Hold of Those Unfaithful Legs), 1974–1975
The artist and a partner wear bands with magnets on one of their legs. Every now and then the union of their bodies transforms them into a being with three legs that walks in the studio.

Zwei Fischchen, die sich an einen Tanz erinnern (Two Little Fish Remember a Dance), 1974–1975
Two plastic fish are filmed on a man's chest: the motion of his body's hairs evoke a bed of algae.

Räume berühren sich in Spiegeln (Rooms Meet in Mirrors), 1974–1975
The possibility of the existence of the invisible is investigated through a play of mirrors. The effect is

obtained by wearing small mirrors and looking at one's own image reflected on large wall mirrors.

Zwischen den feuchten Zungenblättern die Haut abstreifen (*Shedding Skin between Moist Tongue Leaves*), 1974–1975
The metamorphosis of a woman into a vegetal and animal creature.

Mit zwei Scheren gleichzeitig die Haare schneiden (*Cutting One's Hair with Two Scissors Simultaneously*), 1974–1975
The artist is filmed while cutting her red hair. The points of the two pairs of scissors come dangerously close to her eyes.

Wenn die Frau und ihr Geliebter auf der Seite liegen, sich ansehn, und sie mit ihren Beinen die Beine des Mannes umschlingt - bei weit geöffnetem Fenster - ist es die Oase (*When a Woman and Her Lover Lie on One Side Looking at Each Other, and She Twines Her Legs around the Man's Legs with the Window Wide Open, This Is the Oasis*), 1974–1975
In conformity with her interest for Surrealism, at the conclusion of the exercises Horn cites part of a passage of *L'immaculée conception* by Paul Éluard and André Breton.

Der Eintänzer, 1978
transferred from 16 mm film, color, sound, 47 min.
Purchased with the contribution of the Compagnia di San Paolo
In the film, the artist rents her studio during the summer months to a dance school. A blind man, ballerinas, a couple of twins, and a Japanese cook are the main protagonists. Their film characters are developed in virtue of their interactions and relationship with the artist—absent but present thanks to her objects. The story is set in Horn's studio in New York, a place that was often rented to strangers due to her long trips to Europe.

La Ferdinanda - Sonate für eine Medici Villa (*La Ferdinanda - Sonata for a Medici Villa*), 1981
transferred from 35 mm film, color, sound,
85 min.
Purchased with the contribution of the
Compagnia di San Paolo
Filmed in the Renaissance Medici Villa of Cento
Camini in Tuscany in a context rich of historical
memories, the film condenses the complex
vicissitudes of various characters who surround
the protagonist, Caterina de Dominicis. A former
opera star, the woman retreats to the villa once a
year. The roles of the various characters—the
doctor, the nurse, the ballerina, and the musician,
who also appear in Horn's other full-length
films—contribute to making the artist's imagery
tangible. Machines possessing kinetic, sound, and
emotive properties take part in the evolution of
the plot.

Buster's Bedroom, 1990
transferred from 35 mm film, color, Dolby Stereo
sound, 104 min.
Purchased with the contribution of the
Compagnia di San Paolo
Questing for a connection with the spirit of
Buster Keaton, the protagonist, Micha Morgan,
arrives at Nirvana House, a psychiatric clinic
where the actor was interned and which now
hosts patients with peculiar pathologies. The
young woman's trip exposes her to a surreal
universe in which the obsessions of the
protagonists become muddled with reality. An
actor, director, and writer, known for his
melancholy comedy verging on the absurd,
Keaton often used in his films machines he
himself invented. His ability to make these
otherwise inanimate mechanisms vital is a source
of fascination for Horn.

JOAN JONAS
(New York, 1936)

After her studies in sculpture and art history and dance courses held by Trisha Brown, Joan Jonas turned to performance and outdoor action at the end of the sixties. In 1972, she was among the first artists to incorporate in real time a video camera and monitor (for *Organic Honey's Visual Telepathy*) in performances dedicated to the theme of female identity.

In that same year, she began to produce videos that investigate the possibilities of the medium in relation to the gestural scores of the performer and to the space of the performance. These works are centered around the connection between the performance and its reproduction on a monitor, which is used not only as a mirror, but also as a means of recording capable of exploring the many dislocations in physical space and of interweaving the representations of female archetypes.

Jonas' investigations of female subjectivity are structured by a complex and vast repertory of gestures and self-representations influenced by the rarefied stylization of Eastern culture, especially Japanese and Indian theater and dance. Using masks, costumes, veils, and sometimes staging authentic "masquerades," Jonas has expressed an interest in the representative codes of female gestures through a continuous process of overlapping and interweaving that, over the years, has also included fairy tales and legends. The use of mirrors and video, which in time were transformed into large video installations, has contributed to visually enriching the sets of her performances, which can be read as a theater of the body and the subconscious. From her first experiments of confrontation with the audience in which video was adopted as a mirroring technique up to the more densely narrative works of recent years, which reveal a more complex use of audiovisual technologies, the artist has always been a performer in all of her works, inviting the observers to take part in an enigmatic rite of self-discovery and analysis. [F.B.]

Wind, 1968
transferred from 16 mm film, black and white,
silent, 5 min. 37 sec.
Purchased with the contribution of the
Compagnia di San Paolo
Filmed among snowy fields and the seashore in
the presence of an incessant and impetuous wind,
the video stages a series of choreographies
created by a group of performers who carry out
actions hindered and slowed by the strong wind.

Duet, 1972
video, black and white, sound, 3 min. 49 sec.
Purchased with the contribution of the
Compagnia di San Paolo
Face-to-face with her video-recorded portrait,
Jonas performs a duet with herself. The work
explores the phenomenology of the video image
as mirror and "reality."

Left Side Right Side, 1972
video, black and white, sound, 8 min. 50 sec.
Purchased with the contribution of the
Compagnia di San Paolo
Through a series of inversions and reflections
with the use of a mirror, Jonas manipulates her
own image on the screen, thereby addressing
notions of representative ambiguity.

Organic Honey's Visual Telepathy, 1972
video, black and white, sound, 17 min. 24 sec.
Purchased with the contribution of the
Compagnia di San Paolo
In this video, which is based on the performance
of the same name, Jonas moves and acts both as
the subject and as her masked double: Organic
Honey, an alter ego with the face of a doll. The
work stages an enigmatic ritual dealing with
female identity and archetypes.

Organic Honey's Vertical Roll, 1972
video, black and white, sound, 19 min. 38 sec.
Purchased with the contribution of the
Compagnia di San Paolo
In using an interrupted electronic signal as the
dynamic modality of representation, the space,
the frame, and the image of the video show
discontinuity. This form of disturbance fractures
the recognizability of the performer's body, which
exotically dressed and masked reveals itself as an
impossible self-portrait.

Songdelay, 1973
transferred from 16 mm film, black and white,
sound, 18 min. 35 sec.
Purchased with the contribution of the
Compagnia di San Paolo
Filmed with a large cast, the work shows a series
of choreographies intended as a theater of space,
movements, and sound. The ultimate protagonist
is the vast urban landscape of New York.

Three Returns, 1973–1974
video, black and white, sound, 13 min. 14 sec.
Purchased with the contribution of the
Compagnia di San Paolo
A boy playing bagpipes walks in the landscape
and progressively approaches the video camera.
Each successive "return" directs the attention of
the spectator towards the changes of the sounds
in relation to the surroundings.

Barking, 1973–1974
video, black and white, sound, 2 min. 20 sec.
Purchased with the contribution of the
Compagnia di San Paolo
A car is parked near a house in a rural landscape
of Nova Scotia. A dog barks into the distance.
Within a suspended atmosphere a woman enters
the frame to investigate the dog's agitation. She

then moves away. The action is followed by a panoramic view of the landscape.

Disturbances, 1974
video, black and white, sound, 11 min.
Purchased with the contribution of the Compagnia di San Paolo
Like Narcissus, the artist leans over water. Through a series of close-ups the observer only sees reflected and distorted images on the water's surface. Some figures walking on the edge of the water are perceived as almost abstract shimmerings, shadow figures who appear to be dancing.

Good Night Good Morning, 1976
video, black and white, sound, 11 min. 38 sec.
Purchased with the contribution of the Compagnia di San Paolo
During a period spent in New York and Nova Scotia, the artist portrays herself every day, addressing the video camera with a quick "Good Morning" or "Good Night" each time she wakes up and goes to sleep. This self-portrait, filmed over a period of time, evolves into a sort of diary that is both intimate and aloof. This video was conceived for a screen placed at the side of the observer in such a way as to re-create a space similar to a mirror.

Mirage, 1976
transferred from 16 mm film, black and white, silent, 31 min.
Purchased with the contribution of the Compagnia di San Paolo
In this film, from a performance presented at the Anthology Film Archives in 1976, Jonas draws images on sheets and blackboards that she then erases: a continuous process of adding and erasing, transforming and squandering energy.

I Want to Live in the Country (And Other Romances), 1976–1977
video, color, sound, 24 min. 06 sec.
Purchased with the contribution of the
Compagnia di San Paolo
The artist is seen observing private video images
that are metaphorically tied to memories read
from her diary. The studio images, including still
lifes of archetypal objects, are alternated with
Super 8 film shots that nostalgically evoke the
daily rhythms of the countryside, the rural
landscape of Nova Scotia, the ocean, and a farm.

Volcano Saga, 1989
video, color, sound, 28 min.
Purchased with the contribution of the
Compagnia di San Paolo
Based on the thirteenth-century Icelandic saga
Laxdaela Saga, in a description similar to a
reverie, this work narrates the story of a female
character, Gudrun, who possesses supernatural
powers. In fact, her dreams predict the future.
Jonas mixes the story with images of the island's
volcanic landscapes, combined with a first-time
use of a series of digital special effects. Thus the
artist creates associations between landscapes and
psychological states of unusual and striking visual
and oneiric force.

WILLIAM KENTRIDGE
(Johannesburg, 1955)

The question of historical memory is one of the themes that animates William Kentridge's art. His analysis is carried out in that dark, obscure area he calls "dulling," a condition of numbness regarding the ability to experience the intensity of emotions and memories, whether these be personal or collective. This sense of loss is transmitted by the artist in an extensive body of works that includes drawings, engravings, sculptures, films in 16 mm and 35 mm, digital videos, tapestries, bronzes, and works for the theater. The variety of the technical choices corresponds to the scope of Kentridge's interests and, at the same time, to his declared lack of certainties, his continuous search for a model of flexible thought, and the profound political and social changes currently underway.

The dramatic tensions that characterized the years of Apartheid in South Africa, together with the contradictions that have marked the difficult course of reconciliation, are the contexts within which many of his works have been created. Starting in 1989, in particular, he made short animated films he defines as "drawings for projection." Denunciatory works, their subject matter is the rise and successive fall of Soho Eckstein, a white entrepreneur who built a real estate and mining empire. Running parallel are the vicissitudes of Felix Teitlebaum, dreamer and sensitive man, who can be identified as the artist's alter ego.

As opposed to animated drawings, where an enormous number of sketches are used, Kentridge draws, erases, and then redraws an image, using an extremely limited number of sheets, filming the various phases. The process of this technique corresponds to the artist's vision. The centrality entrusted to the act of erasing alludes to amnesia with regards to injustices that in Kentridge's opinion afflict contemporary mankind. This existential suffering is expressed in later works by including documentary sequences that, by being alternated with drawings, possess a strong self-critical value.

His videos in the nineties gradually became dominated by introspection. Together with personal scenarios and reflections concerning his own role as an artist, in these works there is the recurrent presence of images of medical pathologies, metaphors of the country's illness and the process of the elaboration of blame in the years following Apartheid. [M.B.]

7 *Fragments for Georges Méliès*, 2003
video projection, 16 mm and 35 mm film based
on live-action film, video and animated drawing,
transferred to video and DVD, sound, 14 min.
50 sec.
Castello di Rivoli Museum of Contemporary Art,
Rivoli-Turin
In accordance with the centrality Méliès has
throughout his production, the piece is a tribute to
the famous film pioneer and is centered on the
image of Kentridge at work in his studio. The
description of the creative process, of the various
phases of elaboration and the afterthoughts is staged
with great use of reversal and inversion techniques,
thanks to which the images are shown in reverse
order with respect to how they were originally shot.
Invisible Mending
video projection, 16 mm and 35 mm film based on
live-action film, video and animated drawing,

transferred to video and DVD, sound, 1 min. 30 sec.
Once again unified due to a reversal effect, a
large, torn piece of paper recomposes the self-
portrait of the artist with a brush in his hand.
Balancing Act
video projection, 16 mm and 35 mm film based
on live-action film, video and animated
drawing, transferred to video and DVD, sound,
1 min. 20 sec.
The act of climbing a ladder provokes an
inevitable fall.
Tabula Rasa I
video projection, 35 mm film including live-action
film and animated drawing, video, transferred to
video and DVD, sound, 2 min. 50 sec.

At his worktable the artist draws and erases:
abstract signs are alternated with the
appearance of his own portrait as he is thinking.
His companions here are a coffeepot and
various cups of coffee.
Tabula Rasa II (Good Housekeeping)
video projection, 35 mm film including live-action
film and animated drawing, video, transferred to
video and DVD, sound, 2 min 10 sec.
Due to the reversal effect, a piece of paper
stained with coffee becomes perfectly white
again.

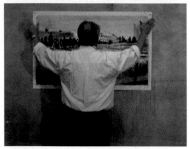

Moveable Assets
video projection, 35 mm film including live-action
film and animated drawing, video, transferred to
video and DVD, sound, 2 min. 40 sec.
The artist hangs a landscape drawing on the
wall: alternately, it is finished or erased and
reduced to a sheet lacking recognizable signs.
Auto-Didact
video projection, 16 mm film including live-action
film and animated drawing, video, transferred to
video and DVD, sound, 2 min. 30 sec.

With his hands in his pockets Kentridge walks
and thinks. Pieces of paper and numerous books
gradually return into his hands.

Feats of Prestidigitation
video projection, 35 mm film including live-action
film and animated drawing, video, transferred to
video and DVD, sound, 1 min. 50 sec.
The torment of the artist faced by a white sheet
of paper and his attempts to transfer his idea onto
its surface are the subject of this fragment.

Journey to the Moon, 2003
video projection, 16 mm and 35 mm film,
transferred to video and DVD, sound, 7 min. 10 sec.
Castello di Rivoli Museum of Contemporary Art,
Rivoli-Turin
The various elements and materials accumulated
during the weeks of shooting the footage become
the protagonists of an attempted escape. Thus the
coffee-cup is transformed into a telescope and the
coffeepot becomes a spaceship. The most
narrative piece from among the fragments in
which the influence of Méliès' film and Jules
Verne's book are most evident, the video is
accompanied by the music of Philip Miller.

Day for Night, 2003
video projection, 35 mm film, transferred to
video and DVD, sound, 7 min.
Castello di Rivoli Museum of Contemporary Art,
Rivoli-Turin
Produced during the *Fragments'* elaboration, the
idea of the video is the result of an invasion of
ants the artist endured over the summer. The
work is created by filming some ants that follow a
path traced out by Kentridge on a sheet of
drawing paper. Made with sugar, the marks
animated by the ants become letters and images
that pulse with vitality. The inversion indicated in
the title refers to the upheaval of the positive and
negative of the images. This procedure
transforms the white of the paper into a black sky
and the ants into little white points that are
similar to galaxies and constellations.

SHIGEKO KUBOTA
(Niigata, Japan,
1937)

After receiving her diploma in sculpture in Tokyo, Shigeko Kubota studied at New York University. She definitively moved to the United States in 1964.

Kubota discovered video at the beginning of the seventies thanks to her involvement with the Fluxus movement and such protagonists as Nam June Paik, Allison Knowles, Allan Kaprow, and George Maciunas. Her early works also show her interest in the theories of Marcel Duchamp and John Cage.

In 1972, she made *Europe on 1/2 Inch a Day*, her first video-diary, while she also explored the possibilities of image transformation and manipulation offered by the technical media available at the most advanced laboratories of television production studios.

Dedicated to diverse themes although often interconnected, her works include installations that pay homage to Duchampian ideas and icons as well as references to the Japanese spiritual traditions tied to nature

and landscape, often focusing on the presence of water and mountains. Her diary project, which documents her own life on video, is a work in progress. It is collectively entitled *Broken Diary*.

Through the observations she dedicates to situations and facts of daily life, Kubota has raised issues regarding the quest for an identity and a female perspective. In her oeuvre, references to the history of art and culture are mixed with the technological component and the resulting images are often electronically elaborated. [F.B.]

Europe on ¹/₂ Inch a Day, 1972
video, black and white, color, sound,
30 min. 48 sec.
Purchased with the contribution of the
Compagnia di San Paolo
Filmed spontaneously and often adventurously, these first video-diaries are the result of the artist's trips and interests, in contact with alternative cultures of the early seventies in Europe. The diary culminates in a homage to the grave of Marcel Duchamp in Paris.

Marcel Duchamp and John Cage, 1972
video, black and white, sound, 28 min. 27 sec.
Purchased with the contribution of the
Compagnia di San Paolo
Kubota offers a heartfelt homage to the two great twentieth-century masters, electronically elaborating photographs of Duchamp and creating her soundtrack with music by Cage. The nucleus of the work is dedicated to the images of the famous chess-concert game played by Duchamp and Cage in 1968 in which the chessboard was "amplified" in such a way as to act as a musical instrument that generated sounds.

Video Girls and Video Songs for Navajo Sky, 1973
video, black and white, color, sound,
31 min. 56 sec.
Purchased with the contribution of the
Compagnia di San Paolo
This work is a fusion and electronic elaboration
of synthesized images and documentary footage.
Created during a sojourn by Kubota at a Navajo
reserve in Arizona, this video presents the women
of the Indian families, with other material shot in
Tokyo, Europe, and New York.

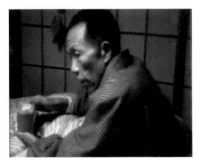

My Father, 1973–1975
video, black and white, sound, 15 min. 24 sec.
Purchased with the contribution of the
Compagnia di San Paolo
Kubota offers a tribute to her dead father by
narrating the last days of his life. In this attentive
and delicate work, television emerges as the
preferred medium between Kubota and her
father, specifically through Japanese music
broadcasts. The music provides an estranging
accompaniment to the artist's personal tragedy.

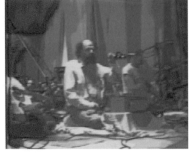

Allan 'n' Allen's Complaint, 1982
in collaboration with Nam June Paik
video, color, sound, 28 min. 33 sec.
Purchased with the contribution of the
Compagnia di San Paolo
The influence of fathers over their children and
the complexity of the relationships in a Jewish
family are the bases of this penetrating and
touching portrait of two artists: the Beat poet
Allen Ginsberg (whose father Louis was also a
poet) and the sculptor and performance artist
Allan Kaprow (whose father was a prominent
lawyer). Both artists are presented in their
relation and opposition to the strong influences
exerted by the patriarchal figures. The video
unfolds through a series of visual and spatial

transformations; the images multiply and proliferate, the speed is accelerated or slowed, while the audio is intentionally unsynchronized.

Rock Video: Cherry Blossom, 1986
video, color, silent, 12 min. 54 sec.
Purchased with the contribution of the Compagnia di San Paolo
In an intense and lyrical fusion of nature and technology, Kubota describes and re-elaborates images of the branches and flowers of a pink cherry tree set against a vividly blue sky, thereby managing to create the equivalent of a visual Haiku. Through a sophisticated, subtle, and fluid use of electronic elaborations, Kubota superimposes, digitizes, slows, recolors, and arrives at abstracting the images of the cherry flowers, thus creating a poetic transmutation of space and image.

George Maciunas with Two Eyes 1972, George Maciunas with One Eye 1976, 1994
video, black and white, sound, 7 min.
Purchased with the contribution of the Compagnia di San Paolo
Taken from the recordings of Kubota's video-diary, in the first part Maciunas is filmed while walking past some buildings in SoHo and commenting on them with some friends (including Nam June Paik, Barbara and Peter Moore, and Yoshi Wada). The setting of the second part of the work is the inauguration of the solo exhibition of Ben Vautier in 1976 at the Guggenheim Museum in New York.

Berlin 1990, 1990
video, color, sound, 20 min. 35 sec.
Purchased with the contribution of the
Compagnia di San Paolo
Filmed after the fall of the Berlin Wall, this video
shows the atmosphere in the German metropolis
immediately after its reunification. The images
focus on the inhabitants crossing the infamous
checkpoints still guarded by soldiers, street
vendors offering food and fragments of the Wall,
all while the results of the elections, which would
open the path to a "new" Germany, are
announced.

Bestiaire (Bestiary), 1985–1990
video, color, sound, 9 min. 04 sec.
Purchased with the contribution of the
Compagnia di San Paolo
Chat écoutant la musique (Cat Listening to Music)
video, color, sound, 2 min. 47 sec.
Marker portrays his own cat comfortably curled
up while listening to his favorite music,
compositions by Mompou played by the artist
himself.
An Owl is an Owl is an Owl
video, color, sound, 3 min. 18 sec.
This video offers a meditation on the enigmatic
and captivating gaze of an owl, recording its
quick, sudden, and unexpected movements.
Zoo Piece
video, color, sound, 2 min. 42 sec.
Showing animals in a large zoo, the work focuses
on issues of captivity, thereby creating a gradual
sense of emotional desolation and pathos.

Prime Time in the Camps, 1993
video, color, sound, 28 min.
Purchased with the contribution of the
Compagnia di San Paolo
Dedicated to the devastating consequences of war
on civilians, this work documents the life of a
community of Bosnian refugees amidst the ruins
of a former military barracks in Roska (Slovenia).
The video shows the activities of a satellite
broadcasting center, pirating signals from
international channels such as CNN, Radio
Sarajevo, and Sky. The young protagonists relay
their critical attitude towards major television
networks and the level of manipulation regarding
"real facts." At the same time, they state their
intention to create an authentic documentary on
the life of refugees.

Family Tyranny / Cultural Soup, 1987
in collaboration with Mike Kelley
video, color, sound, 15 min. 03 sec.
Purchased with the contribution of the
Compagnia di San Paolo
Family Tyranny (Modeling and Molding), 1987
video, color, sound, 8 min. 08 sec.
Cultural Soup, 1987
video, color, sound, 6 min. 55 sec.
In McCarthy's own words: "I was given access to
a community television studio for two days of
shooting and one day of editing . . . [in order] to
do a video tape on child abuse. I taped for one
day alone and one day with Mike Kelley. I asked
Mike Kelley to be the son and I would be the
father. There was no written script. After taping
for two days I edited the tapes, making two
separate tapes."

Heidi, 1992
in collaboration with Mike Kelley
video, color, sound, 62 min. 40 sec.
Purchased with the contribution of the
Compagnia di San Paolo
The work is a tribute to, as well as a drastic
rereading of, the famous novel *Heidi* by Joanna
Spyri. In this version marked by horrific tones, the
grandfather becomes a monstrous maniac, Peter
seems mentally disturbed, and Heidi is elevated to
the role of a pure little girl.

Fresh Acconci, 1995
in collaboration with Mike Kelley
video, color, sound, 45 min.
Purchased with the contribution of the
Compagnia di San Paolo
Through the presence and bodies of young male
and female models in a setting that is intentionally
glossy and reminiscent of California erotic cinema,
McCarthy restages some videos of the early
seventies by Vito Acconci, including *Claim Excerpts*,
Focal Points, *Pryings*, and *Theme Song*.

Out o' Actions, 1998
in collaboration with Mike Kelley
video, color, sound, 4 min. 25 sec.
Purchased with the contribution of the
Compagnia di San Paolo
Adopting a type of editing similar to the filming
of the 1964 performance by Otto Muehl entitled
Mama und Papa, this work records the installation
process of the work made by McCarthy and
Kelley for the exhibition held at the MOCA in
Los Angeles, *Out of Actions: Between Performance
and the Object 1949–1979*.

JONAS MEKAS
(Semeniskiai,
Lithuania, 1922)

Following the traumatic experiences of internment in concentration camps during World War II, Jonas Mekas, together with his brother Adolfas, decided to leave for the United States. They arrived in New York as political refugees. As a poet, writing in his native Lithuanian language during the fifties, he became well-known and was awarded various prizes for his works.

Parallel to his writing he became interested in experimental cinema, leading the organization of film screenings and festivals. He also developed an interest in writing and shooting his own films. He quickly distinguished himself as the most important reference point for the American underground film scene by founding the Filmmakers' Cooperative. In some essays, published between 1955 and 1962 in *Film Culture*, a review created by Mekas, he faced the question of the relationship between criticism and new American cinema. He announced the birth of a new cinematic form, free from economic or stylistic limitations, ready to challenge the notion of the new "modern man." This new form had to establish itself beyond the numerous existing genres, from realistic and political films to poetic cinema. Within New American Cinema, Mekas' work can be recognized above all by the passion and dedication that led him to become a public figure.

His film production is distinguished by a gradual interest in first-hand experience, and in this sense, he uses cinema to document everyday situations. After a number of years working with narrative structures and *mise en scène*, in the late sixties he began to elaborate the considerable quantity of film material accumulated since 1949. This resulted in film-diaries, works that grouped the various material in compositions of a broader temporal perspective.

Most of his works juxtapose independent edits, filmed with different speeds using the single frame technique, which is based on the recording of an image at one photogram per second rather than the usual twenty-four. Besides distancing the spectator from the image, this technique creates color and focus distortions, double exposure, and continuous movement of the image. The editing was mostly carried out while shooting, with the accumulation of sequence upon sequence.

Mekas' film-diaries can be read as scattered pages of a single story: through the memories of forty years in the life of an

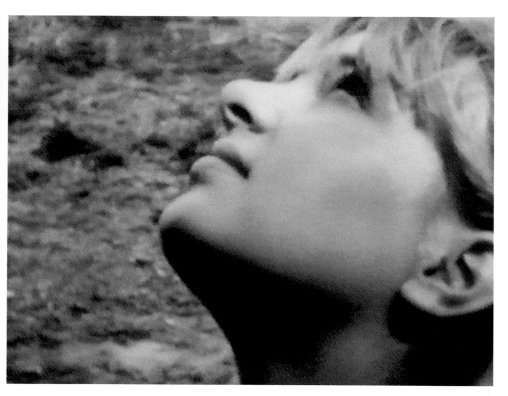

artist who, through the art of filming, created a better life for himself. Scenes of daily life, portraits of acquaintances, family members, friends, colleagues, private moments, and public scenes compose an extraordinary body of work that assembles decades of American avant-garde. [F.B.]

Walden - Diaries, Notes and Sketches, filmed between 1962 and 1968, edited in 1972 transferred from Super 8 and 16 mm film, black and white, color, 180 min.
Purchased with the contribution of the Compagnia di San Paolo
Lost, Lost, Lost - Diaries, Notes and Sketches, filmed between 1949 and 1963, edited in 1976 transferred from Super 8 and 16 mm film, black and white, color, 180 min.
with Jonas Mekas, Adolfas Mekas, Ken and Flo Jacobs, P. Adams Sitney, Gregory Markopoulos,

Allen Ginsberg, Frank O'Hara, LeRoi Jones, Robert Frank, Julian Beck, Judith Malina, Salvador Dalí, Tiny Tim, Ed Emshwiller, Storm de Hirsch, Barbara Rubin, Andy Warhol, Peter Bogdanovich, Shirley Clarke, and Taylor Mead After *Walden*, which represents an authentic letter written from exile, full of old and new memories and the first film to be edited, *Lost, Lost, Lost* is instead a diary of transition in which the idea of loss prevails. It begins with the memories of the most desperate period immediately following Mekas' move to America. The work describes the artist's solitude and concludes when Mekas is finally reconciled with his past, ready for a new beginning.

Scenes from the Life of Andy Warhol, filmed between 1965 and 1982, edited in 1991 transferred from 16 mm film, black and white, color, sound, 38 min.
Purchased with the contribution of the Compagnia di San Paolo
Distributed in the nineties, the work contains footage previously released in other film-diaries. The work gives a portrait of the entire cultural élite that formed Andy Warhol's circle.
Using the single frame technique, the editing consists of explicative titles, whereas the soundtrack uses music of the period, including live recordings of the Velvet Underground, together with live-recorded voices.

Three Friends / Trois Amis
a box containing two videos transferred from 16 mm film and a book
Purchased with the contribution of the Compagnia di San Paolo
The volume entitled *Fluxfriends*, which is included with the videos, offers a comprehensive idea of the Fluxus years, focusing on the friendship of four of its protagonists: George Maciunas, Yoko Ono,

John Lennon, and Jonas Mekas. It is presented as an "editing book," with reference to the film technique, and is made up of archive material, interviews, texts, and excerpts from personal diaries.

Zefiro torna (Or Scenes from the Life of George Maciunas), 1992
transferred from 16 mm film, black and white, color, sound, 34 min.

Zefiro torna contains film footage shot between 1952 and 1978. It begins with brief and rapid images in black and white of Maciunas and his family together with Mekas, accompanied by music from *Zefiro torna* by Monteverdi in the background (the composer Maciunas liked most). When the music ends, the melancholic voice of Mekas reading passages describing the personality of George Maciunas is heard. At the same time, announced by a title, footage of the artist is shown in various public situations, including Fluxus exhibitions, parties, gatherings, and meetings up until the day of his marriage. The second part of the film assembles more personal and private sequences of Maciunas' life: a party, his marriage with Oona, their wedding reception, hospital scenes, his death, his funeral, and his cremation.

Happy Birthday to John, 1995
transferred from 16 mm film, color, sound, 18 min.
Purchased with the contribution of the Compagnia di San Paolo
On October 9, 1972 friends of Yoko Ono and John Lennon—including Ringo Starr and Allen Ginsberg—came together to celebrate Lennon's birthday. This video documents that event, including the improvised songs performed for the occasion. The subsequent images document the party for John and Yoko organized by their agent Klein on June 12, 1971 and the concert held at Madison Square Garden in August 1972. The film ends with images recorded on December 8, 1980, the day Lennon was killed.

**TRACEY MOFFATT
(Brisbane, Australia,
1960)**

Following studies in cinematography and experience in documentary production, Tracey Moffatt evinced a strong interest in a reinterpretation of the evocative power of images: not natural or candid images, but those constructed in relation to precise historical models.

Her work is characterized by an original approach to narrative cinema conventions. Alongside a rich photographic production staged in a refined way, there are film and video works. Moffatt's oeuvre is distinctive thanks to a complex intermingling of subjective memories and elements drawn from the specific social, geographical, and cultural context of Australia. This sensitivity is always filtered by an awareness and knowledge of the world, and the history of cinema and photography, starting with the nineteenth century.

Unconcerned with the traditional distinctions among photoreportage, documentary, and theatrical staging, Moffatt has elaborated an investigation that attempts to recompose fragmentary sensations and sentiments into a vaster and more extensive dream. At the base of her multiform artistic experience there are composite cultural elements ranging from religious or mythological allegories to the sense of the unexpected, provided by the encounter of contemporary and indigenous cultures.

After her debut in the second-half of the eighties, she arrived at professional cinema production in 1993 with *Bedevil*. This film, created with a sequence of episodes, shot with 35 mm film and a considerably large cast, allowed her to fully express her vision. [F.B.]

Heaven, 1987
video, color, sound, 28 min.
Castello di Rivoli Museum of Contemporary Art,
Rivoli-Turin
Working from a series of shots taken by the artist
near beaches, the video presents a number of
brief interviews with surfers after a day at the
beach. The general tone of the video—
documentary-like in its immediacy of images and
recorded sounds—is one of a sophisticated,
ironic, and provocative "laying bare," almost
coaxed out of these athletes. The relationship
between the sexes and their respective roles, the
implicit voyeurism, and the subtle border
between secret admiration and intrusiveness are
the distinguishing characteristics of this work.

MEREDITH MONK
(Lima, Peru, 1942)

Raised in a family of musicians and singers, Meredith Monk quickly developed a multi-faceted career as a composer, singer, director-choreographer, and author of new models of musical theater, opera, film, and installation. As the pioneer of an interdisciplinary concept of theater and performance, Monk has created new visual and acoustic worlds found at the meeting point between music and movement, light and sound, in an intimate investigation aimed at renewing modes of listening and perception. It was precisely through the use of her own voice that Monk re-imagined the technical possibilities of vocal expression, creating musical landscapes able to elicit sensations, impressions, and energies.

After graduating from Sarah Lawrence College in 1964, Monk soon became a performer, broadening the range of her singing potential. In addition to this disciplined physical exercise, Monk elaborated her music beginning with a personal revision of various sources, including material studied during years of experimentation, ranging from folk to opera, contemporary music, and influences by artists such as John Cage. In her search for vocal effects and possibilities, she limited her instrumental accompaniment to a piano or percussion. In 1968, she founded her own Company—The House—dedicated to an interdisciplinary approach to performance. In 1978, she established the Vocal Ensemble in order to extend the forms and possibilities of musical research.

During the course of her career she has created examples of new musical theater, both vocal and instrumental, and two fundamental voice cycles. *Our Lady of Late* and *Songs from the Hills* are the titles of these collections of short pieces that constitute a new genre of vocal recital.

Her first film experience in 1982 was *Ellis Island*, a short work dedicated to the heart-rending memories of the people who passed through the immigration offices on the island facing Manhattan. In the second-half of the eighties, Monk produced *Book of Days*, a wide-ranging filmic work using theater costumes. [F.B.]

Book of Days, 1988
transferred from 35 mm film, black and white,
color, sound, 75 min.
Castello di Rivoli Museum of Contemporary Art,
Rivoli-Turin
Her first full-length film whose musical score is
one of the apexes of Monk's vocal technique, this
work also experiments with the possibilities of
multi-track recording. Conceived as a vocal
concert held in 1985 at Carnegie Hall, its scope
has been extended, thereby becoming an intriguing
historical fresco set in the Middle Ages. The film
stresses the analogies among wars, plague, and,
above all, tendencies towards persecution, thus
producing a powerful metaphor of the
contemporary, obsessive fear regarding AIDS.

LILIANA MORO
(Milan, 1961)

After attending the Accademia di Brera (Milan), Liliana Moro took part in the creation of the experimental space on Via Lazzaro Palazzi in Milan and was one of the founders of the magazine *Tiracorrendo*.

From the very beginning her works have challenged art-historical conventions, using a wide variety of techniques including drawing, installation, performance, sculpture, and video. She assigns no hierarchy to these, using all to various degrees in her work.

In fact, the artist prescribes a certain "lowering" of perspective, which is to say a suspension of dogma and convention in adopting a renewed understanding of culture and society. In this sense, she uses objects borrowed from the world of childhood as linguistic instruments. Toys, cartoon and fairy-tale characters together with stories belonging to oral tradition are some materials used by Moro. Easily recognizable, these items are employed for their strong metaphoric connotations. However, these materials are often deprived of their immediate aesthetic characteristics and are, on the contrary, used with rigor and precision. In this way, the artist manages to transform specific situations into more powerful statements, moving away from the autobiographical aspect of her work to a more universal expression. [M.B.]

Aristocratica (Aristocratic), 1994
video, color, sound, 4 min. 55 sec.
Purchased with the contribution of the
Compagnia di San Paolo
Partially masked by a carnivalesque pig snout and
wearing a skull-cap that covers her hair, the artist
is immobile in front of the camera. Although her
identity is partially concealed by the mask and
cap, the artist is posing, as if for a portrait that
seems to allude to a painting by Antonio del
Pollaiolo. The only movement that animates the
video is the involuntary blinking of its subject.
The contrast between the almost hieratic pose
and the self-deprecating disguise is underscored
by the pop music of the Italian group Matia
Bazar. The title of the song is also the title of this
work.

Stamping in the Studio, 1968
video, black and white, sound, 62 min., loop
Purchased with the contribution of the
Compagnia di San Paolo
Nauman walks inside his studio, beating the
rhythm with his feet. His movements are either
diagonal or spiral. The camera is placed upside-
down.

Walk with Contrapposto, 1968
video, black and white, sound, 60 min., loop
Purchased with the contribution of the
Compagnia di San Paolo
At every step taken on a contrapposto pose
Nauman walks along the narrow space of a
corridor made in his studio for the occasion. The
architectural element would later be the basis of
his first installation, focused on the space of a
corridor.

Wall-Floor Positions, 1968
video, black and white, sound, 60 min., loop
Purchased with the contribution of the
Compagnia di San Paolo
The fixed video camera records the actions of the
artist who while remaining inside the field of
vision takes on different positions in relation to
the floor and the wall. Similar exercises—totaling
twenty-eight positions—were carried out by the
artist in a 1965 performance.

Bouncing Balls, 1969
transferred from 16 mm film, black and white,
silent, 9 min.
Purchased with the contribution of the
Compagnia di San Paolo
With an extreme close-up the video records the
action of the artist who touches his testicles with
his hand.

Bouncing in the Corner, No. 2: Upside Down, 1969
video, black and white, sound, 60 min., loop
Purchased with the contribution of the
Compagnia di San Paolo
This video is analogous to the 1968 one with the
same title. In this case, the image shows the body
of the artist with a 180° rotation.

Gauze, 1969
transferred from 16 mm film, black and white,
silent, 8 min.
Purchased with the contribution of the
Compagnia di San Paolo
Filmed with the video camera upside-down, the
video shows Nauman pulling a long strip of gauze
out of his mouth.

Manipulating a Fluorescent Tube, 1969
video, black and white, sound, 62 min., loop
Purchased with the contribution of the
Compagnia di San Paolo
The artist takes on different positions in relation
to a neon tube. The video records actions
previously analyzed in a 1965 performance.

Pacing Upside Down, 1969
video, black and white, sound, 56 min., loop
Purchased with the contribution of the
Compagnia di San Paolo
The artist walks along the sides of a square
designed on the floor, describing perimeters that
become more extended, up to the point of
disappearing from the field of vision. The camera
is upside-down, thus altering the idea of the
ceiling and the floor.

**DENNIS OPPENHEIM
(Electric City,
Washington, 1938)**

Upon completing his studies at Stanford University in Palo Alto, California and after a visit to New York in 1966, Dennis Oppenheim decided to stop creating artistic objects. He moved to New York and up until 1969 he dedicated himself to making large-scale projects centered on interventions in natural settings. The artist engaged in the landscape or the transfer of landscape elements to a radically different space, such as the land works on the two snow-covered banks of the St. John River or the concentric circles imposed on the border between Canada and the United States.

Within a few years he produced a series of open-air actions, key works of the first period of Land Art, and, almost concurrently, developed a series of performances of intense physical involvement, attracting the attention of critics. A precise awareness of the potentials of his body, developed during the creation of numerous Land Art projects, led him to consider it as a malleable field of transformable resistance and energy.

Compression – Fern (Face),
1970

Among the first artists to employ film and video as a means not only of documenting but also of investigating and testing

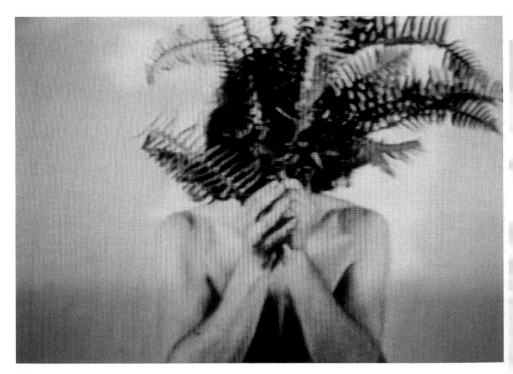

his own physical and psychological limits, Oppenheim, in a vast series of experiments conducted mainly between 1970 and 1974, used his body as a site for challenging limits. Through the transformation and manipulation of materials with his own body, he created performative actions possessing an intense ritualistic component. Using natural elements taken from the environment—such as plants or stones—he developed physical forms of relationships between his own forces and these objects, or directly on the natural environment itself. In his films and videos, the actions are developed in real time. In some exceptional cases, the artist also intervenes in the works' post-production. [F.B.]

Program One: Aspen Projects, 1970
video, black and white, color, silent, 30 min. 15 sec.
Castello di Rivoli Museum of Contemporary Art,
Rivoli-Turin
Material Interchange, 1970
transferred from 16 mm film, black and white,
silent, 2 min. 44 sec.
A close-up of the artist's nail rubbing against a
wooden surface.
Identity Transfer, 1970
transferred from 8 mm film, black and white, silent,
1 min.
The artist records the pressure between a thumb,
an index finger, and finger nails, which in turn leave
a sign on the skin.
Rocked Hand, 1970
transferred from 8 mm film, color, silent,
3 min. 34 sec.
One hand is slowly covered with stones by the
other hand.
Compression - Fern (Hand), 1970
transferred from 16 mm film, color, silent,
5 min. 46 sec.
A fern is slowly crushed inside the hand that holds it.
Pressure Piece #1, 1970
transferred from 8 mm film, color, silent,
1 min. 40 sec.
The fingers of a hand produce pressure and mark
the surface of a mirror covered with condensation.

Glassed Hand, 1970
transferred from 16 mm film, color, silent,
2 min. 56 sec.
A hand is slowly covered with small glass splinters.
Compression - Poison Oak, 1970
transferred from 16 mm film, silent, 2 min. 46 sec.
Analogous to the fern, a red oak flower is slowly
crushed in the hand that holds it.
Compression - Fern (Face), 1970
transferred from 16 mm film, color, silent,
5 min. 22 sec.
Hidden behind a fern he holds, the artist
progressively crushes the entire plant in his hands.
Leafed Hand, 1970
transferred from 16 mm film, color, silent,
3 min. 44 sec.
A hand is progressively and entirely covered with
dry leaves.

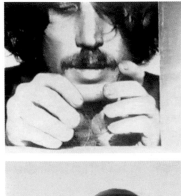

Program Two, 1970
transferred from Super 8 and 16 mm film, color,
silent, 15 min. 08 sec.
Castello di Rivoli Museum of Contemporary Art,
Rivoli-Turin
Extended Armor, 1970
transferred from Super 8 film, black and white,
silent, 2 min. 08 sec.
In a fixed shot, the artist pulls out some hair,
makes a ball with it, and then uses it to inhibit
the movements of a tarantula inside a narrow
wooden container.
Gingerbread Man, 1970
transferred from 8 mm film, black and white,
silent, 1 min. 42 sec.
The artist spreads molasses on his teeth and
proceeds to eat a gingerbread man.
Nail Sharpening, 1970
transferred from 16 mm film, black and white,
silent, 2 min. 57 sec.
A close-up of a toenail sharpened by a stone.

Toward Becoming a Devil, 1970
transferred from 16 mm film, black and white,
silent, 2 min. 20 sec.
The artist methodically sleeks his hair onto his
forehead, hiding his face.
Rocked Stomach, 1970
transferred from 16 mm film, color, silent,
2 min. 48 sec.
Stones placed on the artist's stomach are moved
with muscular contractions.
Fusion: Tooth and Nail, 1970
transferred from Super 8 film, color, silent,
2 min. 58 sec.
Oppenheim brings his fingernails to his teeth and
paints them with red nail polish.

Program Three, 1972–1974
transferred from 16 mm film, black and white,
color, sound, 24 min. 30 sec.
Castello di Rivoli Museum of Contemporary Art,
Rivoli-Turin
Brush, 1973
transferred from 16 mm film, color, sound,
4 min. 56 sec.
An extreme close-up of a brush placed on a
spinning long-playing record playing soul music.
I'm Failing, 1972–1973
transferred from 16 mm film, color, sound,
1 min. 48 sec.
A series of close-ups of air bubbles emitted by the
mouth of the artist who is under water. The view
is blurred by the same bubbles he produces.
My Father's Socks, 1972
transferred from 16 mm film, black and white,
sound, 5 min. 50 sec.
The artist's legs are shown in extreme close-up as
he methodically puts on a series of socks, one
after the other.
Mittens, 1974
transferred from 16 mm film, black and white,
sound, 4 min. 21 sec.
A little girl is engaged in a struggle with her
gloves as though they provoke the continuous

movement of her arms.
Disappear, 1972
transferred from 16 mm film, black and white,
sound, 5 min. 57 sec.
A continuous shot of a right hand frenetically
moving challenges the possibility of recording the
action.

Program Four, 1971–1972
video, black and white, silent, 44 min. 50 sec.
Castello di Rivoli Museum of Contemporary Art,
Rivoli-Turin
Vibration #1, 1971
video, black and white, silent, 13 min. 30 sec.
A lengthy shot from above a membrane that is
made to vibrate by the percussive action of two
hands in such a way as to progressively move dust.
Vibration #2, 1972
video, black and white, silent, 11 min. 24 sec.
With the shadow of his hand the artist mimes the
gesture of destroying a pile of sand that, in
reality, is flattened by concomitant vibrations.
*2 Stage Transfer Drawing (Advancing to a Future
State)*, 1971
video, black and white, silent, 7 min. 42 sec.
Erik, the artist's son, traces out a drawing on his
father's back who in turn tries to duplicate the
drawing on a wall.
*2 Stage Transfer Drawing (Returning to a Past
State)*, 1971
video, black and white, silent, 12 min. 04 sec.
With regards to the previous exercise, the roles
are reversed and the artist draws on his son's back
who in turn tries to reproduce the same drawing
on a sheet of paper.

Program Five, 1970–1971
video and transferred from 8 mm film, black and
white, color, silent, 37 min. 45 sec.
Castello di Rivoli Museum of Contemporary Art,
Rivoli-Turin

Air Pressure (Hand), 1971
video, color, silent, 5 min. 25 sec.
Two close-up shots show the results of strong air
pressure, first on the back and then on the palm
of a hand.

Lead Sink for Sebastian, 1970
video, color, silent, 4 min. 42 sec.
The video shoots a performance in San
Francisco. The protagonist is a man with an
amputated leg. The missing limb is substituted
with a lead prosthesis that, due to the heat of a
torch, gradually melts.

Nail Sharpening, 1970
video, color, silent, 6 min. 02 sec.
A new color version of the unusual, previously
recorded sculptural gesture.
Gingerbread Man, 1970–1971
video, transferred from Super 8 film, black and
white, silent, 8 min. 45 sec.
The artist chews and then swallows a gingerbread
man.
Fusion: Tooth and Nail, 1970
video, transferred from Super 8 film, color, silent,
12 min. 03 sec.
As in the previous version, Oppenheim brings the
nails of a hand to his teeth, although this time he
paints them with nail polish of different colors:
silver, red, blue, and yellow.

Program Six, 1971–1972
video, transferred from Super 8 film, black and
white, color, silent, 27 min. 18 sec.
Castello di Rivoli Museum of Contemporary Art,
Rivoli-Turin
Forming Sounds, 1971
video, black and white, color, silent,
7 min. 14 sec.
In a close-up, a face is manipulated by two hands
that alter vocal emissions.
*2 Stage Transfer Drawing (Advancing to a Future
State)*, 1971
transferred from Super 8 film, color, silent,
2 min. 48 sec.
A new color version of the drawing exercise
previously recorded in black and white.
*2 Stage Transfer Drawing (Returning to a Past
State)*, 1971
transferred from Super 8 film, color, silent,
2 min. 57 sec.
A new color version of the drawing exercise
previously recorded in black and white.
A Feedback Situation, 1971
transferred from Super 8 film, color, silent,
3 min. 02 sec.

Oppenheim and his son simultaneously draw on each other's back without seeing the results.
3 Stage Transfer Drawing, 1972
transferred from Super 8 film, color, silent, 3 min. 07 sec.
The artist draws a series of shapes on the back of his daughter, Chandra, which the little girl then draws on the back of her brother who, in turn, tries to reproduce them on a sheet of paper placed in front of him.
2 Stage Transfer Drawing (Returning to a Past State), 1971
transferred from Super 8 film, color, silent, 3 min.
A further version of the drawing exercise carried out by father and son.
Objectified Counterforces, 1971
video, color, silent, 2 min. 06 sec.
Erik and Kristin Oppenheim have a sack race.
Shadow Project, 1971
video, color, silent, 3 min. 04 sec.
The hands of the artist rapidly produce a series of Chinese shadows on a wall.

Program Seven, 1968–1972
video, transferred from Super 8 film and from 35 mm slides, black and white, color, silent, 27 min. 19 sec.
Castello di Rivoli Museum of Contemporary Art, Rivoli-Turin
Feedback, 1971
video, black and white, silent, 1 min. 50 sec.
The artist mimes the letters of the alphabet on his daughter Kristin's back.
Extended Expressions, 1971
video, black and white, silent, 5 min. 05 sec.
Oppenheim and his son Erik are shot in close-up, imitating each other by making faces.
Ground Gel, 1972
transferred from a 35 mm slide, color, silent, 6 min. 50 sec.
In a film composed of still-images, one dissolving into the next, a human figure spins a little girl

round while holding her arms.

Air Pressure (Hand), 1972
video, black and white, silent, 6 min. 37 sec.
The results of strong air pressure are shown on a hand.

Landslide, 1968
transferred from Super 8 film, color, silent,
2 min. 55 sec.
The work consists in a sequence of shots of landslides filmed in Long Island.

Preliminary Test for 65° Vertical Penetration, 1970
transferred from Super 8 film, color, silent,
3 min. 37 sec.
In a series of shots, from a distance and in close-up, the artist lets himself slide down a landslip hill.

Arm Scratch, 1970
transferred from Super 8 film, color, silent,
1 min. 56 sec.
The focus is on the continuous image of a hand scratching an arm.

Identity Transfer, 1970
transferred from Super 8 film, black and white,
silent, 4 min. 24 sec.
Two thumbs and thumbnails touch and rub each other, rotating and marking each other with black ink.

Program Eight, 1969–1972
video, transferred from Super 8 film, black and white, color, silent, 28 min. 44 sec.
Castello di Rivoli Museum of Contemporary Art, Rivoli-Turin

Go-Between, 1972
video, black and white, silent, 6 min. 15 sec.
While seated, Oppenheim and his family touch each other and cross their arms and legs.

Stewing Around, 1972
video, black and white, silent, 3 min. 37 sec.
In a series of still images, the artist rotates a weight around himself.

Whipping into Shape, 1972
video, color, silent, 5 min. 35 sec.
With whip lashes the artist tries to give form to

some objects and wooden rods placed on the ground.

Landslide #2, 1972
transferred from Super 8 film, black and white, silent, 6 min.
Further shots of stones rolling down a hill.

Parallel Arcs, 1970
transferred from Super 8 film, black and white, silent, 2 min. 35 sec.
Oppenheim progressively lets himself fall frontwards, dragging with him a young tree that is tied to his belt.

Broad Jump, 1969
transferred from Super 8 film, black and white, silent, 2 min. 20 sec.
Fixed framing records the artist jumping over a line.

Slow Punch, 1970
transferred from Super 8 film, black and white, silent, 1 min. 02 sec.
A slowed sequence of punches to a stomach.

Rocks in Navel, 1970
transferred from Super 8 film, black and white, silent, 2 min.
A series of close-ups of small pebbles placed on a bare navel.

TONY OURSLER
(New York, 1957)

Since the mid-seventies, Tony Oursler has created a vast oeuvre comprising installation, painting, sculpture, performance, and video. In his installations, figures of heads, puppets, and dolls are animated by video projections with a narrated voice-over. Prior to this, spanning a period of twenty years, the artist created a large production of videos characterized somewhere between the visionary and the hallucinatory.

Oursler's videos form oblique and sinister narrations with often bizarre, obsessive tones and atmospheres. They pay tribute to German Expressionist cinema and the vigorous Neo-Figurative painting of the late seventies and early eighties. The persistence of an unmistakable dark hum or is mixed with *mise en scène* of a distinctive and theatrical artificiality.

A veritable miniature universe, created and painted by hand, mixed with scenes of animation and projections, forms the stage of Oursler's personal narrative re-interpretation. Influenced by a post-punk sensibility, characterized by the presence of narrating voices often off-screen, and by an affinity for disturbing sound collages, his production suggests an atmosphere of oneiric states or trances.

The playful and ironic approach to assembling heterogeneous materials from an enormous mass of cultural and subcultural artifacts is tied to an interest in those adolescent fantasies, dreams, and obsessions, at times also macabre and frightful, found in Western society.

An uninhibited penchant for forms of simulation and parody of cinema and electronic special effects often leads him to results that are ironically self-referential and recognizable in their ability to reveal the mechanisms of illusion. His themes and references range from an interest in psychotic states, sexual frustration, and alienation to forms of mania, hysteria, and violence through the fundamental dichotomies of Good and Evil, life and death.

In the late eighties, his growing interest in technology has led Oursler to investigate the most buried and repressed aspects of the human psyche and imagination so as to create forms of social analysis and criticism. [F.B.]

Sucker, 1987

184

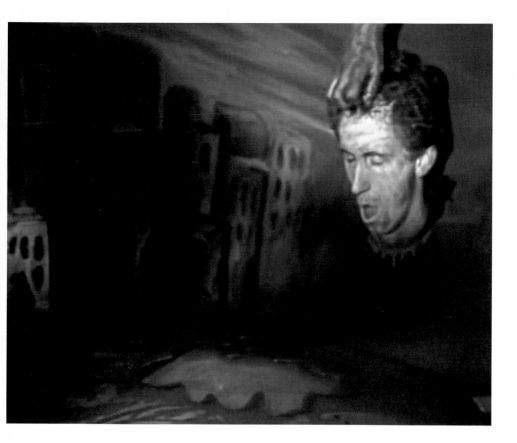

Selected Works, 1979
video, black and white, sound, 34 min. 20 sec.
Purchased with the contribution of the
Compagnia di San Paolo
Diamond (Head), 1979
video, black and white, sound, 13 min. 52 sec.
In a vast assortment of objects and drawings
filmed in close-up, images of vaguely identifiable
characters—a head and other anthropomorphic
figures—become visible.
Good Things and Bad Things, 1979
video, black and white, sound, 11 min. 51 sec.
This work is composed of a series of scenes
similar to vignettes, in which faces and figures
appear in succession, a hand indicates—and
dirties—the pages of an open book, and a face is

literally torn to pieces by six arms.

Life, 1979
video, black and white, sound, 9 min. 17 sec.
In a series of short "animated" scenes, we observe the labored growth of a small plant in front of a building and the disturbing destinies of some insects placed in small, transparent plastic tubes.

The Weak Bullet, 1980
video, color, sound, 12 min. 41 sec.
Purchased with the contribution of the Compagnia di San Paolo
In a painterly setting with dark and sinister shades, a bullet fired by small figures travels, entering other situations. The bullet kills a would-be suicide, straightens an antenna, and penetrates the body of a woman.

Grand Mal, 1981
video, color, sound, 22 min. 36 sec.
Purchased with the contribution of the Compagnia di San Paolo
Beginning with an image of a device in a phase of emergency, this video accumulates images that are particularly gloomy and expressionistic in a crescendo of anxieties addressing themes of sex and death, passing among visions of terrorizing metropolises and the Garden of Eden.

Son of Oil, 1982
video, color, sound, 16 min. 08 sec.
Purchased with the contribution of the Compagnia di San Paolo
In this video, the "machine" of the human brain is in crisis. Somewhere between signs of panic and hopelessness, Oursler depicts the story of a modern hero, played by an actor, who is obsessed with ghostly voices that bring him to the point of

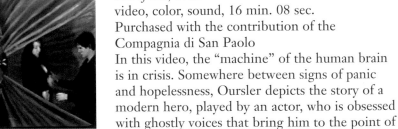

alienation, amidst scenes of urban and industrial decadence.

Diamond: The 8 Lights (Spheres of Influence), 1985
video, color, sound, 53 min. 47 sec.
Purchased with the contribution of the
Compagnia di San Paolo
Produced parallel to the large multi-media
installation of the same name, created for the
Centre Pompidou in Paris, this video articulates a
series of oneiric and often almost horrific scenes.
The work shows human figures at the mercy of
spirits and sinister presences. It alternates
animated figures with the corporeal presences of
actors immersed in dark and supernatural
scenarios.

Sucker, 1987
video, color, sound, 5 min. 33 sec.
Purchased with the contribution of the
Compagnia di San Paolo
Consecutively, this brief work shows a series of
frightful images and situations that mix sacred
images and iconography with visions of violent
death and blood—all against pictorial
backgrounds of unexpected beauty.

Joyride[TM], 1988
video, color, sound, 14 min. 23 sec.
Purchased with the contribution of the
Compagnia di San Paolo
Created as a collaboration between the artist and
the writer Constance De Jong, this video
advances like a frenetic journey, as the title
suggests, through experiences and discoveries in a
sort of modern Odyssey of the American culture
of sensationalism and consumerism.

ONOUROWN, 1990
video, color, sound, 45 min. 40 sec.
Purchased with the contribution of the
Compagnia di San Paolo
Performed by actors, this video traces the
wanderings of two patients who leave a
psychiatric hospital. In having returned with a
certain reluctance into the real world, Tony, Joe,
and their dog Woody find themselves having to
once again get used to everyday life and to the
prospect of looking for a job and preparing their
own food (besides having to keep a video-diary of
their experiences). Produced in collaboration with
Joe Gibbons, the video offers a series of situations
of extravagant, almost dark humor, closely
touching upon themes of solitude, health,
abnormality, and death impulses.

Top of page, *Joyride*™, 1988

Tunic (Song for Karen), 1990
video, color, sound, 6 min. 17 sec.
Purchased with the contribution of the
Compagnia di San Paolo
Produced in collaboration with the experimental
post-punk band Sonic Youth, this music video is
dedicated to the tragic figure of a famous
seventies American pop star, Karen Carpenter,
and to her problems with anorexia.

Model Release, Par-Schizoid-Position, and Test, 1992
video, color, sound, 11 min. 44 sec.
Purchased with the contribution of the
Compagnia di San Paolo
Model Release, 1992
video, color, sound, 3 min. 24 sec.
In this brief video, a female figure holds in her
arms what appears to be a puppet. She recites
legal texts, drawing a parallel among slavery,
prostitution, and possession of the spirit through
the power of mass media.

Par-Schizoid-Position, 1992
video, color, sound, 2 min. 53 sec.
Featuring Kim Gordon, the video shows the face
of the performer superimposed over abstract
backgrounds with a stream-of-consciousness
narration.

Test, 1992
video, color, sound, 5 min. 23 sec.
Analogous to *Par-Schizoid-Position*, in *Test* the face
of the performer—Karen Finley—is coupled with
abstract backgrounds and free-association voice-
over.

NAM JUNE PAIK
(Seoul, 1932)

After studying music and philosophy in Japan, Nam June Paik collaborated with the avant-garde composer Karlheinz Stockhausen in Cologne and took part in Fluxus performances and events using musical instruments, such as "prepared pianos," and modified television equipment. It was in Germany, precisely when Fluxus was at its apex, where Paik met and collaborated with artists such as Joseph Beuys and Wolf Vostell, but it was his encounter with John Cage that unleashed new ideas and a complete, renewed outlook on art. After arriving in New York in 1964, Paik "discovered" the Sony Portapak portable video camera and started making videos. It was in New York that Paik embarked upon a collaboration, destined to last years, with the avant-garde cellist Charlotte Moorman, with whom he realized numerous performances that, at the time, were occasionally considered scandalous.

By adopting a series of ironic and disarming artistic modalities, Paik developed an approach that deconstructs and mixes the flowing of images, re-creating the language of the television communication universe. Establishing a vision marked by theories of global communication, with a sensitivity and creativity that absorbs the somewhat confrontational side of Pop Art, his work explores the sudden transitions and junctions between mass art and culture in an age where the medium is the message. Following his initial works dealing with the modification of electronic signals by means of magnets placed on television sets, he arrived at innovatory works thanks to the video synthesizer, a piece of equipment he had developed as early as 1969, together with electronics engineer Shuya Abe.

By re-elaborating heterogeneous materials with a "neo-Dada" spirit and irony, Paik created a radical synthesis of video language based on the audiovisual grammar and syntax of television, while at the same time transforming its language.

The artist's network of friendships and artistic references—John Cage, Merce Cunningham, Allen Ginsberg, Allan Kaprow, Julien Beck, and Judith Malina of the Living Theater—have been progressively cited in richly constructed works in which the recurrent and emblematic themes and motifs of Pop iconography are alternated with figures of the international avant-garde. [F.B.]

Rare Performance Documents 1961–1994. Volume 1:
Paik-Moorman Collaborations, 1961-1994,
compiled in 2000
video, black and white, color, silent and sound,
25 min. 08 sec.
Purchased with the contribution of the
Compagnia di San Paolo

Performance Documentation, Aachen, Germany,
1965
video, black and white, silent, 4 min. 14 sec.
Silent recordings of the preparation of the
musical and performance events held by Paik and
Moorman in a university room in Aachen in
1965.

Charlotte Moorman at the Howard Wise Gallery,
1969
video, color, silent, 1 min. 43 sec.
Brief color fragments of Moorman playing the
cello and assorted percussion instruments during
a performance in a private gallery.

TV Bed, The Everson Museum of Art, 1972
video, black and white, sound, 1 min. 10 sec.
Scenes of Moorman playing her cello and talking
with the public while stretched out on a surface
made up of television monitors.

TV Cello Performance, 1973
video, black and white, silent, 1 min. 42 sec.
Extracted from a performance by Moorman who
is playing a cello (while Paik is busy smoking).
Composed of various turned-on TV screens.

Waiting for Commercials (Performance), 1972
video, black and white, sound, 8 min. 20 sec.
Moorman with her cello and David Behrman at
the piano alternate playing pieces of classical
music during a television broadcast in which a
video by Paik created with commercials is shown.

New Television Workshop Performance, 1971
video, color, sound, 7 min. 25 sec.
Moorman, after her entrance "on all fours" and
dressed in military uniform, has her cello on her
back. First she plays her instrument, then a
bomb, and then Paik's back.

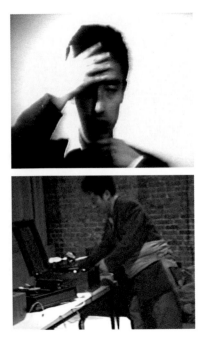

Rare Performance Documents 1961–1994. Volume 2,
1961–1994, compiled in 2000
video, black and white, color, silent and sound,
18 min. 37 sec.
Purchased with the contribution of the
Compagnia di San Paolo

Hand and Face, 1961
video, black and white, silent, 1 min. 42 sec.
With a close-up shot on a completely white
background, Paik passes his hand across his face,
forehead, and eyes in an engrossed ritual.

Fluxus Sonata at Anthology Film Archives, 1975
video, black and white, sound, 6 min. 12 sec.
On a series of record players and gramophones
Paik plays some old records he then
systematically breaks into pieces.

Violin Dragging, Brooklyn, NY, 1965
video, color, sound, 1 min. 37 sec.
The artist drags a violin tied to a piece of string
through streets and fields.

Tribute to GM (aka Video Venus), 1978
video, color, sound, 2 min. 56 sec.
The artist performs a score on a piano while a
naked woman is seated on the same piano.

Nam June Paik with The Bad Brains, 1991
video, color, sound, 1 min. 19 sec.
Paik is seated next to the drums of the musical

group during one of their concerts held at the American Museum of the Moving Image (September 14, 1991).

An Evening with Nam June Paik at The Kitchen, 1994
video, color, sound, 4 min. 35 sec.
The artist plays the piano while a large screen projects images filmed with a micro video camera he has with him.

Button Happening, 1965
video, black and white, silent, 2 min.
Purchased with the contribution of the Compagnia di San Paolo
In a half-bust view of rapid and synthetic recording, the artist buttons and unbuttons his jacket.

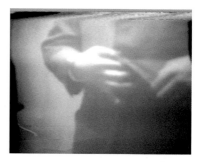

Video Synthesizer and "TV Cello" Collectibles, 1965–1971
in collaboration with Jud Yalkut
video, color, silent, 23 min. 25 sec.
Purchased with the contribution of the Compagnia di San Paolo

Early Color TV Manipulations, 1965–1971
video, color, silent, 5 min. 18 sec.
Color elaboration of TV signals.

Video Commune (Beatles from Beginning to End), 1972–1992
video, color, silent, 8 min. 36 sec.
These period recordings by Jud Yalkut represent the earliest documentation of Paik's interventions: first with magnetized television monitors and then with his first interactive performance in the WGBH television studio in Boston. This video also marks the "on air" debut of Paik's video synthesizer—Abe/Paik—that took place in August 1970.

TV Cello Premiere, 1971
video, color, silent, 7 min. 25 sec.
This film is the precious documentation of Paik's
first *TV Cello* performance together with
Moorman at the Bonino Gallery in New York in
1971.

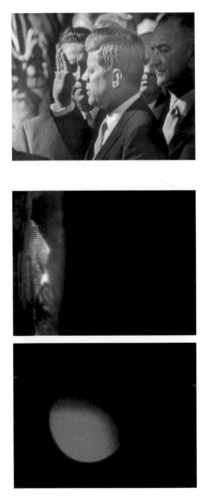

Digital Experiment at Bell Labs, 1966
video, black and white, silent, 4 min.
Purchased with the contribution of the
Compagnia di San Paolo
Permitted to use the Bell Company laboratories,
Paik creates a short but essential—almost
minimal—experiment with electronic images in
which numbers and dots move on a black
background.

Film Video Works #3, 1966–1969
in collaboration with Jud Yalkut
transferred from 16 mm film, video, black and
white, color, silent and sound, 5 min. 36 sec.
Purchased with the contribution of the
Compagnia di San Paolo
Missa of Zen, 1966–1969
transferred from 16 mm film, black and white,
color, silent, 2 min. 28 sec.
Fragmentary images giving a sense of a
phantasmic presence appear on a television
screen, filmed from an oblique viewing point.
Their moving presence on the screen is rendered
even more abstract by the distance and darkness
that surrounds them.
Electronic Moon, 1966–1969
video, black and white, color, sound,
3 min. 08 sec.
Artificially colored images of the moon are
accompanied by Glenn Miller's famous
"Moonlight Serenade."

Video-Film Concert, 1966–1972
in collaboration with Jud Yalkut
video, black and white, color, sound,
34 min. 50 sec.
Purchased with the contribution of the
Compagnia di San Paolo

Video Tape Study #3, 1966–1969
video, black and white, sound, 4 min.
Images of a press conference held by the
President of the United States, Lyndon Johnson,
and the Mayor of New York, John Vliet Lindsay,
are distorted and manipulated.

Beatles Electroniques, 1966–1969
video, black and white, color, sound, 3 min.
In this short video, Paik manipulates and modifies
the presences of the most famous pop stars of the
sixties.
Electronic Moon #2, 1969
video, color, sound, 4 min. 30 sec.
With a piece by Debussy heard in the
background, Paik re-elaborates images of the
moon.

Electronic Fables, 1966–1972 and 1992
video, black and white, color, sound,
8 min. 45 sec.
This work mixes elaborations of images with
sound fragments of sentences by John Cage.
Electronic Yoga, 1972–1992
video, black and white, color, sound,
7 min. 30 sec.
Images of a person in the lotus position are
alternated with figures of colored abstractions.

Waiting for Commercials, 1972
video, color, sound, 6 min. 45 sec.
Constructed as a condensed collection of
Japanese TV commercials of the early seventies,
this work is one of the first examples of Paik's
ironic approach to appropriating television
images of consumer products in order to
represent them as objects of Pop Art.

9/23/69: Experiment with David Atwood, 1969
in collaboration with David Atwood,
Fred Barzyk, and Olivia Tappan
video, color, sound, 80 min.
Purchased with the contribution of the
Compagnia di San Paolo
Produced by Paik while a guest artist of the
WGBH television channel in Boston, this work
was integrally televised only in recent years. The
title refers to the date of the broadcast:
September 23, 1969. This visual collage is a blend
of spontaneous experimentation, which combines
electronic manipulations of pre-existing television
material and pure abstractions, including images
filmed live in the TV studio. The result is a
multiform and amalgamate visual and sound
symphony.

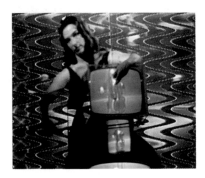

Global Groove, 1973
in collaboration with John Godfrey
video, color, sound, 28 min. 30 sec.
Purchased with the contribution of the
Compagnia di San Paolo
Characterized by an inexhaustible sound and
visual rhythm, this video shows a series of dancers
engaged in performing the most varied styles—
from rock'n'roll to jazz, contemporary, tap, and
traditional Korean dances—along with the
alternating and unexpected appearance of Allen
Ginsberg, John Cage, or Jud Yalkut interviewing
Charlotte Moorman. The continuous electronic
elaboration and overlapping, together with the
incessant presence of the music, produce a
sensation of contagious vital energy.

A Tribute to John Cage, 1973, reedited in 1976
video, color, sound, 29 min. 02 sec.
Guest: Alvin Lucier
Performers: John Cage, Marianne Amacher,
Richard Teitelbaum, Pulsa, Charlotte Moorman,
David Behrman, David Tudor, Cathy Berberian,

Jud Yalkut, Francis Lee, David Rosenboom, Jackie Cassen, Stan VanDerBeek, and Alfons Schilling
Purchased with the contribution of the Compagnia di San Paolo
In this portrait of John Cage, Paik superimposes live performances, interviews, and anecdotal memories with friends and colleagues of the great musician and offers examples of musical executions and works for television with Cage and his aleatoric and participatory research.

Merce by Merce by Paik, 1978
in collaboration with Charles Atlas, Merce Cunningham, and Shigeko Kubota
video, color, sound, 28 min. 45 sec.
Purchased with the contribution of the Compagnia di San Paolo
Part One: Blue Studio: Five Segments, 1975–1976
by Charles Atlas and Merce Cunningham
video, color, sound, 15 min. 38 sec.
A series of short choreographies expressly carried out by Cunningham for the video shows the dancer multiplied on the screen, accompanied by a sound collage of the voices of John Cage and Jasper Johns.
Part Two: Merce and Marcel, 1978
by Shigeko Kubota and Nam June Paik
video, color, sound, 13 min. 05 sec.
Paik and Kubota dedicate the second part of the work to the relationships among art, movement, and gesture while the question "Is this dance?" is repeated. Included in the video are aerial images of the streets of New York and a baby's first steps.

almost ritualistically and rhythmically beats his knees against the surface of the floor. As the "chant" quickens, he gets up and violently throws himself against the walls, as if trying to escape from the imprisonment of that space.

Body Music II, 1974
video, black and white, sound, 10 min. 30 sec.
Purchased with the contribution of the Compagnia di San Paolo
Palestine wanders around the labyrinthine rooms of an old villa, recording with a video camera in his hand. Moving more and more quickly and singing in the reverberating space of the rooms he creates a force equivalent to the frenetic waste of physical energy as he runs.

Four Motion Studies, 1974
video, black and white, sound, 13 min. 24 sec.
Purchased with the contribution of the Compagnia di San Paolo
Filmed with a camera in his hand on the rides and roller-coasters at Coney Island, these studies are experimented by the public through the eyes and movements of Palestine during the shootings. Each study becomes more abstract, transmitting a sense of vertigo and estrangement in space.

Snake, 1974
video, black and white, sound, 10 min. 43 sec.
Purchased with the contribution of the Compagnia di San Paolo
With a ritualistic approach Palestine uses the body as an instrument for creating sounds and movements. Placed in a fetal position, the artist lies on the floor. With every breath he produces a profound sound and slowly turns himself in a circle. In this way, he creates an exercise in which his voice acts as a source of motion.

Internal Tantrum, 1975
video, black and white, sound, 7 min. 35 sec.
Purchased with the contribution of the
Compagnia di San Paolo
Seated in front of the video camera the artist
keeps his body in tension. Slowly, he begins to
sing and sway as if to communicate a sense of
irritation and pain.

Running Outburst, 1975
video, black and white, sound, 5 min. 56 sec.
Purchased with the contribution of the
Compagnia di San Paolo
Palestine sings inside a loft. He quickly moves
among small animals made of cloth that are scattered
about the room. On having reached an almost
hysterical intensity, he gradually returns to a calmer
movement, employing the subjective camera.

*You Should Never Forget the Jungle - St. Vitas
Dance*, 1975
video, color, sound, 19 min. 59 sec.
Purchased with the contribution of the
Compagnia di San Paolo
You Should Never Forget the Jungle, 1975
video, color, sound, 11 min. 09 sec.
The artist in a closed room wears a scarf and
holds a glass of cognac in his hand. He begins to
sing, grow angry, and throw himself against the
walls as if trying to get out of the room.
St. Vitas Dance, 1975
video, color, sound, 8 min. 50 sec.
Seated in front of a grouping of little teddy bears,
dolls, and scarves, the artist tightly holds the
video camera against his body. The artist's
presence is indicated only by his shadow, while
his voice sings.
The filmed images become increasingly agitated,
visceral, true physical extensions of his intense
gesture to the point of arriving at abstract forms
of sheer movement.

Andros, 1975–1976
video, black and white, sound, 57 min. 13 sec.
Purchased with the contribution of the
Compagnia di San Paolo
Filmed entirely from a subjective viewing point,
this intense external and spiritual journey begins
with a man looking at television in a dark room
and talking about his laziness, his sense of
frustration and anguish. He then goes out onto
the street, takes the subway, and arrives at a place
enveloped by fog. He starts to run. He then
begins talking and shouting to himself and to the
spectator about his need to flee from his pain and
the thoughts that obsess him.

Island Song - Island Monologue, 1976
video, color, sound, 31 min. 34 sec.
Purchased with the contribution of the
Compagnia di San Paolo
Island Song, 1976
video, color, sound, 16 min. 29 sec.
Filmed on an island in Hawaii, the video shows
the artist who, having attached the video camera
to a motorbike, travels in search of a way out. His
singing is mixed with the incessant roar of the
engine, superimposing the shaking of the video
camera. The video ends—like the artist's trip—
with the close-up of rocks on a beach.
Island Monologue, 1976
video, color, sound, 15 min. 05 sec.
Palestine tries to escape from the island on which
he finds himself. Enveloped by thick fog, this
becomes the symbol of the psychological
reclusion the artist tries to overcome. In hiding
himself or trying to see beyond the fog, he talks
about his own exasperation. He then moves close
to the tower of the lighthouse, which acts as a
liberating force.

Where It's Coming From, 1977
video, black and white, sound, 56 min. 50 sec.
Purchased with the contribution of the
Compagnia di San Paolo
The tape is the recording of a long conversation
between Palestine and Wies Smals, at that time
Director of the De Appel Foundation in Amsterdam.
Palestine and Smals discuss art, analyzing works with
the body, performance, the role of the video camera,
who directs and how, the invasion of privacy, the
implicit voyeurism, and the forms of catharsis.

Dark into Dark, 1979
video, color, sound, 19 min. 28 sec.
Purchased with the contribution of the
Compagnia di San Paolo
In a dark space, one hears the artist mutter and
whisper. His eyes slowly appear, followed by his
face. Palestine directly addresses the spectator
with a tone that is menacing, joking, and
accusatory all at the same time. From the way in
which the artist moves, coming closer to or
moving away from the light, the darkness
becomes a metaphor of safety and security, given
by ignorance and isolation, while the observer is
accused of being the irritating presence that
brings light.

PAUL PFEIFFER
(Honolulu, 1966)

The works of Paul Pfeiffer analyze the complex level of construction that composes the images and protagonists of the mass-media universe. The artist's working method consists of appropriating existing material, often parts of television broadcasts on sporting events. By digitally elaborating these fragments the artist redirects the spectators' attention towards a new message. Boxing, baseball, and hockey matches are the material chosen by the artist insofar as they are an exemplary model of transforming everything into a spectacle built for consumption by an enormous viewing audience. From these recordings Pfeiffer erases the players or the athletes, the protagonists of the event, and elaborates the resulting images that are then broadcast on small screens (the artist also designs the wall brackets and metal structures that support them). The insistence on this process of cancellation contradicts the centrality entrusted to the role of the human figure in the history of Western art. On the other hand, the attention paid to the sporting events manifests a reflection on collective myths, especially those that dominate the imaginary of American TV audiences. The artist elaborates his videos in such a way as to broadcast them in a loop. Together with the peculiar sculptural apparatus that accompanies them, Pfeiffer creates the conditions for establishing a direct dialogue with his audience, paving the way for an intimate and almost hypnotic experience of the work. [M.B.]

Corner Piece, 2002–2003
video installation, DVD, color, sound, loop,
monitor, metal structure, 23 ³/₅ x 23 ³/₅ x 39 ²/₅ in.
Permanent loan of the Region of Piedmont
The work is constructed like a sculpture that
obliges the visitor to draw near the image
appearing on a small monitor. Mounted on three
wall brackets, the work presents a video, the
digital elaboration of footage from a boxing
match during which the athlete is medicated. As
in most of his works, the artist extracts the image
of the protagonist, thereby exposing his nature as
a constructed figure for the use and consumption
of viewing audiences.

YVONNE RAINER
(San Francisco,
1934)

Dancer, choreographer, performer, filmmaker, and theorist. There are few roles that Yvonne Rainer, a key figure in the history of New York avant-garde movements, has not filled, thanks to the importance of her writings and artistic practice. Following her early acting studies in San Francisco, she moved to New York where she attended dance courses at Martha Graham's school and classes held by Merce Cunningham. With a somewhat informal group of dancers and performers she founded the Judson Dance Theater, which was soon to become one of the epicenters of the New York experimental dance scene.

Rainer created her first choreographies in 1961 and her first films between 1966 and 1967, defining them as "filmed choreographic exercises." In the seventies, she began making full-length films, and during her career she has produced twelve films, including the first silent full-length films made for multi-media performances. The point of interest represented by her transition from dance to experimental cinema has an historical antecedent in experimental filmmakers of the forties and fifties who dedicated their works to the analogies between dance and cinema as "kinetic" artistic forms par excellence. References to cinema already had a defined presence in her choreographic work, highlighted by the use of projections and, successively, filmic citations. Dance and cinema find themselves profoundly linked thanks to the intense critical effort developed regarding the conventions of the respective disciplines and through a radical questioning of the very role of performance itself. The importance of performance is the central element throughout her oeuvre: in all of her films, it is both an essential aspect and characterizing motif.

The changes made to her choreographic work led her to abandon the sphere of contemporary dance, considered elitist and self-referential, in the desire to describe social and intimate relationships. This interest in emotions can also be interpreted as a reaction to the new Minimalist tradition and to John Cage, who influenced her choreography during the sixties. [F.B.]

Five Easy Pieces, 1966
transferred from 16 mm film, black and white,
silent, 48 min.
Castello di Rivoli Museum of Contemporary Art,
Rivoli-Turin
Hand Movie
transferred from 16 mm film, black and white,
silent, 5 min.
A close-up of a hand whose fingers depict a
sensual dance.
Volleyball
transferred from 16 mm film, black and white,
silent, 10 min.
A volleyball enters the image and comes to a stop.
Two legs wearing gym shoes, seen from the knees
down, enter the shot and stop. These same
actions are repeated from a different viewing
point.
Rhode Island Red
transferred from 16 mm film, black and white,
silent, 10 min.
Ten minutes filming an enormous chicken farm.
Trio Film
transferred from 16 mm film, black and white,
silent, 13 min.
A man and a woman, both naked, interact by
using a big ball in a large white space.
Line
transferred from 16 mm film, black and white,
silent, 10 min.
A blonde woman wearing white pants and a
sweater interacts with the camera and a round,
mobile object.

Trio A, 1978
transferred from 16 mm film, black and white,
sound, 10 min. 30 sec.
Castello di Rivoli Museum of Contemporary Art,
Rivoli-Turin
Made in 1965, this choreographic composition
initially consisted in a sequence of movements
lasting 4 ½ minutes. It was first presented as part
of the event *The Mind Is a Muscle, Part I* held at

Judson Church in January 1966. At that time it was interpreted "simultaneously but not in unison" by Yvonne Rainer, David Gordon, and Steve Paxton. In 1978, five years after she had stopped interpreting it, Rainer once again performed it at the studio of Merce Cunningham for a 16 mm film.

After Many a Summer Dies the Swan: Hybrid, 2002
video, color, sound, 31 min.
Castello di Rivoli Museum of Contemporary Art, Rivoli-Turin
At the beginning of 2000 the Barišnikov Dance Foundation commissioned Yvonne Rainer with a dance piece for the White Oak Dance Project. Titled *After Many a Summer Dies the Swan: Hybrid*, from the novel of the same name written in 1939 by Aldous Huxley, the piece focuses on a story set in Hollywood. The choreography contains configurations of various movements,

sentences taken from the last words of famous personalities on their deathbeds, and visual and literary material dedicated to late nineteenth-century Vienna. The work is developed as an elegiac meditation on the transience of time and involves a cameo appearance by Michail Barišnikov, Director of the White Oak Company.

in the use of language.

With the emergence of cultural modernism, history had lost its power as a source for meaning and action.

**PIPILOTTI RIST
(Rheintal,
Switzerland, 1962)**

Pipilotti Rist is the original inventor of a particular visual and sound universe within which the sensorial and emotive dimensions are the main protagonists. Her works, conceived as videos for monitors or complex multi-media installations, include elements of performance, poetry, music, and sculpture aimed at involving visitors in a total experience.

Rist's complex evolution as an artist includes, in addition to video and animation studies, experience as a set designer for music groups and a long period spent as a musician with a band called Les Reines Prochaines. Her interest and participation in pop culture, especially in rock music, represents an important component of her oeuvre. This aspect goes hand in hand with a redefining of female sensibility.

From her debut with the single-channel video, such as *I'm not the Girl who Misses Much* (1986), the artist has in fact used the visual and sound language of music for an analysis of the behavioral codes systematized by mass media. Rist's face and body are sometimes the protagonists of these works. However, rather than autobiography the artist is interested in defining a common sphere that can allow her to come into contact with the public. Above all, in the case of installations, this contact is achieved by literally immersing the audience in a setting that is mental, psychedelic, sensual, ironic, and erotic, all at one and the same time. As she has declared on various occasions, her intention is not to use video technology for recording or imitating reality. According to Rist this technology cannot compete with the complexity of reality. Rather, the artist explains her interest for video in that it is a malleable medium, endowed with pictorial qualities or belonging to a Western concept of everyday life. In exasperating these effects, Rist experiments with the entire range of possible visual elaborations, conceiving new ones and elaborating a personal aesthetic made up of acid, saturated colors and images that are intentionally either disturbed or distorted. Pulsing and vital, the artist's videos and installations transmit almost organic characteristics, as if they were a flow of thoughts and emotions made visible. In numerous interviews, Rist has expressed her interest in the unconscious, both personal and technological. [M.B.]

I'm Not The Girl Who Misses Much, 1986
video, color, sound, 7 min. 46 sec.
Purchased with the contribution of the
Compagnia di San Paolo
Rist screamingly sings the words that give the
title to the work, inspired by John Lennon's
"Happiness Is a Warm Gun." The particular
distortions of the sound, the images with their
saturated colors, and the use of pop culture all
establish the premises for successive video works.
The artist is the energetic creative source of this
particular, sensually feminine, and contagiously
ironic universe.

Sexy Sad I, 1987
video, color, sound, 4 min. 36 sec.
Purchased with the contribution of the
Compagnia di San Paolo
Inspired by music videos, although taken to
amusing and entertaining excesses, this work is a
close-up investigation of an anonymous male
body. The careful scrutiny is rendered with
extremely saturated colors, while the setting is a
rural context. The title is inspired by the Beatles'
"Sexy Sadie," whose melody is used as the
soundtrack.

*(Entlastungen) Pipilottis Fehler (Absolutions -
Pipilotti's Mistakes)*, 1988
video, color, sound, 11 min. 10 sec.
Purchased with the contribution of the
Compagnia di San Paolo
The images of this video are characterized by
experimental elaboration that enhances the
pictorial nature and quality. Thus defects and
imperfections become moments of pure poetry
and transform the work into a study on the
subconscious and on the psychology of the
camera.

You Called Me Jacky, 1990
video, color, sound, 4 min. 06 sec.
Purchased with the contribution of the
Compagnia di San Paolo
Amusing and estranging, the video shows the
artist impersonating the role of the rock star with
explosive and overwhelming energy. Rist imitates
Madonna, exaggerating the singer's movements
and gestures. In this way, she proclaims her
dependence on pop culture together with her
right to use it as a source of rebelled inspiration.

*Als der Bruder meiner Mutter geboren wurde, duftete
es nach wilden Birnenblüten vor dem
braungebrannten Sims* (*When My Mother's Brother
Was Born It Smelled like Wild Pear Blossom in front
of the Brown-Burnt Sill*), 1992
video, color, sound, 3 min. 55 sec.
Purchased with the contribution of the
Compagnia di San Paolo
The event of birth is represented in the peaceful
context of the Swiss Alps. The video unites the
artist's private world as well as references to pop
culture and mass culture. As in the case of other
works, here as well the artist takes part in
composing the soundtrack.

Pickelporno (*Pimple Porno*), 1992
video, color, sound, 12 min. 02 sec.
Purchased with the contribution of the
Compagnia di San Paolo
The carnal meeting between a man and a woman
is the subject of this video, filmed by applying a
small surveillance video camera at the end of a
pole. Subjective shots of the bodies, whose details
are enlarged out of proportion, are alternated
with delightful visions of flowers and fruit. The
work can be interpreted both as a parody of a
banal pornographic video and as the sensual
interpretation of a genre that is traditionally
lacking in artistic intentions.

Blutclip (Bloodclip), 1993
video, color, sound, 2 min. 40 sec.
Purchased with the contribution of the
Compagnia di San Paolo
Structured as a music video that celebrates the
female reproductive cycle, the work evidences the
artist's personal feminist vision and her ability to
treat difficult topics with energetic fun. In this
case, Rist films her own naked body in a forest.
Images of her own menstrual blood are
juxtaposed with animations of the moon and the
planets.

I'm a Victim of This Song, 1995
video, color, sound, 5 min. 06 sec.
Purchased with the contribution of the
Compagnia di San Paolo
The artist interprets the pop song "Wicked
Game" by the singer Chris Isaak. The words are
shouted, the gestures are comically disjointed,
and the images are elaborated in such a way as to
transmit the essence of Rist's personal world,
ironically superimposed over the sentimentalism
and melancholy of the original interpreter.

Aujourd'hui (Today), 1999
video, color, sound, 10 min.
Purchased with the contribution of the
Compagnia di San Paolo
This is a monitor version of the installation
entitled *I Couldn't Agree with You More*. The video
camera is fixed on the artist's face, characterized
by a hypnotic stare. Similar to recurrent or
fleeting thoughts, small images animate her face,
hypothesizing the possibility of an almost
telepathic contact with the observers.

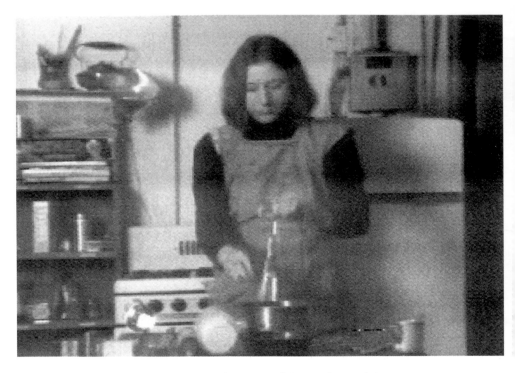

Semiotics of the Kitchen, 1975
video, black and white, sound, 6 min. 09 sec.
Purchased with the contribution of the
Compagnia di San Paolo
Framed by a fixed camera, the artist recites the
alphabet that she illustrates by holding ordinary
kitchen utensils. The objects chosen soon prove
dangerous and are wielded in such a way as to
accentuate their potential as weapons.

Losing: A Conversation With The Parents, 1977
video, color, sound, 18 min. 39 sec.
Purchased with the contribution of the
Compagnia di San Paolo
Produced in the form of a television interview
with two young parents who lost their daughter
to anorexia, the video faces the theme of illness
brought on by social and cultural pressures.

The East Is Red, the West Is Bending, 1977
video, color, sound, 19 min. 57 sec.
Purchased with the contribution of the
Compagnia di San Paolo
In her kitchen, the artist reads the presentation
booklet of an electric wok—the typical Chinese
frying pan—thus transforming herself into an
improbable television demonstrator and
expounding the incongruities of the text she is
reciting.

Vital Statistics of a Citizen, Simply Obtained, 1977
video, color, sound, 39 min. 20 sec.
Purchased with the contribution of the
Compagnia di San Paolo
The video presents the artist undergoing a
pseudo-medical exam, which consists in
measuring various parts of her body. The exam
involves the gradual undressing of the woman's
body, subjected to a humiliating situation of
control. The video continues with a sequence of
images and a text illustrating a long series of
crimes against women.

Domination and the Everyday, 1978
video, color, sound, 32 min. 07 sec.
Purchased with the contribution of the
Compagnia di San Paolo
The video's soundtrack is dominated by the
voices of a mother, her small son, and a radio
interview. The mother and son are busy with
their daily routine, whereas the person
interviewed talks about the contemporary art
system. Images from the artist's family album are
juxtaposed with fragments of reality as given by
the press. By avoiding a narrative structure this
work is a sort of self-portrait of Rosler, woman,
artist, and mother.

MICHAEL SNOW
(Toronto, 1929)

Michael Snow is a versatile and prolific artist. Painting, photography, sculpture, jazz, and experimental cinema comprise his media spanning over forty years of activity. In each of his works, regardless of the discipline involved, his research is focused on the analysis of representation and its materials. Through his experience above all as an experimental filmmaker, Snow has created a vast body of work that both reflects and questions the chosen medium in a constant analytical alternation between what is represented, the process employed, and the material used. At the core of every video project developed by Snow the exploration of the organizational principles dominates the structural composition. In his research, the interest in the physical experience and the process of perception always coexist. [F.B.]

Rameau's Nephew by Diderot (Thanks to Dennis Young) by Wilma Schoen, 1970–1974
transferred from 16 mm film, color, sound, 4 hrs. 26 min.
Purchased with the contribution of the Compagnia di San Paolo
This work offers an extensive and in-depth exploration of the various possibilities of the use of sound in film. The film is based on the study, illustration, and trial of all the relationships between images and sounds. The artist focuses on the associations between people and words, including the processes of identification established in film projection and viewing. In an articulated research, culminating in a sort of video transfer, he examines the multiple possibilities of psychological and emotive illusion produced by the experience of looking at and listening to a film.

Michael Snow Presents, 1981
transferred from 16 mm film, color, sound, 90 min.
Purchased with the contribution of the Compagnia di San Paolo
The film opens with an abstract image on a black background that progressively reveals itself as a woman in bed. This is shortly followed by a parody of Structuralist cinema divided into three sequences focusing on the position of the camera. In the first long scene, the video camera is immobile while the entire set moves. In the second, the video camera—enclosed in a transparent plexiglass armor— physically invades the set, destroying everything that comes into its path. Finally, the wall of the set is passed through and the film moves on to frenetically take exterior zigzag shots mimicking the natural trajectories of a human eye.

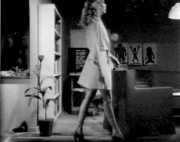

221

**CATHERINE
SULLIVAN
(Los Angeles, 1968)**

The complex relationship among the actor, the role interpreted, and the way in which gestures and actions establish different levels of empathy with the audience lies at the base of Catherine Sullivan's oeuvre. Her background includes acting studies as well as a degree from the Art Center College of Design in Los Angeles. Both of these experiences have come to influence her art, which formally includes one or multi-channel video installations and performances done live for the theater. In both cases, the artist writes the scripts and directs her cast, using professional as well as amateur actors and dancers. Their actions, physicality, excesses, acting ability or professional skills represent the true medium through which the artist expresses herself. The analysis of these dynamics passes through a variety of sources including the history of theater, cinema, literature, and a wide range of references to popular culture.

Intentionally overlapping, joined in deliberately arbitrary relationships, the references Sullivan uses in constructing her works are never employed to stage logical narrations. On the contrary, in her works opposing or similar interpretative models are juxtaposed in order to investigate the proliferation of meanings. At the same time, the abundance of references contributes in highlighting the basic elements and the very heart of the concept of theater acting and interpretation, which remain the fundamental components of the artist's oeuvre. [M.B.]

'Tis Pity She's a Fluxus Whore, 2003
two-channel video installation, DVD transferred
from 16 mm film, color, sound, 26 min.,
dimensions determined by the space
Permanent loan of the Region of Piedmont
The title *'Tis Pity She's a Whore* refers to a play
published in 1633 by the English dramatist John
Ford. The production caused a scandal due to the
story's plot of an incestuous relationship between
Giovanni and Annabella, brother and sister
condemned to a tragic fate. The term "Fluxus,"
added by the artist to compose the title of her
work, refers to the famous avant-garde movement
that, bridging the sixties and seventies, wed the
experimentation of various artists in Europe and
the United States, often unsettling both the
audience and critics with seemingly illogical or
disarmingly simple actions.
Sullivan's work, installed in the form of two
videos on monitors, unites these two different
episodes in the history of performing arts by
comparing two cases of disruption in the
relationship between the actor, the role
portrayed, and the spectator. The work was
initially produced for an exhibition held by the
artist at the Wadsworth Atheneum in Connecticut
where Ford's play had been staged in 1943.

ALESSANDRA TESI
(Bologna, Italy, 1969)

Like a world covered by a veil made of paint, in the vision of Alessandra Tesi reality is an uncertain dimension within which the visible and the invisible, the tangible and the elusive co-exist. Desire, obsession, and memory are, for this artist, forces capable of modeling matter, transforming reality into a ductile element whose colors and forms are only a more or less distorted projection.

By preference, her artistic path unfolds inside spaces imbued with a feeling of absence, places the artist interprets as momentarily abandoned stage-settings, though charged with potential energy. Managing to capture traces of the osmosis that defines the relationship between bodies and inhabited places, her photographic images of hotels, deserted rooms and places, or apartments full of secrets retain the emotion of the human presence that inhabited the space at length or even briefly.

In developing works in the form of videos or installations, Tesi has increasingly directed her attention to aspects of otherwise hidden reality, investigating the possibility of rendering visible that which lies hidden within the folds of reality.

In taking this analysis to extremes, she became interested in the idea of crime for one of her major projects. For a year, Tesi followed the criminal investigations of the Paris Criminal Brigade, the section of the French judiciary police specialized in cases characterized by a seeming absence of clues and, at times, made even more dramatic by the uncertain identity of the victim. Intended as a moment of intense energy, a crime, for this artist, is like a cut in the skin of reality, an event that opens up an unbearable void within which all appearances vanish, but after which the forces that created the situation remain suspended. The artist repeatedly returns to the scene of the crime. The numerous shots taken lose all documentary quality and correspond to a gradual immersion in a dimension that is otherwise intangible.

By continuously and painstakingly investigating the most unusual aspects of vision and the physical and mental mechanisms that regulate optical laws, Tesi often projects her videos onto experimental materials she invents. These include mirroring surfaces or reflective paints, glass marbles or sequins, treated in such a way as to extend and expand the pictorial properties. [M.B.]

Nuit F-75003 (Night F-75003), 1999
video projection, color, sound, loop, blue sequins,
dimensions determined by the space
Castello di Rivoli Museum of Contemporary Art,
Rivoli-Turin
The work is the vision of the energies, colors,
and sounds that belong to the city at night,
rendered as a throbbing universe. Filmed in Paris
and titled with the zip code of the area where the
artist lives, the video contains no descriptive or
narrative element whatsoever. Attention is instead
concentrated on some lighting details, such as
police sirens or the lights of a pinball machine in
a bar that paint the night with their colors. A
mirage of light, the video is projected onto a bed
of sky blue sequins arranged on the floor.
The installation contrasts with the absolute
darkness surrounding it, a conceptual image of
the dense black, which is the matter of night.

225

GRAZIA TODERI
(Padua, Italy, 1963)

Grazia Toderi has elaborated her own poetics that elevates even minimal situations, transforming them into powerful reflections on the human condition. In choosing video as her medium of expression, the artist has created works that investigate the possibility of transcending human finiteness and the diachronic development that defines the common experience of time. Her images allude to a spatial dimension that tends to infinity, making visible the breadth and scope of the mind's horizons. Often created with a fixed video camera, and in more recent cases using digital elaboration, Toderi's videos are made for looping projections in darkened spaces. For the artist, these are the optimal conditions for immersing the spectator within a temporal suspension analogous to the one that characterizes her images.

Her first videos, at times created for monitors, have domestic microcosms as their subject matter. In later works, the investigation also incorporates the artist's body. She has progressively raised her eyes, and from a vision immersed in the world she has literally elevated her perspective. By starting with her own memories tied to watching the landing on the moon on TV, the artist initiated a series of works that have the universe and its sidereal spaces as their subject matter. By investigating the real, although giving us a sublimated version of it, the artist combines an intimate vision of an individual, historical memory with a fantastical dimension, alluding to the collective imaginary. This theme is further investigated in subsequent works in which Toderi concentrates her attention on stadiums, arenas, and theaters. Examined as microcosms of energy, these places are privileged insofar as they are spaces intended for public gatherings and, above all, spectacle. Whether they are places for sporting events, theater, or concerts, the artist investigates their potentials prior to their becoming an image. She gives life to their choral aspects, to the feeling of expectation that belongs to these places. In the series on stadiums, she investigates laws and shapes, transforming these circumscribed spaces into dynamic forms. With regard to theater halls, the artist does not address herself to the stage, but to the audience, its sounds and movements. Towns, cities, and gardens also form part of her exploration. By elaborating aerial photographs with a computer, Toderi invents new and unusual views of cities, such as Rome, Florence, or London, showing the ways and geometries with which the urban dimension presents itself. [M.B.]

L'atrio (The Atrium), 1998
double video projection, DVD, color, silent, loop,
dimensions determined by the space
Castello di Rivoli Museum of Contemporary Art,
Rivoli-Turin
To the vital rhythm of action and rest, a female
and male figure respectively throw a ball or play
with some spheres. Their gestures allude to the
possible coexistence of different spatial and
temporal laws. The work was created by the
encounter between the artist and the historical
rooms of the Castello di Rivoli on the occasion of
her solo exhibition in 1998. The title of the work
refers to the original function of the room where
the video is filmed: called the *Room of Bacchus and
Ariadne*, it was conceived by Juvarra—the
architect of the Castello—as the room joining the
apartments of the king and queen.

Il decollo (The Take Off), 1998
video projection, DVD, color, stereo sound, loop,
dimensions determined by the space
Gift of the Supporting Friends of the Castello di
Rivoli
Shot from above, the television view of the Paris
stadium is elaborated and transformed into a sort
of spaceship ready for a voyage far from the limits
of the Earth, removed from the contingency of
events. In the background, the sound made by the
crowd narrates intense emotions.

Spettatori/Audience, 2000
video projection, DVD, color, stereo sound, loop,
dimensions determined by the space
Purchased with the contribution of Sipea S.r.l.
Pubblicità
Facing a starry vault, a theater hosts a crowd of
spectators, luminous figures gathered to see the
wonders of the celestial sphere. The structure of
the filmed boxes is inspired by the Municipal
Theater of Casale Monferrato, a typical Italian
"beehive" theater.

Subway Series, 2001
four video projections, DVD, color, stereo sound,
loop, dimensions determined by the space
Fondazione CRT Project for Modern and
Contemporary Art
The particular geometry of baseball and its
relative spaces are rendered as the meeting of
triangular and circular forms. The images and the
title refer to Shea and Yankee Stadiums in New
York.

Breathdeath, 1963
transferred from 16 mm film, black and white, sound, 15 min.
The artist alternates images of destruction and death with a series of youngsters dancing to pop music.
Poemfield No. 2, 1966
transferred from 16 mm film, color, sound, 6 min.
Beginning with electronic elaborations of colored computer graphics on monitors, the work concentrates on the creation and decomposition of pixelled words that become more and more abstract.

Achooo Mr. Kerrooschev, 1960
transferred from 16 mm film, black and white, sound, 2 min.
A short but insistent animation based on repertory and press images shows a selection of funny, even grotesque poses of Nikita Khrushchev.
See Saw Seams, 1965
transferred from 16 mm film, black and white, sound, 9 min.
With almost optical illusions the continuous overlapping, enlargement, and dissolving create collage effects in motion.

Panels for the Walls of the World, 1967
transferred from 16 mm film, black and white, sound, 8 min.
A refined work of montage, starting with many reportage and newsreel photos.
Oh, 1968
transferred from 16 mm film, color, sound, 10 min.
Characterized by the use of bright colors, this animation piece shows faces, profiles, hands, and figures that seem to come out of spots of color, thereby playing with the perceptive processes.
Symmetricks, 1972
transferred from 16 mm film, black and white, sound, 6 min.
The work features animations in rapid superimposition—or in split screen—of circular, luminous plays and movements that create psychedelic and visionary effects and atmospheres.

Selected Works I, 1976–1977
video, color, sound, 48 min. 30 sec.
Purchased with the contribution of the
Compagnia di San Paolo
Newsreel of Dreams: Part I, 1976
video, color, sound, 28 min.
Based on a series of choreographies carried out
for the Elaine Summers Dance Company, in an
almost abstract flow of movements and electronic
sounds, this work includes dance sequences,
poetry, and electronic elaborations of images in
motion, thus structuring a sort of collective
oneiric condition.
Strobe Ode, 1977
video, color, sound, 11 min.
This visionary piece, in which the music is also by
the artist, presents exercises of video feedback
applied to images that are modified and rendered
abstract by means of luminous stroboscopic
flashes.
Vanishing Point Left, 1977
video, color, sound, 9 min. 30 sec.
The vanishing point, referred to in the title, is an
analogy by which to indicate looking at a video
screen that progressively takes on the forms of a
mandala and a flower.

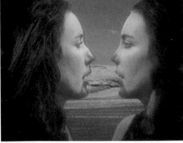

Selected Works II, 1977–1981
video, color, sound, 29 min. 03 sec.
Purchased with the contribution of the
Compagnia di San Paolo
Color Fields Left, 1977
video, color, sound, 7 min. 47 sec.
Abstract images in motion that superimpose
colored bands are the subject matter of this
work. The resulting hypnotic effect is one of
pulsing and increasing luminosity that is also
enhanced by the use of electronic sounds.
Mirrored Reason, 1979
video, color, sound, 9 min. 22 sec.
A narrative evoked by the female face portrayed
in the video tells the story of a woman who
feels obsessed and then persecuted by her
double.
Face Concert, 1981
video, color, sound, 11 min. 54 sec.
The face of a woman produces vocal sounds and
expressions of every kind, while the flow of
images presents multiplied and overlapping
faces that are often in negative.

Selected Works III, 1981–1983
video, color, sound, 29 min. 30 sec.
Purchased with the contribution of the
Compagnia di San Paolo
After Laughter, 1981–1982
video, color, 7 min. 28 sec.
Satellite images of the Earth together with
recordings of off-screen voices give way to a rapid
editing of images of men in motion who seem to
parody the idea of human evolution.
Reeling in TV Time, 1982–1983
video, color, sound, 3 min. 40 sec.
A series of electronic elaborations of a hand in
front of a monitor with a visual feedback effect.

Self-Poured Traits, 1983
video, color, sound, 4 min. 52 sec.
To the reciting of poems by Kenneth Rexroth the
artist creates an electronically elaborated portrait
starting with a photograph and the numerous
superimpositions obtained from it.
Sonia and Stan Paint a Portrait of Ronnie,
1982–1983
video, color, sound, 13 min. 30 sec.
Vanderbeek and the artist Sonia Sheridan carry
out a series of electronic manipulations beginning
with an image of Ronald Reagan and produced
thanks to digital graphic effects created in real
time.

FRANCESCO VEZZOLI
(Brescia, Italy, 1971)

As a collector who gathers considerable quantities of scattered fragments, in his works Francesco Vezzoli collects a complex interweaving of references and citations, thereby recomposing worlds that would otherwise be lost. In combining *auteur* cinema, fashion, art history, and pop culture icons, Vezzoli creates stories imbued with beauty and decadence, fame and human suffering, using, depending on the project, video, photography, installation, performance, and petit-point embroidery.

His approach to cinema is almost pathological and remains the indisputable breeding ground of the artist's myths. Vezzoli's initial inspiration was Visconti's films, beginning with *Conversation Piece*, and has continued over the years in the intimacy of his home thanks to TV broadcasts and video reproductions. The perseverance of this close vision is translated into works that stage Vezzoli's recurrent dream: to be on the set together with his stars, above all those who are nearing the end of their careers. Consequently, video, as "domestic cinema," is the most diffused medium employed by the artist. However, the installation in the form of a projection of large size in darkened rooms intentionally evokes the lost magic of traditional cinema spaces.

Every video is centered on a celebrity or on more than one icon whose intensely human sides are shown by the artist with insistence. Together, and sometimes as a silent extra, the improvised actor—Vezzoli—impersonates himself. An important role in creating the work is entrusted to the production component, organized by using increasingly larger troupes of professionals who are invited to collaborate. In invoking the presence of an external eye, his first videos were directed by well-known cinema directors chosen for their affinity to the project and in virtue of the further references that their presence could generate. This is the case with *An Embroidered Trilogy*, three videos that concentrate on the art of embroidery, another of the artist's great passions. Embroidery in the form practiced and intentionally idealized by Vezzoli is in fact the private aspect of a certain star system, the human torment that is hidden behind the icon of the star. A desperate admission of pain, the act of embroidering has been shared by ranks of stars and some unsuspected intellectuals and, for Vezzoli, it has the form of make-up details, although more often of

blood and tears that when embroidered on canvas correct the surface of the myth.

The blending of "high and low" culture continues in his most recent videos, within which Vezzoli explores the world of television, the format of reality shows that nourish the imaginary, thereby transforming anonymity into a fleeting promise of notoriety. [M.B.]

An Embroidered Trilogy, 1997–1999
Permanent loan of the Region of Piedmont
Ok, The Praz Is Right!, 1997
video projection, DVD, color, stereo sound, 5 min., dimensions determined by the space
The title is a pun referring to the TV show *Ok, The Price Is Right*, whose Italian counterpart was hosted for years by the singer Iva Zanicchi. In the museum-house in Rome of the English studies scholar Mario Praz, the artist is busy making a petit-point embroidery portrait of the scholar while Zanicchi emphatically interprets "La riva bianca la riva nera" ("The White Bank the Black Bank"), one of her hits. The couch on which Vezzoli is seated was in fact embroidered by Praz. The video is directed by John Maybury.

Il sogno di Venere (*The Dream of Venus*), 1998
video projection, DVD, color, stereo sound, 4 min., dimensions determined by the space
The title is the result of an elaboration of *Il sogno di Venere* (*The Dream of Venus*), a film interpreted and co-written by Franca Valeri. In the video, Valeri falls asleep on a couch embroidered by Silvana Mangano, muse of Italian cinema and a solitary embroideress. Valeri dreams of dancing in a nightclub dressed in a sumptuous gown made by Roberto Capucci, the fashion designer who made Silvana Mangano's clothes for the film *Teorema* (*Theorem*) by Pier Paolo Pasolini. In the same club, Vezzoli embroiders details of Mangano's face, whose image is taken from a film by Visconti. The video is directed by Lina Wertmüller while the soundtrack is "Das Model" by Kraftwerk.

The End (teleteatro - teletheater), 1999
video projection, DVD, color, stereo sound, 4
min., dimensions determined by the space
The conclusive episode of the trilogy is filmed in
the home of actress Valentina Cortese, an
apartment with a wealth of fabrics she herself
embroidered. While Vezzoli embroiders the face
of Douglas Sirk—the movie director considered
the inventor of Hollywood cinema melodrama—
Cortese interprets "Help!" by the Beatles.
Directing and photography are by Carlo Di
Palma.

The End of the Human Voice, 2001
double video projection, DVD, black and white,
color, stereo sound, 15 min., dimensions
determined by the space
Purchased with the contribution of the
Compagnia di San Paolo
The video is inspired by the theatrical text *La
voix humaine* (*The Human Voice*) by Jean Cocteau

and brought to the silver screen by Roberto Rossellini. As in the original version, the story stages the slow agony of an unrequited love, told through the monologue of a woman who for the last time talks on the phone with the man who has left her. The woman is interpreted by Bianca Jagger. The male lover is Francesco Vezzoli who, in homage to Jean Cocteau, portrays himself with his eyelid covered by the photograph of an eye. Also inspired by Cocteau is the choice of music, the "Gymnopédies" by Erik Satie. This is the first video directed by Vezzoli, while the photography is by Darius Khondji.

BILL VIOLA
(New York, 1951)

For Bill Viola, art is part of a process of transformation, offering the possibility to develop a deeper understanding of existence by means of an extremely personal course. Viola's works delineate new spheres in the history of video, and the artist's career is a paradigm for comprehending the development of this form of expression. While still an adolescent, Viola conducted his first experiments with sound and visual recording techniques. He enrolled at Syracuse University (New York), where he took part in a pilot program dealing with the new electronic technologies. Upon completion of his studies, he worked as a video technician at the Everson Museum, also at Syracuse. It was here that he collaborated in the installation of the first exhibitions entirely dedicated to video and its pioneers.

His first works dating to the early seventies participated in that spirit which defined the possibilities of the electronic medium. Particular visual or acoustic properties were the subject of his first tapes, produced by recording and observing the real world and subjecting the images to elaboration and editing. What became apparent was the attention paid to psychic and emotive states characterizing human experience (with the artist often appearing in these videos). A potentially anonymous subject, his presence does not, however, imply any autobiographical reference. Throughout his career, the attention to subject matter in his works runs parallel to his particular use of the most sophisticated techniques available (often creating new applications for them).

Viola's continuous traveling is an integral part of his research. The diversity of the artist's travels contributes to an uninterrupted spiritual exploration.

From the eighties onwards, the artist has developed his works in the form of multiple-channel video installations, conceived with the intention of enveloping the observer with images and sounds whose non-linearity represents the manifold possibilities of the psyche and the human soul. Archetypal images, processes of birth, growth, and death represent some of the recurrent themes. The main starting point is the artist's personal experiences, though transformed into situations of universal value.

Raised in a Christian environment, Viola followed his own spiritual path that led him to Oriental mysticism.

However, in works produced from the mid-nineties, he has returned to explore Christian iconography, paying particular attention to its Medieval, Renaissance, and Mannerist representations.

The progressive degree of complexity found in Viola's installations also demands the use of actors and a large ensemble that the artist directs on sets comparable to those of cinema and built in the studio. The recorded images—sometimes also using 35 mm film—are successively elaborated with the most advanced digital technology. Music, sound effects, and computer elaboration are integral parts of the installations.

His latest works include, in addition to large-scale projected images, plasma or LCD screens that recall the history of religious painting, from altar-pieces to the intimate scale of votive paintings. [M.B.]

The Reflecting Pool –
Collected Works,
1977–1980

Red Tape - Collected Works, 1975
video, color, sound, 30 min.
Purchased with the contribution of the
Compagnia di San Paolo
The first collection presented by the artist
anticipates many of the themes more fully
investigated in his later production. Though
independent, the five videos contained in this
collection represent a thematic whole.

Playing Soul Music to My Freckles, 1975
video, color, sound, 2 min. 46 sec.
The freckles on the artist's skin are the public
audience to which music by Aretha Franklin is
dedicated, transmitted by way of a loudspeaker
placed on his back.

A Non-Dairy Creamer, 1975
video, color, sound, 5 min. 19 sec.
The simple, daily ritual of drinking coffee is the
subject "amplified" by means of a fixed camera
image and a "soundtrack" that concentrates on
every minute noise connected to human
presence and activity. The coffee drinking
coincides with the disappearance of the image
of the person reflected in the coffee cup.

The Semi-Circular Canals, 1975
video, color, sound, 8 min. 51 sec.
Surrounded by a rural setting and its sounds,
the half-bust frame of the artist's body is the
pivot around which the small microcosm shot
by the camera revolves. The title refers to the
portion of the inner ear that controls balance.

A Million Other Things (2), 1975
video, color, sound, 4 min. 35 sec.
The direct recording of different sounds and
situations of light articulates the otherwise fixed
framing of a man near a warehouse overlooking
a lake. Filmed over the course of eight hours,
the video concludes with the singular image of a
man in profile.

Return, 1975
video, color, sound, 7 min. 15 sec.
The artist holds a bell that he rings
intermittently. As he moves closer to the
camera, each time he rings the bell the man's
body is returned to its starting point, as if
incapable of achieving the goal he had set for
himself.

Four Songs, 1976
video, color, sound, 33 min.
Purchased with the contribution of the
Compagnia di San Paolo
Viola calls the four videos here collected "canti"
in order to underline the close relationship that
ties him to the principles of musical
composition.
Junkyard Levitation, 1976
video, color, sound, 3 min. 11 sec.
In a junkyard of metal waste bordering on a
railway, a man carries out an exercise of
levitation.
Songs of Innocence, 1976
video, color, sound, 9 min. 34 sec.
On a sunny day, a children's choir interprets a
song. When they finish, the choir leaves the
field filmed by the camera, which remains fixed
in order to record the hours passing, from
sunset until the darkness of night, describing
the inexorable flowing of time, the persistence
of memory, and the inevitability of death.
The Space between the Teeth, 1976
video, color, sound, 9 min. 10 sec.
Seated at the end of a long corridor a man
emits a liberating shout at regular intervals.
The movement of the camera describes the
close physical and emotive relationship between
architectural space and the sound that
periodically invades it. The video is carried out
using the most advanced editing techniques
available at the time.

243

Truth through Mass Individuation, 1976
video, color, sound, 10 min. 13 sec.
A man carries out different actions: he throws a metal object into a flock of pigeons, he shoots into the air in the streets of New York and then into a crowd at a stadium. The title refers to the writings of Carl Jung on notions of the individual and the masses.

Migration, 1976
video, color, sound, 7 min.
Purchased with the contribution of the Compagnia di San Paolo
The sound of a gong articulates the structure of this video that is centered on the analysis of an image whose detail unfolds gradually. The work culminates in the close-up of a drop of water, a microcosm capable of reflecting and enclosing within itself the uniqueness of the person observing it.

Memory Surfaces and Mental Prayers, 1977
video, color, sound, 29 min.
Purchased with the contribution of the Compagnia di San Paolo
The three videos regard the nature of reality, understood as an entire body of simultaneous elements that happen in different spaces.
The Wheel of Becoming, 1977
video, color, sound, 7 min. 40 sec.
The image has the form of a quadripartite mandala. Inside it are images of an equal number of individuals, underlining the concomitance in time and space of events and actions.
The Morning after the Night of Power, 1977
video, color, sound, 10 min. 44 sec.
The frame is fixed on a vase placed on a table. Domestic life unfolds around the object. The title refers to a passage in the Koran: the night during which the disciples receive inspiration from

angels descended from the sky.
Sweet Light, 1977
video, color, sound, 9 min. 08 sec.
A moth approaches the light, only to be
destroyed by it. This event becomes a metaphor
of human experience.

Palm Trees on the Moon, 1977
video, color, sound, 26 min. 06 sec.
Purchased with the contribution of the
Compagnia di San Paolo
Set on the Solomon Islands, the video records a
traditional dance and music festival at
Guadalcanal, an island that was a theater of cruel
clashes during World War II. The video is
constructed in relation to the artist's experience
on the island, juxtaposing indigenous cultures and
Western influences. During the same period,
UNESCO organized a workshop dealing with
the use of video technology with the intention of
offering the local populations a means for
recording and possibly preserving their culture.

The Reflecting Pool - Collected Works, 1977–1980
video, color, sound, 62 min.
Purchased with the contribution of the
Compagnia di San Paolo
The collection comprises five autonomous
works that when grouped together narrate the
stages of existence from life to death. Filmed
with varying techniques, the videos are
characterized by images of transition, lingering
on the passing from day to night, from
movement to immobility, and from the
transient to the eternal.
The Reflecting Pool, 1977–1979
video, color, sound, 7 min.
A pond in the heart of the woods reflects the
flowing of time.
Moonblood, 1977–1979

video, color, sound, 12 min. 48 sec.
A woman, the alternation of day and night, light and shadow, movements of water, city sounds, nature, and the calm of the desert: these images and sounds flow with intentional slowness, isolating sensations and emotions that would otherwise be indefinable.
Silent Life, 1979
video, color, sound, 13 min. 14 sec.
Filmed in documentary style, the video is set in the maternity ward of a hospital and films newborn babies, lingering on their expressions, first emotions, and the specific language made up of sounds, crying, and wailing.
Ancient of Days, 1979–1980
video, color, sound, 12 min. 21 sec.
In a process comparable to musical composition, Viola weaves natural and subjective time and their different rhythms. The changes in nature are summarized in the final image of a still life painted on canvas and mounted on a wall.
Vegetable Memory, 1978–1980
video, color, sound, 15 min. 13 sec.
Structured as a cyclical vision and intentionally repetitive, the video contemplates the phenomenon of time, death, and material dissolution.

Chott el-Djerid (A Portrait in Light and Heat), 1979
video, color, sound, 28 min.
Purchased with the contribution of the Compagnia di San Paolo
Images of the desert, filmed at moments of maximum temperature, are alternated with winter shots recorded in Illinois and Saskatchewan. With special telephoto lenses, the artist captures the mirages caused by the sun's heat and the loss of visibility due to snowstorms, recording images at the limit of perception. The title refers to a salt lake, a location on the Tunisian side of the Sahara.

246

Sodium Vapor (Including Constellation and Oracle),
1979, published in 1986
video, color, sound, 14 min. 41 sec.
Purchased with the contribution of the
Compagnia di San Paolo
The title refers to the type of urban lighting used
in New York. Set in the heart of the night, the
video films city life and the slowed rhythm that
characterizes the night hours, capturing lights,
shadows, and particular effects caused by the
illumination.

Hatsu Yume (First Dream), 1981
video, color, stereo sound, 56 min.
Purchased with the contribution of the
Compagnia di San Paolo
In meditating on the notion of light, its
relationship with water, and the opposites
represented by darkness and night, the video is
set in the landscape of contemporary Japan. The
observation of location, described through the
cycle of a sunny day, becomes the symbolic
metaphor of life and death.

Anthem, 1983
video, color, sound, 11 min. 30 sec.
Purchased with the contribution of the
Compagnia di San Paolo
The shout of an immobile girl, inside a station of
Los Angeles, is modified in such a way as to
produce a sequence of seven notes reminiscent of
a religious canto (repeated during the video). The
sequence articulates an alternation of images that
record elements of daily life, the realities of heavy
industry, surgical operations, and obsessions
regarding the body.

Reasons for Knocking at an Empty House, 1983
video, black and white, sound, 19 min. 11 sec.
Purchased with the contribution of the
Compagnia di San Paolo
The fixed position of the video camera records
the passing of time and the behavior of the artist,
secluded for three consecutive days in an
apartment.

*Reverse Television - Portraits of Viewers (Compilation
Tape)*, 1984
video, color, sound, 15 min.
Purchased with the contribution of the
Compagnia di San Paolo
Through a series of portraits of people of
different ages, filmed in their homes while seated
and staring into the camera, the artist creates a
project intended for closed-circuit television that
undermines the traditional relationship between
TV and its "invisible" audience. Conceived as
surprise inserts within television shows, the
images were broadcast for the first time by
WGBH-TV television channel in Boston from
November 14 to 28, 1983. This 1984 video
documents the project in a collection of the
portraits, reduced to fifteen seconds each.

I Do Not Know What It Is I Am Like, 1986
video, color, sound, 89 min.
Purchased with the contribution of the
Compagnia di San Paolo
A journey in search of the intimate connections
to animal consciousness all humans carry within,
the video unfolds by a progression of images
beginning from the natural world (from the
initial non-differentiated stages of life) up to
logical and spiritual states. The work is structured
in five parts: *Il Corpo Scuro* (*The Dark Body*), *The
Language of the Birds*, *The Night of Sense*, *Stunned
by Drum*, and *The Living Flame*. The title of the
work was taken from the *Rigveda*, a Sanskrit text

that through the stages of birth, awareness, primordial existence, intuition, knowledge, and rational thought and faith arrives at a transcendent reality, beyond the laws of physics.

Angel's Gate, 1989
video, color, sound, 4 min. 50 sec.
Purchased with the contribution of the Compagnia di San Paolo
Brief sequences of images describe dissolution, impermanence, the passing of time, and the explosive beginning of life documented through the birth of a baby boy. The final image consists in a metaphoric passage by means of a gate and entrance to a world of pure light.

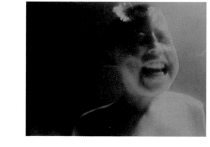

The Passing, 1991
video, black and white, sound, 54 min. 13 sec.
Purchased with the contribution of the Compagnia di San Paolo
Memory and reality, infancy and old age, birth and death become blurred in the images that flow like multiple experiences of the spirit and the mind. The personal point of view and the family life of the artist narrate experiences of a universal value.

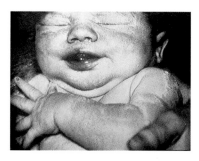

Déserts (Deserts), 1994
video, color, sound, 26 min.
Purchased with the contribution of the Compagnia di San Paolo
The work begins in accompaniment to a concert by Edgar Varèse, executed by the German group Ensemble Modern. The video presents natural landscapes ranging from ocean beds to deserts and urban views. The only human presence is a man, alone, inside a rarefied domestic surrounding. The light that is artificial, natural, reflected, or emanated by the fire is a recurrent element that enhances the musical sonorities. The choice of the images develops some notations left by the composer.

WILLIAM WEGMAN
(Holyoke,
Massachusetts,
1943)

After his studies, William Wegman soon developed a systematic interest in unconventional means within experimental artistic research works. Interested in the actions and reactions of sound, light, and a wide range of different materials such as mud, vegetal elements, strings and cords, radios, tennis rackets, and even gunpowder, the artist nurtured his curiosity regarding the potentials of photography and video. Fascinated by the possibility of recording the most unexpected, sudden, and ephemeral situations, he has used both media throughout his career. From its early stages, Wegman's oeuvre has been characterized by his essential descriptive tone, dry and rich in humor. Minimal actions carried out in a seemingly informal way create considerably surprising effects.

As the artist recalls, almost out of necessity, he chose his dog—a Weimaraner named Man Ray—as his main protagonist. This choice rapidly became a project that evolved over the years and in which the dog has been elevated to the role of the artist's alter ego. The many performances—initially quite basic, though gradually more complex and at times even with the participation of other dogs of the same breed—create a body of highly recognizable, conceptual works.

Through an immediate use of the audiovisual medium, Wegman created unexpected and often brilliant, ironic situations that, over time, have evolved to more extensive narrative forms. Since his first videos, shot in real time in front of a fixed video camera, Wegman's work is structured as brief, anecdotal narration, often characterized by a surreal visual aesthetic.

His peculiar ability to focus on the character of Man Ray, electing him as the "protagonist," instigates a reversal of roles, producing grotesque, ironic, even tender situations where the dog's ability to react is key. In retrospect, most of Wegman's videos can be interpreted as an authentic counterpoint to a number of investigations and actions developed during the same period within the fields of Conceptual and Body Art. [F.B.]

Selected Works: Reel 1, 1970–1972
video, black and white, sound, 30 min. 38 sec.
Purchased with the contribution of the
Compagnia di San Paolo
In this first compilation of short works, Wegman
creates a series of ironic scenes with film material
dealing with his own body, everyday objects and
situations, and his dog Man Ray.
In a sequence shot frontally with a fixed camera,
Wegman moves out of the frame while leaving a
long streak of milk that drips from his mouth
onto the floor and which Man Ray laps up
enthusiastically, crossing the same space in the
opposite direction. In another sequence, Wegman
makes his naked chest and stomach "sing" and
"talk," almost miming facial expressions with the
simple and somewhat daft ability to contract his
navel and stomach muscles.

Selected Works: Reel 2, 1972
video, black and white, sound, 14 min. 19 sec.
Purchased with the collaboration of the
Compagnia di San Paolo
Wegman plays with viewers' expectations and the
ability to manipulate the outcome of an action.
Man Ray pushes a bottle across the floor trying
to access its contents. The video ends when the
bottle is broken. In another sequence, the artist
and his dog seem to exchange a long and
passionate kiss. The classic game of coin flipping
follows: depending on whether the result is heads
or tails, the artist physically turns Man Ray.

Selected Works: Reel 3, 1973
video, black and white, sound, 17 min. 54 sec.
Purchased with the contribution of the
Compagnia di San Paolo
This collection concentrates on absurd aspects of
the *mise en scène*. In one video, with his cheeks
covered with shaving cream, Wegman tells a story
about himself, stating that he was born without a

mouth. In another work, Man Ray is given a close-up, alert and obedient with his head raised looking upwards, as if trying to understand what he is asked to do from an off-screen voice. In another video, Man Ray rotates his head as if his movements were human.

Selected Works: Reel 4, 1973–1974
video, black and white, sound, 20 min. 57 sec.
Purchased with the contribution of the Compagnia di San Paolo
A series of monologues, which seems to recall commercial advertising, involves Man Ray once more. For example, the dog is happily sleeping on a bed until unexpectedly woken up by an alarm clock. Alternately, he is called to go in two different directions by two people, thus turning his head from left to right to left again. Also, seated on a table, Man Ray is subjected to pronunciation lessons by Wegman in a classical and predictable didactic fashion.

Selected Works: Reel 5, 1974–1975
video, black and white, sound, 26 min. 38 sec.
Purchased with the contribution of the Compagnia di San Paolo
In this selection, the focus is on long actions Man Ray's presence brings to abrupt and unexpected finales. In an extreme close-up, the dog laps up the entire content of a glass of milk. In another scene, he maintains an elegant and dignified pose until a small ball surprisingly pops out of his mouth. In another one, he observes a lump of sugar on a table until he finally decides to eat it.

Selected Works: Reel 6, 1975
video, black and white, color, sound, 18 min. 35 sec.
Purchased with the contribution of the Compagnia di San Paolo
Logical incongruities between what is seen and what is unseen result in a number of comical actions. Moving their heads from right to left, in synchronization, Man Ray and another dog carefully follow something rigorously kept off-screen.

Selected Works: Reel 7, 1976–1977
video, color, sound, 17 min. 54 sec.
Purchased with the contribution of the Compagnia di San Paolo
The narrative forms developed in this series of videos are mainly concentrated on the unpredictable behavior of Man Ray. Wegman asks his dog to smoke or, seated with him on a couch, tries to get his attention with pathetic calls. Moreover, with extreme close-ups of his mouth, both talking and whistling, the artist impersonates two characters, while the dog performs almost like a professional actor.

Selected Works: Reel 8 (Revised), 1997–1998
video, color, sound, 25 min. 40 sec.
Purchased with the contribution of the Compagnia di San Paolo
Most of these short works focus on the world of entertainment and television, with Wegman playing the role of a magician, a set assistant, a writer, or a director. The various situations are alternated with footage of the artist's appearance on the well-known David Letterman Show, along with portraits of Wegman seated on a large sofa in the company of his beloved Weimaraners.

**LAWRENCE WEINER
(New York, 1942)**

Lawrence Weiner has elaborated a rigorous oeuvre that reflects and encourages the interaction of both linguistic and artistic themes, having worked with installations (especially site-specific ones), videos, films, books, audio recordings, sculptures, and performances.

Considered one of the founders of Conceptual Art, Weiner is known for his interest in establishing new artistic forms, searching for innovative modes of reception. His commitment in terms of a renewed notion of "democratic" art, an art capable of adapting itself and modifying its forms in relation to cultural and social changes, is the fundamental characteristic of his entire body of work. His videos and films are the result of an analysis and research dealing with the process and the act itself of "making art" in relation to the nature of the artistic object and the variable contexts in which the most diverse materials are employed.

Since his first works, Weiner has developed an artistic investigation expressed both through video and cinema. This consisted in using all of the elements of cinema production, although restructuring these and often drastically reinventing their underlying rules and conventions.

Weiner's particular and original work method takes on form in the audiovisual medium exactly as it does in his

A First Quarter, 1973

publications, posters, and vast site-specific installations. His typical "statements"—often in the form of phrases or sentences—become instruction-objects, a work method proposed and personified through actors, situations, and actions. With cinema and video Weiner demonstrates the multiplicity of possibilities with which investigation and reflection can take on form—whether physical or theoretical—and how this can influence our own interpretation of the world. [F.B.]

Beached, 1970
transferred from 16 mm film, black and white, sound, 3 min.
Purchased with the contribution of the Compagnia di San Paolo
Dedicated to five material possibilities relating to a piece of wood, this work presents the artist involved in different actions in which he grasps or removes the wood floating on the sea.

Broken Off, 1970
video, black and white, sound, 2 min.
Purchased with the contribution of the Compagnia di San Paolo
Five specific actions "under the direct responsibility of the artist" make up this video. He snaps a branch, hits the ground with his foot, detaches a piece of wood from a stake-fence, scratches a stone with his fingers, and, in conclusion, disconnects the cables of the console.

Shifted from the Side, 1972
video, black and white, sound, 1 min.
Purchased with the contribution of the Compagnia di San Paolo
With a fixed framing, a packet of cigarettes on a table is repeatedly moved back and forth by a hand while an off-screen voice repeats the manifold conditions of existence of a work of art.

To and Fro. Fro and To. And To and Fro. And Fro and To, 1972
video, black and white, sound, 1 min.
Purchased with the contribution of the
Compagnia di San Paolo
A glass ashtray is repeatedly moved by a hand
from one side of a table to the other while an off-
screen voice rapidly pronounces the same
sentences of the *Shifted from the Side* video. The
framing remains fixed.

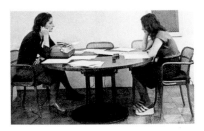

A First Quarter, 1973
16 mm film transferred from video, black and
white, sound, 85 min.
Purchased with the contribution of the
Compagnia di San Paolo
The artist's first full-length film, it was originally
produced in video form and transferred to 16 mm
film, which lends the images a soft and blurred
texture. In a variety of situations, shot both
outside and inside, we follow the days of two
women and a man who live and often work
together, sharing spaces and places. The
occasional dialogues consist in an equal number
of statements of the artist, works read,
interpreted, and lived by the protagonists.

Affected and/or Effected, 1974
video, black and white, sound, 20 min.
Purchased with the contribution of the
Compagnia di San Paolo
The video opens with the close-up of a woman
who reads a book seated at a table. A male off-
screen voice repeats "affected." A female voice
completes the phrase replying "and/or effected."
In the course of the video, the two voices
alternate and propose different verbal associations
between the word "affected" and fragments of
phrases, leading to the statement on which the
work is based.

Done To, 1974
transferred from 16 mm film, black and white, sound, 23 min.
Purchased with the contribution of the Compagnia di San Paolo
A woman is seated alone on a couch while reading. She is then joined by a girlfriend with whom she begins to talk. Simultaneously, two alternated voices give rise to a quick series of questions and statements. As in a number of Wiener videos, the woman is Kathryn Bigelow.

A Second Quarter, 1975
transferred from 16 mm film, black and white, sound, 85 min.
Purchased with the contribution of the Compagnia di San Paolo
This second full-length film was created during a study sojourn in Berlin. The entire film reflects the close proximity of barriers, focusing on concepts of borders and the geophysics and geopolitics of the city that at the time was divided by the Wall.

Green as Well as Blue as Well as Red, 1975–1976
video, color, sound, 18 min.
Purchased with the contribution of the Compagnia di San Paolo
Two women sit opposite each other at a table, using and handling some objects and two small red books. Off-screen, the voices of a woman and a man, Bigelow and Weiner, are heard along with a march in the background, an historical recording of a Brigade during the Spanish Civil War. The work is structured around a series of dialectical relationships among the staged actions, focusing on gestures and words, colors of objects and clothing, and topics discussed by the voices, including methodology, logic, dialectics, syllogisms, and forms of domination.

A Bit of Matter and a Little Bit More, 1976
video, color, sound, 23 min.
Purchased with the contribution of the
Compagnia di San Paolo
The relationships between man and woman,
between subject and object are here taken to a
degree of explicit representation. The video
portrays heterosexuals, homosexuals, and more
eccentric heterosexual behavior. In particular, a
young woman discusses with an off-screen female
voice her role as observer and moderator. Finally,
a male voice reads two statements regarding
"some questions and an equal number of answers
dealing with images in motion."

Do You Believe in Water?, 1976
video, color, sound, 39 min.
Purchased with the contribution of the Compagnia
di San Paolo
"Do you think you are able to give qualitative
judgements about colors? Do you think there can
be emotive answers to colors?" In these questions,
repeated more than once in this long and refined
video, lies the heart of the work itself. In a spacious
loft with columns and a large octagonal table, there
are three couples: one is composed of two women,
one by two men, and one by a woman and a man.
Various actions—including those of an erotic
nature—are elaborated by the protagonists while
lighting conditions vary and some cylindrical and
square objects are moved. This work was created
for Weiner's solo exhibition held in New York at
The Kitchen in 1976. Ambiences and objects
present in the video were also part of the exhibition
installations.

For Example: Decorated, 1977
video, color, sound, 23 min.
Purchased with the contribution of the
Compagnia di San Paolo
In a single, long, and continuous sequence, two

men and a woman—Peter Gordon, Sarkis, and Britta LeVa—gaudily dressed and made-up and seated around a table, talk about themes regarding the relationship between artists and their activity, between activity and the new forms of communication and television, and between the artist and the public. The audio track becomes progressively confused with the superimposition of sound from previous audio works by Weiner. The conversation moves successively on to other themes like fashion, cross-dressing, and lifestyles.

Altered to Suit, 1979
transferred from 16 mm film, black and white, sound, 23 min.
Purchased with the contribution of the Compagnia di San Paolo
Set in the artist's studio, it is the first film by Weiner in which the narrative aspect is prevalent. Through the use of images often unsynchronized with the soundtrack, together with the choice of unusual framings, the film reconstructs the story of a man, his female companion who suffers from agoraphobia, their daughter, and a female friend of the family.

There But For, 1980
video, color, sound, 20 min.
Purchased with the contribution of the Compagnia di San Paolo
Filmed inside an apartment, the video is centered on the daily life of a couple in crisis and their friends. The story takes place in a clearly defined domestic space in which the interaction among the stereotyped characters of the protagonists constitutes the structure of the narration. The soundtrack by Peter Gordon is played live during the shooting.

Passage to the North, 1981
transferred from 16 mm film, color, sound, 16 min. 20 sec.
Purchased with the contribution of the Compagnia

di San Paolo
A group of men and women are forced to share cramped spaces. Some of them would like to go north, others do not want to, and others do not seem to care and discuss the differences between north and south. Some of the dialogues are improvised while others are part of the script. Images of a boat in flames, put out by firemen, are included in the course of the dialogue. The atmosphere is tense, cold, and uncertain: the themes of the journey, of emigration, and of distance recur almost as refrains to the occasional and spontaneous flow of the meetings and dialogues of the characters.

Plowman's Lunch, 1982
transferred from 16 mm film, color, sound, 29 min.
Purchased with the contribution of the Compagnia di San Paolo
Probably Weiner's most complete film, the work is a fictional narrative with characters. Filmed in color, with original music by Peter Gordon, the film involves three protagonists, two women and a transvestite, in a plot dealing with the theme of emigration and the journey. Mainly set on an old boat while traveling, this work describes the desires, thoughts, and actions of the various characters and mixes different languages, including English, Dutch, French, and German. In a continuous intersection of different situations, the journey continues amidst dialogues, discussions, and clashes as the group complains to the Captain of the boat. As stated by the protagonists they want to go "somewhere" but they have simply arrived "nowhere" and wonder why they have not arrived "anywhere."

Nothing to Lose, 1984
video, color, sound, 22 min.
Purchased with the contribution of the Compagnia di San Paolo
The video documents a performance presented in the morning and in the evening on October 16,

1984 at the Cultureel Centrum Kuiperspoort in Middleburg (Holland). The set of the event is made up of two buildings around which a sailor and two women in costume—one interpreted by Marina Abramovic—obsessively repeat the same gestures.

Reading Lips, 1996
video, black and white, sound, 10 min.
Purchased with the contribution of the Compagnia di San Paolo
Three women in close-up discuss death and emotional topics while busy carrying out simple, everyday activities.

Hearts and Helicopters: A Trilogy, 1999, compiled in 2000
video, color, sound, 52 min. 25 sec.
Purchased with the contribution of the Compagnia di San Paolo
Eyes on the Prize: Part One of Hearts and Helicopters, 1999
video, color, sound, 19 min. 25 sec.
How Far Is There: Part Two of Hearts and Helicopters, 1999
video, color, sound, 17 min.
With a Grain of Salt: Part Three of Hearts and Helicopters, 1999
video, color, sound, 16 min.
Divided into three parts, the work investigates a moment of change in the life of the four protagonists. In an analogous way to the previous videos with their strong narrative impact, the three episodes stage refined linguistic games and role playing.

ROBERT WILSON
(Waco, Texas, 1941)

Robert Wilson has been interested in the theater since he was an adolescent. He studied business and, after moving to New York, he attended courses in architecture and design. In New York, he soon became interested in the choreography of such modern dance masters as George Balanchine, Merce Cunningham, and Ann Halprin, and he attended the classes of Martha Graham. In 1963, he made an experimental work called *Slant*. He also designed decor and costumes for several artistic events and studied painting in Paris. In 1969, he made his debut in New York with *The King of Spain* and *The Life and Times of Sigmund Freud*. Among his most important works, these two productions involve theatrical images combined with an innovative use of light and time.

He was subsequently highly praised for his *Deafman Glance*, a silent "opera" made in collaboration with Raymond Andrews, a deaf and mute boy Wilson had adopted. From that moment on he presented new productions including *Ka Mountain and Guardenia Terrace*, lasting seven days in Shiraz (Iran) in 1972, and *The Life and Times of Joseph Stalin*, another silent work lasting twelve hours, presented in New York in 1973 and subsequently in Europe and South America. During the nineties, for the Thalia Theater of Hamburg, he created a series of musical works, the fruit of collaboration with musicians such as Tom Waits and Lou Reed: *The Black Rider* (1991), *Alice* (1992), *Time Rocker* (1996), and *Poetry* (2000).

Wilson's highly stylized "theater of images" is characterized by a strong interest in the scenic arts of the Far East and by a particular analysis of theatrical temporality, forms of non-verbal communication, an architecturally conceived stage production, and a totally unique use of actors.

Intrigued by the possibilities offered by electronic technology, since 1978 he has produced innovative works for television (such as *Video 50* in 1978 and *Deafman Glance* in 1981). Visually stylized in the same way, these video stories are rendered with a controlled, careful, visual elegance and sober yet abundant use of unexpected symbolic images, ritual gestures, and hyperreal atmospheres. The lights and movements, the time and the space take the place of language. Atmospheres at the same time sinister, frozen, imaginative, and almost surreal live together in situations where minimal actions and repeated gestures structure Wilson's poetics. [F.B.]

Video 50, 1978
video, color, sound, 51 min. 40 sec.
Purchased with the contribution of the
Compagnia di San Paolo
Almost a sort of video notebook, *Video 50* is a
collection of approximately one hundred short
episodes, somewhere between the dramatic and
the humorous, originally produced for TV and
with an average duration of 30 seconds. The
intense theatricality, the affinity to symbolic
images, and a certain surreal taste are mixed with
combinations and repetitions of skillfully
orchestrated visual motifs.

Deafman Glance, 1981
video, color, sound, 26 min. 53 sec.
Purchased with the contribution of the Compagnia
di San Paolo
A television adaptation of the eponymous work—
often defined as a "silent opera"—the video shows
a highly and darkly stylized story of homicide,
reinventing the values and customs of the time and
space represented. A careful use of lighting and
isolated sounds that replace words emphasizes the
period atmosphere. The recurrent actions, always
silent, set in a house with an essential and spartan
appearance, develop an atmosphere somewhere
between dream and nightmare, repelling and
inviting all at the same time.

Stations, 1982
video, color, sound, 56 min. 19 sec.
Purchased with the contribution of the
Compagnia di San Paolo
In thirteen short segments, this video narrates the
story of an eleven-year-old boy who in order to
realize his fantasies approaches a magical world,
one obviously extraneous to his family. Through
the large kitchen window of his home he sees his
inner fantasies come true, becoming elegant,
pictorial compositions.

JULIE ZANDO
(Watertown, New York, 1961)

In her videos, centered on elaborate and expressive staging, Julie Zando dedicates herself to narrative forms bound to an attentive psychoanalytical interpretation of the private sphere and to a study of female relationships.

Through an analysis of social dynamics of different forms of relationships among lovers, friends, mothers, and daughters, she has explored scenarios of subjectivity and sexuality in multiform expressions of obsession, dependence, manipulation, submission, exhibitionism, voyeurism, masochism, and victimization.

Enthralling, at times almost crude and possessing an immediate force, Zando's video works are characterized by their ability to unite psychoanalytical theory with performance, though never renouncing the use of narrative structures, which help to show how different phenomena, such as the many forms of emotion and love, are often used as a means of blackmail, exploitation, or psychological control. Combining narrative dramatizations and documentary descriptive forms, over the years the artist has developed a novel approach to interpreting the complex interactions among narration, psychological description, and technological mediation. [F.B.]

Let's Play Prisoners, 1988
video, black and white, sound, 22 min.
Purchased with the contribution of the Compagnia di San Paolo
The video presents two versions of a short story in which a young girl manipulates and abuses a girlfriend. In one version, the author of the story and the artist take on the roles of the girls. In the other version, a young girl re-tells the story following the suggestions of her mother. In Zando's reconstruction, the underlying dynamic that characterizes relationships of dominance and submission between persons of the same sex is the explicit focus.

The A Ha! Experience, 1988
video, color, sound, 4 min. 32 sec.
Purchased with the contribution of the Compagnia di San Paolo
A young woman, returning from a rendezvous, becomes unsettled as she sees in the mirror the vision of her mother in her bed.
The imagined presence of her mother's body profoundly obsesses and haunts the girl's sexual desire to the point of conditioning her behavior. With a style that alternates slowed images and overlappings, the artist creates an oneiric flow in which she investigates the psychoanalytical, social, and personal dynamics of intimate relationships.

The Bus Stops Here, 1990
video, black and white, color, sound, 27 min.
Purchased with the contribution of the Compagnia di San Paolo
Ana, a writer, develops her own sexual and psychological identity by means of the novel she is writing. Her sister, chronically depressed, progressively loses autonomy and power, gradually withdrawing into silence. The manuscript of the novel, which Ana hides, tells the story of her desires.

DOCUMENTARIES

MONOGRAPHIC DOCUMENTARIES

Architecture

Tadao Ando, 1989
video, color, sound, 59 min. 12 sec.
Production: Michael Blackwood Productions
Purchased with the contribution of the
Compagnia di San Paolo

Frank O. Gehry: An Architecture of Joy, 2000
video, color, sound, 57 min.
Production: Michael Blackwood Productions
Purchased with the contribution of the
Compagnia di San Paolo

Arata Isozaki, 1985
video, color, sound, 54 min.
Production: Michael Blackwood Productions
Purchased with the contribution of the
Compagnia di San Paolo

Arata Isozaki II, 1991
video, color, sound, 58 min. 39 sec.
Production: Michael Blackwood Productions
Purchased with the contribution of the
Compagnia di San Paolo

*Berlin's Jewish Museum: A Personal Tour with Daniel
Libeskind*, 2000
video, color, sound, 57 min. 47 sec.
Production: Michael Blackwood Productions
Purchased with the contribution of the
Compagnia di San Paolo

*Renzo Piano: architecte au long cours (Renzo Piano: Long-Term
Architect)*, 1999
video, color, sound, 52 min.
Production: Mirage Illimité, Grand Canal, Centre Georges
Pompidou
Castello di Rivoli Museum of Contemporary Art,
Rivoli-Turin

Art

Bacon, 1985
video, color, sound, 55 min.
Production: Home Vision PMI Company
Castello di Rivoli Museum of Contemporary Art,
Rivoli-Turin

Francis Bacon and the Brutality of Fact, 1985
video, color, sound, 58 min. 30 sec.
Production: Michael Blackwood Productions
Purchased with the contribution of the
Compagnia di San Paolo

Basquiat, 1996
video, color, sound, 107 min.
Production: Miramax International, Pathé, John Kilik
Castello di Rivoli Museum of Contemporary Art,
Rivoli-Turin

Joseph Beuys. Difesa della natura: Bolognano 13 maggio 1984
(Defense of Nature: Bolognano May 13, 1984), 1984
video, color, sound, 26 min. 10 sec.
Production: Associazione culturale Il Clavicembalo, Centro
Molok Rosso
Castello di Rivoli Museum of Contemporary Art,
Rivoli-Turin

Diagramma terremoto (Earthquake Diagram): Joseph Beuys,
Naples, 1981, 1997
video, color, sound, 16 min. 15 sec.
Production: Scognamiglio & Teano
Castello di Rivoli Museum of Contemporary Art,
Rivoli-Turin

Christian Boltanski. Signalement (Descriptions), 1992
video, color, sound, 113 min.
Production: Centre Georges Pompidou
Castello di Rivoli Museum of Contemporary Art,
Rivoli-Turin

Christian Boltanski, 1997
video, color, sound, 53 min.

Production: Phaidon, Gerald Fox
Castello di Rivoli Museum of Contemporary Art,
Rivoli-Turin

*Christian Boltanski. Les archives de C. B. (The Archives
of C. B.)*, 1998
video, color, sound, 52 min.
Production: Les films du Siamois, Canal+, Love Streams,
Centre Georges Pompidou
Castello di Rivoli Museum of Contemporary Art,
Rivoli-Turin

Louise Bourgeois, 1993
video, color, sound, 52 min.
Production: Terra Luna Film, Centre Georges Pompidou
Castello di Rivoli Museum of Contemporary Art,
Rivoli-Turin

Buren, 1998
video, color, sound, 13 min. 25 sec.
Production: Imago
Castello di Rivoli Museum of Contemporary Art,
Rivoli-Turin

Daniel Buren, 2000
video, color, sound, 52 min.
Production: Terra Luna Film, Delegation aux Arts
Plastiques
Castello di Rivoli Museum of Contemporary Art,
Rivoli-Turin

Alexander Calder: Mobile, 1979
video, color, sound, 24 min.
Production: National Gallery of Art
Castello di Rivoli Museum of Contemporary Art,
Rivoli-Turin

From Chillida to Hokusai: Birth of a Work of Art, 1997
video, color, sound, 31 min.
Production: La Bahia Centro Audiovisual
Castello di Rivoli Museum of Contemporary Art,
Rivoli-Turin

Christo. Running Fence, 1978
video, color, sound, 59 min. 21 sec.
Production: Maysles Film
Castello di Rivoli Museum of Contemporary Art,
Rivoli-Turin

Christo. Islands, 1986
video, color, sound, 57 min.
Production: Maysles Film, Zwerin Production
Castello di Rivoli Museum of Contemporary Art,
Rivoli-Turin

Christo and Jeanne-Claude, 2002
video, color, sound, 57 min. 35 sec.
Production: Michael Blackwood Productions
Purchased with the contribution of the
Compagnia di San Paolo

Maya Deren. Experimental Film, 1994
video, black and white, silent and sound, 44 min. 20 sec.
Production: Re:Voir Video
Castello di Rivoli Museum of Contemporary Art,
Rivoli-Turin

Marcel Duchamp: A Game of Chess, 1987
video, color, black and white, sound, 56 min.
Production: RM Arts, Institut de l'Audiovisuel
Castello di Rivoli Museum of Contemporary Art,
Rivoli-Turin

Marcel Duchamp dialoga sulla vita e sull'arte (*Marcel Duchamp
Discusses Life and Art*), 1993
video, black and white, sound, 33 min.
Production: RTBF, Allemandi Vision
Castello di Rivoli Museum of Contemporary Art,
Rivoli-Turin

Marlene Dumas. Miss Interpreted, 1997
video, color, sound, 63 min.
Production: MM Produkties
Castello di Rivoli Museum of Contemporary Art,
Rivoli-Turin

Studio Olafur Eliasson, 2000
video, color, sound, 15 min.
Production: The Institute of Contemporary Art, Boston
Castello di Rivoli Museum of Contemporary Art,
Rivoli-Turin

Peter Fischli and David Weiss: In a Restless World, 1997
video, color, sound, 20 min.
Production: The Institute of Contemporary Art, Boston
Castello di Rivoli Museum of Contemporary Art,
Rivoli-Turin

The Secret Files of Gilbert & George, 2000
video, color, sound, 35 min.
Production: BDV
Castello di Rivoli Museum of Contemporary Art,
Rivoli-Turin

Philip Guston: A Life Saved: 1913–1980, 1981
video, color, sound, 56 min. 28 sec.
Production: Michael Blackwood Productions
Purchased with the contribution of the
Compagnia di San Paolo

Drawing the Line: A Portrait of Keith Haring, 1989
video, color, sound, 30 min.
Production: VPI Videofilm Producers
Castello di Rivoli Museum of Contemporary Art,
Rivoli-Turin

Hans Hartung: A German Destiny, 1989
video, color, sound, 55 min.
Production: Kilina Film, RM Arts
Castello di Rivoli Museum of Contemporary Art,
Rivoli-Turin

Victor Ganz & Sally Ganz: Discovering Eva Hesse, 1999
video, color, black and white, sound, 27 min.
Production: Michael Blackwood Productions
Purchased with the contribution of the
Compagnia di San Paolo

Rebecca Horn. Cutting through the Past, 1995
transferred from 16 mm film, color, sound, 55 min.
Production: Tramontana, Berlin
Purchased with the contribution of the
Compagnia di San Paolo

Jasper Johns: Decoy, 1973
video, color, sound, 18 min. 19 sec.
Production: Michael Blackwood Productions
Purchased with the contribution of the
Compagnia di San Paolo

Jasper Johns: Ideas in Paint, 1989
video, color, sound, 56 min.
Production: Phaidon, Rick Tejada Flores
Castello di Rivoli Museum of Contemporary Art,
Rivoli-Turin

Kahlo, 1993
video, color, sound, 62 min.
Production: RM Arts, Herson Guerra, WDR Production
Castello di Rivoli Museum of Contemporary Art,
Rivoli-Turin

Kandinsky, 1986
video, color, sound, 56 min. 20 sec.
Production: RM Arts, Centre Georges Pompidou,
Bayerische Rundfunk
Castello di Rivoli Museum of Contemporary Art,
Rivoli-Turin

Fernand Léger: les motifs d'une vie (*Fernand Léger: The Reasons of a Life*), 1997
video, color, sound, 52 min.
Production: Centre Georges Pompidou, RNM
Castello di Rivoli Museum of Contemporary Art,
Rivoli-Turin

Boris Lehman. À la recherche du lieu de ma naissance (*In Search of My Birthplace*), 2000
video, color, sound, 75 min.
Production: Re:Voir, Amidon Paterson
Castello di Rivoli Museum of Contemporary Art,
Rivoli-Turin

Sol LeWitt: Four Decades, 2000
video, color, sound, 56 min. 29 sec.
Production: Michael Blackwood Productions
Purchased with the contribution of the
Compagnia di San Paolo

Roy Lichtenstein, 1976
video, color, sound, 53 min. 40 sec.
Production: Michael Blackwood Productions
Purchased with the contribution of the
Compagnia di San Paolo

Roy Lichtenstein, 1991
video, color, sound, 49 min.
Production: Phaidon
Castello di Rivoli Museum of Contemporary Art,
Rivoli-Turin

Lipchitz, 1977
video, color, sound, 58 min.
Production: Jacques Lipchitz Foundation
Castello di Rivoli Museum of Contemporary Art,
Rivoli-Turin

Magritte: Portrait of an Artist, 1978
video, color, sound, 60 min.
Production: RM Arts
Castello di Rivoli Museum of Contemporary Art,
Rivoli-Turin

Magritte: Monsieur René Magritte, 1978
video, color, sound, 60 min.
Production: Phaidon
Castello di Rivoli Museum of Contemporary Art,
Rivoli-Turin

Tatsuo Miyajima. Running Time, Clear Zero, 1995
video, color, sound, 29 min. 25 sec.
Production: Hackneyed Productions
Castello di Rivoli Museum of Contemporary Art,
Rivoli-Turin

Robert Morris. Deux films de Teri Wehn Damisch (Two Films by Teri Wehn Damisch), 1995
video, color, sound, 70 min.
Production: Centre Georges Pompidou
Castello di Rivoli Museum of Contemporary Art,
Rivoli-Turin

Robert Morris: Retrospective, 1995
video, color, sound, 49 min. 34 sec.
Production: Michael Blackwood Productions
Purchased with the contribution of the
Compagnia di San Paolo

Helmut Newton. Frames from the Edge, 1988
video, color, sound, 96 min.
Production: Phaidon
Castello di Rivoli Museum of Contemporary Art,
Rivoli-Turin

Claes Oldenburg: The Formative Years, 1975
video, color, black and white, sound, 51 min. 30 sec.
Production: Michael Blackwood Productions
Purchased with the contribution of the
Compagnia di San Paolo

Claes Oldenburg, 1996
video, color, sound, 54 min.
Production: Phaidon
Castello di Rivoli Museum of Contemporary Art,
Rivoli-Turin

Giuseppe Penone. Empreintes (Imprints), 1992
video, black and white, sound, 22 min. 30 sec.
Production: Terra Luna Film, Alain Renault Productions
Castello di Rivoli Museum of Contemporary Art,
Rivoli-Turin

Le Mystère Picasso (The Picasso Mystery), 1955
video, color, sound, 78 min.
Production: Arte Video, RNM, Filmsonor
Castello di Rivoli Museum of Contemporary Art,
Rivoli-Turin

Picasso, 1985
video, color, sound, 81 min.
Production: RM Arts
Castello di Rivoli Museum of Contemporary Art,
Rivoli-Turin

New Ways of Seeing: Picasso, Braque, and the Cubist Revolution,
1989
video, color, sound, 58 min.
Production: Stephanie French, Minkoff/Clayman
Productions
Castello di Rivoli Museum of Contemporary Art,
Rivoli-Turin

Michelangelo Pistoletto. I Have a Mirror You Have a Mirror,
1988
video, color, sound, 29 min. 45 sec.
Production: Cataloga, Fondo Rivetti per l'Arte
Castello di Rivoli Museum of Contemporary Art,
Rivoli-Turin

Michelangelo Pistoletto. Anno bianco (White Year), 1990
video, color, sound, 16 min. 39 sec.
Production: Cataloga
Castello di Rivoli Museum of Contemporary Art,
Rivoli-Turin

Michelangelo Pistoletto. L'Homme Noir (The Black Man), 1995
video, color, sound, 45 min.
Production: Regards Productions, Wega Film
Castello di Rivoli Museum of Contemporary Art,
Rivoli-Turin

Robert Rauschenberg: Retrospective, 1979
video, color, sound, 43 min.
Production: Michael Blackwood Productions
Purchased with the contribution of the
Compagnia di San Paolo

Robert Rauschenberg. Man at Work, 1997
video, color, sound, 57 min.
Production: Phaidon, BBC, RM Arts, Guggenheim

Castello di Rivoli Museum of Contemporary Art,
Rivoli-Turin

Faith Ringgold. The Last Story Quilt, 1991
video, color, sound, 20 min. 57 sec.
Production: L & S Video Enterprises
Castello di Rivoli Museum of Contemporary Art,
Rivoli-Turin

James Rosenquist. Welcome to the Water Planet, 1990
video, color, sound, 31 min.
Production: Seven Hills Production
Castello di Rivoli Museum of Contemporary Art,
Rivoli-Turin

Rothko's Rooms, 2001
video, color, sound, 59 min.
Production: BBC, Reiner Moritz Associates
Castello di Rivoli Museum of Contemporary Art,
Rivoli-Turin

Io, Alberto Savinio (I, Alberto Savinio), 1993
video, color, sound, 28 min.
Production: Istituto Luce
Castello di Rivoli Museum of Contemporary Art,
Rivoli-Turin

The Artist's Studio: Meyer Shapiro Visits George Segal, 1982
video, color, sound, 29 min. 24 sec.
Production: Michael Blackwood Productions
Purchased with the contribution of the
Compagnia di San Paolo

Willoughby Sharp Videoviews: Vito Acconci, 1973
video, black and white, sound, 62 min. 07 sec.
Production: Electronic Arts Intermix, inc.
Purchased with the contribution of the
Compagnia di San Paolo

Andy Warhol, 1973
video, color, black and white, sound, 51 min. 33 sec.
Production: Michael Blackwood Productions

Purchased with the contribution of the
Compagnia di San Paolo

Andy Warhol, 1987
video, color, black and white, sound, 79 min.
Production: Phaidon
Castello di Rivoli Museum of Contemporary Art,
Rivoli-Turin

Andy Warhol, 1987
video, color, black and white, sound, 79 min.
Production: RM Arts
Castello di Rivoli Museum of Contemporary Art,
Rivoli-Turin

Andy Warhol: Made in China, 1989
video, color, sound, 30 min.
Production: Visionary
Castello di Rivoli Museum of Contemporary Art,
Rivoli-Turin

Rachel Whiteread: Sculpture, 1993
video, color, sound, 22 min.
Production: The Institute of Contemporary Art, Boston
Castello di Rivoli Museum of Contemporary Art,
Rivoli-Turin

Rachel Whiteread. House, 1998
video, color, sound, 26 min. 25 sec.
Production: Artangel, Hackneyed Productions
Castello di Rivoli Museum of Contemporary Art,
Rivoli-Turin

*H.G.: Robert Wilson & Hans Peter Kuhn in London
1895–1995*, 1998
video, color, sound, 52 min. 50 sec.
Production: Artangel
Castello di Rivoli Museum of Contemporary Art,
Rivoli-Turin

Performing Arts

Thelonious Monk, 1968
video, black and white, sound, 57 min. 55 sec.
Production: Michael Blackwood Productions
Purchased with the contribution of the
Compagnia di San Paolo

Philip Glass and the Making of an Opera, 1985
video, color, sound, 87 min. 32 sec.
Production: Michael Blackwood Productions
Purchased with the contribution of the
Compagnia di San Paolo

Philip Glass, Sol LeWitt. Five Metamorphoses, 1991
video, color, sound, 26 min. 11 sec.
Castello di Rivoli Museum of Contemporary Art,
Rivoli-Turin

ANTHOLOGICAL DOCUMENTARIES

Architecture

Japan: Three Generations of Architects, 1988
Tadao Ando, Arata Isozaki
video, color, sound, 59 min. 13 sec.
Production: Michael Blackwood Productions
Purchased with the contribution of the
Compagnia di San Paolo

Deconstructivist Architects, 1989
Peter Eisenmann, Zaha Hadid, Daniel Libeskind, Bernard
Tschumi
video, color, sound, 59 min. 04 sec.
Production: Michael Blackwood Productions
Purchased with the contribution of the
Compagnia di San Paolo

The New Modernists: Six European Architects, 1992
Jacques Herzog, Eduardo Souto de Moura, Hans Kollhoff,
Kristian Gullichsen, Jean Nouvel, Antonio Cruz
video, color, sound, 56 min. 30 sec.
Production: Michael Blackwood Productions
Purchased with the contribution of the
Compagnia di San Paolo

The New Modernists: Nine American Architects, 1993
Tod Williams, Billie Tsien, Henry Smith-Miller, Laurie
Hawkinson, Steven Holl, Thom Mayne, Michael Rotondi,
Stanley Saitowitz, Mark Mack
video, color, sound, 56 min. 38 sec.
Production: Michael Blackwood Productions
Purchased with the contribution of the
Compagnia di San Paolo

Bauhaus: The Face of the 20th Century, 1994
video, color, sound, 50 min.
Production: Phaidon
Castello di Rivoli Museum of Contemporary Art,
Rivoli-Turin

The New Modernists: German Architecture for the 21ˢᵗ Century, 1999
Michael Schumacher, Peter Wilson, Julia Bolles, Hilde Leon, Konrad Wohlhage, Thomas Britz, Peter Alt, Thomas Herzog, Christoph Inghenhoven, Till Schneider, Walter Nageli
video, color, sound, 56 min. 27 sec.
Production: Michael Blackwood Productions
Purchased with the contribution of the Compagnia di San Paolo

Art

American Art in the Sixties, 1973
Robert Rauschenberg, Jasper Johns, Andy Warhol, Roy Lichtenstein, Frank Stella, John Cage, George Segal, Claes Oldenburg, Donald Judd, Dan Flavin, Ellsworth Kelly, Kenneth Noland, Morris Louis, Ed Ruscha, Sam Francis, Robert Indiana
video, color, sound, 58 min.
Production: Michael Blackwood Productions
Purchased with the contribution of the Compagnia di San Paolo

Masters of Modern Sculpture. Part 1: The Pioneers, 1978
Auguste Rodin, Edgar Degas, Medardo Rosso, Vladimir Evgrafovič Tatlin, Pablo Picasso, Man Ray, Alexander Calder, George Segal, Sol LeWitt, Christo, Donald Judd, Dan Flavin, Walter De Maria, Constantin Brancusi, Henry Moore
video, color, sound, 56 min. 10 sec.
Production: Michael Blackwood Productions
Purchased with the contribution of the Compagnia di San Paolo

Masters of Modern Sculpture. Part 2: Cubism, 1978
Auguste Rodin, Edgar Degas, Medardo Rosso, Vladimir Evgrafovič Tatlin, Pablo Picasso, Man Ray, Alexander Calder, George Segal, Sol LeWitt, Christo, Donald Judd, Dan Flavin, Walter De Maria, Constantin Brancusi, Henry Moore
video, color, sound, 56 min. 08 sec.
Production: Michael Blackwood Productions

Purchased with the contribution of the
Compagnia di San Paolo

Masters of Modern Sculpture. Part 3: New World, 1978
Auguste Rodin, Edgar Degas, Medardo Rosso, Vladimir
Evgrafovič Tatlin, Pablo Picasso, Man Ray, Alexander
Calder, George Segal, Sol LeWitt, Christo, Donald Judd,
Dan Flavin, Walter De Maria, Constantin Brancusi, Henry
Moore
video, color, sound, 56 min. 07 sec.
Production: Michael Blackwood Productions
Purchased with the contribution of the
Compagnia di San Paolo

A New Spirit in Painting: Six Painters of the 1980's, 1984
Markus Lupertz, David Salle, Sandro Chia, Julian
Schnabel, Francesco Clemente, Georg Baselitz
video, color, sound, 56 min. 31 sec.
Production: Michael Blackwood Productions
Purchased with the contribution of the
Compagnia di San Paolo

*Four Artists: Robert Ryman, Eva Hesse, Bruce Nauman, Susan
Rothenberg*, 1987
video, color, sound, 45 min. 11 sec.
Production: Michael Blackwood Productions
Purchased with the contribution of the
Compagnia di San Paolo

Magiciens de la Terre (*Magicians of the Earth*), 1989
video, color, sound, 55 min.
Production: Centre Georges Pompidou
Castello di Rivoli Museum of Contemporary Art,
Rivoli-Turin

*Mind Over Matter: Six Conceptual Artists at the Whitney
Museum*, 1991
Ashley Bickerton, Nayland Blake, Tishan Hsu, Ronald
Jones, Liz Larner, Annette Lemieux
video, color, sound, 58 min. 27 sec.
Production: Michael Blackwood Productions
Purchased with the contribution of the
Compagnia di San Paolo

After Modernism: The Dilemma of Influence, 1992
Richard Wentworth, Bertrand Lavier, Isa Genzken, Laurie
Simmons, David Hamilton, Mike Kelley
video, color, sound, 58 min. 56 sec.
Production: Michael Blackwood Productions
Purchased with the contribution of the
Compagnia di San Paolo

Reclaiming the Body: Feminist Art in America, 1995
Penny Arcade, Judith Weinperson, Maureen Connor,
Nancy Spero, Carole Schneemann, Ida Applebroog, Faith
Ringgold, Kiki Smith, Renée Cox, Louise Bourgeois, Susan
Silas
video, color, sound, 55 min.
Production: Michael Blackwood Productions
Purchased with the contribution of the
Compagnia di San Paolo

Enterprise: Venture and Process in Contemporary Art, 1997
video, color, sound, 17 min. 42 sec.
Production: The Institute of Contemporary Art, Boston
Castello di Rivoli Museum of Contemporary Art,
Rivoli-Turin

Gothic, 1997
video, color, sound, 32 min. 49 sec.
Production: The Institute of Contemporary Art, Boston
Castello di Rivoli Museum of Contemporary Art, Rivoli-
Turin

Le Centre Pompidou, 1999
video, color, sound, 26 min.
Production: Centre Georges Pompidou, La Sept Art, Les
Film d'Ici
Castello di Rivoli Museum of Contemporary Art,
Rivoli-Turin

Speaking of Abstraction: A Universal Language, 1999
Jonathan Lasker, Richard Serra, Robert Mangold, Günther
Förg, Gerhard Richter, Philip Taaffe, Brice Marden,
Helmut Federle, Gunther Umberg, Frances Scholz
video, color, sound, 50 min.
Production: Michael Blackwood Productions

Purchased with the contribution of the
Compagnia di San Paolo

Art in Our Time: Towards a New Museum of Modern Art,
2001
video, color, sound, 58 min. 09 sec.
Production: Michael Blackwood Productions
Purchased with the contribution of the
Compagnia di San Paolo

Marlene Dumas, Rineke Dijkstra, Layah Ali, 2001
video, color, sound, 24 min.
Production: The Institute of Contemporary Art, Boston
Castello di Rivoli Museum of Contemporary Art,
Rivoli-Turin

Performing Arts

Making Dances: Seven Post Modern Choreographers, 1980
Trisha Brown, Lucinda Childs, David Gordon, Douglas
Dunn, Kenneth King, Meredith Monk, Sara Rudner
video, color, sound, 88 min. 02 sec.
Production: Michael Blackwood Productions
Purchased with the contribution of the
Compagnia di San Paolo

Retracing Steps: American Dance since Postmodernism, 1988
Molissa Denley, Bill Jones, Arnie T. Zane, Diane Martel,
Stephen Petronio, Johanna Boyce, Wendy Perron, Jim Self,
Blondell Cummings
video, color, sound, 87 min. 53 sec.
Production: Michael Blackwood Productions
Purchased with the contribution of the
Compagnia di San Paolo

The Sensual Nature of Sound: 4 Composers, 1993
Laurie Anderson, Tania Leon, Meredith Monk, Pauline
Oliveros
video, color, sound, 58 min. 15 sec.
Production: Michael Blackwood Productions
Purchased with the contribution of the
Compagnia di San Paolo

Musical Outsiders: An American Legacy, 1995
Harry Partch, Lou Harrison, Terry Riley
video, color, sound, 58 min.
Production: Michael Blackwood Productions
Purchased with the contribution of the
Compagnia di San Paolo

New York Composer: Searching for a New Music, 1996
Phil Kline, David Lang, Tan Dun, Michael Gordon, Lois
Vierk, Julia Wolfe
video, color, sound, 59 min. 14 sec.
Production: Michael Blackwood Productions
Purchased with the contribution of the
Compagnia di San Paolo